Portrait Photographs from Isfahan

Portrait Photographs from Isfahan

Faces in Transition, 1920–1950

Parisa Damandan

SAQI

Prince Claus Fund Library

British Library Cataloguing-in-Publication Data
A catalogue record of this book is available from the British Library

ISBN 0 86356 553 0
EAN 9-780863-565533

Design Samar Maakaron
Printing Chemaly & Chemaly
Paper Leman Silk 150 g.

This edition first published 2004

**Prince Claus
Fund Library**

SAQI
26 Westbourne Grove
London W2 5RH
www.saqibooks.com

Hoge Nieuwstraat 30
2514 EL The Hague
www.princeclausfund.nl

Contents

Foreword

1968

I was not yet a year old when my parents took me to a photographer's studio for the first time to have my picture taken. The studio was near our house in the Julfa district of Isfahan. Naturally I have no recollection of the day itself, but the photo has recorded something that serves as a pictorial memory. It is the oldest proof of my physical identity in my albums and as such it has special and eternal value for me. Not having the negative or any other copy has only doubled my regard for this unique print.

More than anything else, perhaps, it is the look on my face that makes this photograph particularly valuable to me – a look of unbounded love and joy – and it is the reason behind that look that matters to me.

In the picture, I am looking not at the photographer but at my mother, who is standing beside me and supporting me on the chair with her hand. (She is out of the frame and the photographer has cropped the photograph to remove the image of the hand.) With a few sweet winks and smiles, she has managed to draw out onto my face all the fervent love of which my small self is capable. To this day, the same emotion awakens in me every time I look at the photograph and I am once again reunited in spirit with my mother, out of sight beyond the frame of the photo.

Vahan, the kind and skilful Armenian who took my baby photo, was for years my family's only photographer. Well known himself, he was the son of Minas Patkerhanian Mackertich, renowned as a pioneer photographer in Isfahan.

I completed primary school in the final years of the Pahlavi era, a time of peace, when no portent of revolution and change impinged on my childish mind. As a schoolchild, I was required to have photographs of myself taken to attach to school certificates. So I visited Vahan's studio several times before I finished primary school. In these photographs, which seem like snapshots of a gradually disintegrating time, a small, short-haired schoolgirl in uniform turns into a young girl with long straight hair and finally into one on the threshold of womanhood.

1978

Isfahan experienced martial law ahead of other cities in Iran. A popular revolution, based on ideals, removed the Pahlavi monarchy from power and attained a republic for the first time, but the new regime caused upheavals. The Islamic Republic swept away existing institutions and put in place harsh laws. Iranian women, who had been forced to abandon Islamic garb at the start of the Pahlavi reign, were now forced back into it.

Some photographers' studios were burnt down and it was forbidden to take photographs of women who were not wearing full Islamic attire.

My first photograph wearing the *hijab* was not taken in Vahan's studio, as Vahan had shut up shop and declared himself retired. In fact, the closing of Vahan's studio corresponded to the start of one era and the end of another, an era whose faces were now filed away in his archive of photographs.

I was never pleased with the photographs that were taken of me in subsequent years in other studios near our new house. In these photos, I find a girl growing up and at the same time struggling to adjust to her new appearance. The early pictures show her wearing a thin scarf, loosely knotted beneath the chin but still revealing the tresses underneath. Later she appears in the ready-made black head-and-shoulder coverings from which only the face appears through a circular opening. This last photograph was for my entry into university.

1989

In order to study photography, I enrolled at the University of Tehran. At that time, just after the end of the Iran-Iraq war, the universities and academic and cultural institutions were – like the entire country – in a state of chaos. The camera became my favourite companion wherever I went, and portraits of people out of doors in changing light and in everyday roles and unpredictable poses were my main subject.

I continued to visit Isfahan. The city holds my existential archives, my sensory archives of scents, of colours, of hundreds of perceptions of light, of an understanding of the meaning of beauty – and my photographs, which are a part of the archives of its photographers' shops. It was on one of these visits to Isfahan that I plucked up the courage to go to the photographer's house to see him and perhaps to find the negatives of my old photographs. I went to Vahan's paternal house in Julfa, an old house that had been one of Isfahan's first photographer's studios. The photographer and his courteous wife knew my family well and welcomed me warmly. Vahan, now eighty years old, had cataracts and was hard of hearing, but he spent hours telling me stories about his father and the city's other old photographers. He told me too about the archive of photographs that now sat in a disused attic. The attic was reached by a narrow staircase. Another flight of stairs led from the landing down to the cellar, and Vahan said that when he was a child, his father used to tell him many tales about the treasure that lay buried beneath the cellar. For me, however, the true treasure lay forgotten not in the cellar but in the attic, beneath the nest of a pair of turtledoves and covered with layers of dust and spiderwebs.

Thousands of glass-plate negatives had been arranged on shelves in cardboard boxes. In another corner of the room, the archive of Vahan's father's negatives shone like a big jewel in the treasure trove. As none of the sons had taken up their father's profession, the treasure had been left without heirs.

I carefully noted down the story of Vahan's father's life. It was the start of my research into photo-portraiture, which continued for the next ten years and took me on repeated visits to the city of my birth.

This kind of research is not based on written sources. Information has to be sought in the field. One must look for leads – a person's name, the name of a street, the inscription on a gravestone, a photograph in an old album or in an antiques shop, the private letters of a photographer, a cemetery's registration book, an old photographer's shop, a distant recollection in the mind of an elderly photographer. Isfahan photographers long past their youth – many of them no longer alive today – were and are the best sources for my research. Like old friends and colleagues, they obligingly helped me assemble the jigsaw of the story of photography in Isfahan and the life stories of the previous generation, the pioneer practitioners, whose relatives made space for me in their families so that I could note down their recollections in comfort and ease. Many of these dear people trustingly allowed me access to their fathers' archives. In only one instance, where the photographer had no children, was the archive purchased from the photographer's relatives.

So far, I have managed to amass more than 20,000 original copies and negatives, mostly glass plates, measuring 4 x 6, 6 x 9, 9 x 12, 13 x 18 and 18 x 24 cm. This valuable collection is piled high in a corner of my study. And in the middle of it all, the precious treasure trove of my childhood photographer shines particularly bright. (In this book, the photographs originally taken from glass-plate negatives have been reproduced with their black borders showing.)

Some of the glass negatives are broken, and the original copies have suffered serious damage. These photographs were mainly taken in the first half of the 20th century and contain valuable information about the changing face of Iranians in a period of transition from a traditional to a modern society, as well as displaying the distinguishing features of Iranian photo-portraiture.

The outcome of part of this research was published as my thesis. But the photographs have received no worthy presentation until today, especially the portraits of women without the *hijab* from the Pahlavi era, which censors at the Ministry of Islamic Culture and Guidance will not allow to be published.

I became acquainted with Marlous Willemsen, a policy officer at the Prince Claus Fund for Culture and Development, at a conference on the

history of photography in the Qajar era in Iran, organized in 2001 at Leiden University in the Netherlands by the Qajar Society. This allowed me the opportunity to establish a link with the Prince Claus Fund and to gain the Fund's backing for the publication of a book on photo-portraiture in Isfahan. This admirable cultural fund strives actively to connect with artists in all the regions it covers. Thanks to its support, the treasure hunter has flushed out the treasure and been induced to put its beauties on display for all to see. The result is here, within the covers of this book.

The book contains a selection of photographs in my collection and an article about the development of photo-portraiture in Isfahan. In addition, I invited Reza Sheikh and Josephine van Bennekom to contribute articles. Reza Sheikh, an Iranian writer and researcher, has been studying the history of photography and especially photo-portraiture in Iran for years. In his article, he writes about developments in photo-portraiture in Iran and the process of its popularization, shedding new light on the subject. Josephine van Bennekom is a Dutch writer who has been writing about photography for many years. Josephine's father is also a renowned photographer in the Netherlands, and Josephine wrote a study of his archive of photographs which led her to writing extensively about photographs generally, especially family photographs. In this book, Josephine writes about some album photographs, working from the photographs themselves and drawing on her knowledge rather than on details supplied to her. I should like to express my gratitude to both of them.

While preparing this book, I received unstinting and wholehearted assistance from many individuals, without whom the project would not have come to fruition. It is my pleasant duty to thank each and every one of them.

Soheil Nafisi, who has been my ally and companion for years in this research project, and Maryam Raz, both dear friends, had the difficult task of extracting the selected glass plates from the thousands of plates in the collection.

The esteemed family of Isfahan photographers, especially Vahan Patkerhanian Mackertich, Reza Jala, Reza Siamaki, Zaven Gharakhanian and Amir Shams, and Behjat Chehreh-Nama, Nini and Frida Schunemann and Leidik Thoonian, were unfailingly helpful.

Long-established Isfahan photographers, especially Amanollah Tariqi, provided valuable leads, which helped me obtain the information presented here.

The distinguished researchers Muhammad Reza Tahmasbpur, Arman Stepanian, Leon Minasian and Sona Zargarian gave me the benefit of their views. Els van der Plas, Marlous Willemsen, Geerte Wachter and Malu Halasa, along with others in the Prince Claus Fund, extended the utmost cooperation in establishing the link with the Fund and in the publication of this book. Saqi Books also spared no effort in seeing this book through to publication.

I thank Leo Divendal, Sharog Heshmatmanesh, Tineke Muileboom and Bernard Kruitwagen for their assistance.

I also thank Herman Divendal of AIDA Netherlands, who, for years now, has provided me with long wings and the necessary instructions for flying.

Parisa Damandan
March 2004

The Development of Portrait Photography in Isfahan

Parisa Damandan

In 1868, Iran's first professional photographer and photographer to the royal court opened the first public photographer's studio in Tehran.[1] The high cost of taking a photograph, however, restricted portraiture at this time to courtiers, aristocrats and grandees, among whom it had already become fashionable.

A few Iranian photographers followed suit in the 1870s, establishing shops in the capital, but it would be another decade before the first professional photographers appeared in other Iranian cities.

Photographers in Tabriz, then Iran's second biggest city, could take advantage of the city's proximity to Russia, which served as a good training ground. Tabriz was also home to the court of the Qajar dynasty's crown prince, Muzaffar al-Din Mirza, where court photographers could hone their skills by taking portraits of the heir to the throne. The city's first public photographer's studio opened there in the early 1880s.[2]

Isfahan, Iran's third city, which the shahs of the Safavid dynasty had chosen as their capital in the 17th century, had been a place of economic and artistic splendour in its day and was still of particular importance to Iran's central government. Photography was introduced to Isfahan at almost the same time as Tabriz and for a similar reason: it was the home of a powerful Qajar prince, Mas'ud Mirza Zell al-Sultan (1848–1917), ruler of Isfahan and Nasir al-Din Shah's eldest son.

Zell al-Sultan was three years older than his brother Muzaffar al-Din Mirza and, according to the laws of succession, ought to have inherited

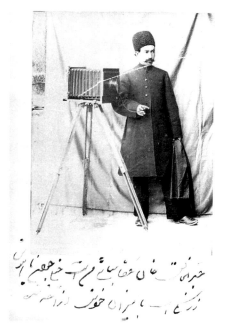

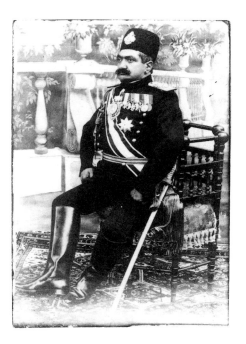

1. *Abdolkhaleq Khan, Zell al-Sultan's court photographer. Zell al-Sultan, 1901. Original caption: 'Abdolkhaleq Khan, my personal photo-man, he is a very shrewd and intelligent youth, taken with his own settings.'*

2. *Zell al-Sultan. Thooni Johannes, late 1890s.*

the crown after Nasir al-Din Shah's demise. However, since his mother had been one of the shah's wives at a time when the shah was still crown prince, and since she was not considered a wife with a full and permanent marriage contract, Zell al-Sultan was passed over. His lust for power and yearning for kingship fuelled the jealousy of his brother that had been present since childhood and, in the many years that he ruled over nearly half of Iran, he was a villainous accumulator of wealth, land and power.[3]

Zell al-Sultan (meaning 'the shadow of the king') strove to present a truly kingly image of himself. He emulated his father by establishing, in Isfahan, the first newspaper, the first modern-style school and the first academy to train volunteers for his military force.[4] Sharing too his father's interest in photography, he employed the city's first photographers and welcomed them into his court.

The albums that remain contain hundreds of photo portraits of Zell al-Sultan,[5] mostly with captions in his own handwriting, proof of his particular

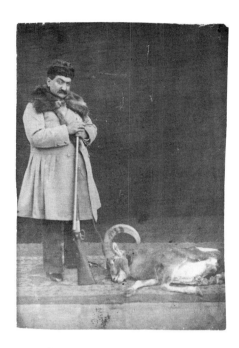

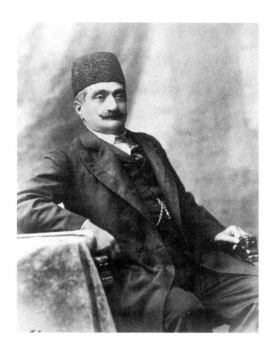

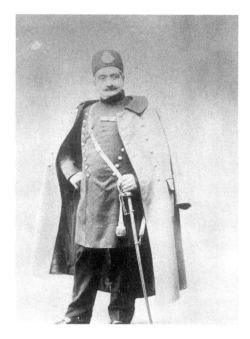

3. *Zell al-Sultan. Anonymous, 1880s.* 4. *Zell al-Sultan. Ernst Hoeltzer, 1890s.* 5. *Zell al-Sultan. Thooni Johannes, 1900s.*

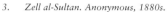

interest in and devotion to photography. Mirza Nasrollah, Mirza Reza Khan Mostowfi-Shirazi[6] and Abdolkhaleq Khan[7] were among the *Sardari* photographers (photographers attached to the court) employed by Zell al-Sultan in the 1880s and 1890s.

Zell al-Sultan's photographers had a duty above all to take portraits of him that displayed his majesty and power. Without a doubt, the task of covering up the flaws and shortcomings of their subjects so as to present an ideal beauty – which preoccupied photographers in the initial decades of photography – was one of the main problems the *Sardari* photographers faced in Isfahan. The prince was fat and short and, because of an injury to one of his eyes in infancy, had a slightly drooping eyelid; hence, most of his portraits show him in three-quarters profile, his eyes turned away from the camera. His wardrobe was crammed with the costumes of European sovereigns, cashmere cloaks and modern-style military uniforms, and he donned them in turn in order to appear in the most splendid and graceful guise in photographs.[8]

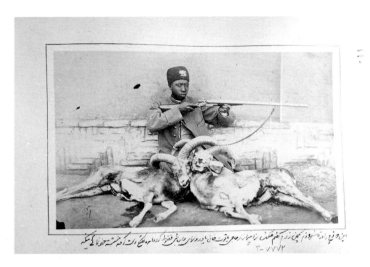

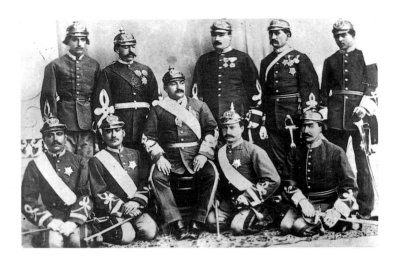

6. *Zell al-Sultan's harem retainer, Haji Yaqut Khan. Abdolkhaleq Khan, 1900. Original caption: 'I shot these two bucks in Qameshlou. Had their photographs taken. Haji Yaqut Khan, coadjutor and chief steward, with his tomfoolery, has taken a gun and is sitting there, showing off.'*

7. *Military officials of Zell al-Sultan's Jalali Regiment. Anonymous, 1890s.*

The pleasure-loving prince was particularly keen on hunting and horse-riding and spent several months in such recreations in the temperate regions around Isfahan.[9] Several of his photo albums are dedicated to photographs of hunting and show him, his sons and his court retainers and courtiers standing beside carcasses. Trophy antlers were later hung along the terrace all around the palace yard.

From time to time Zell al-Sultan would command military exercises to show off his well-equipped force, which was modelled on European armies and was considered impressive even by the capital's standards. On these occasions, he took particular care to have photographs taken of the military camp and the physical fitness exercises, as well as portraits of his army commanders. He even invited famous photographers from the capital, such as Antoin Sevruguin.[10]

Although Richard Maddox's gelatin dry-plate silver bromide process and the use of gelatin instead of collodion on the sensitized glass plates gained extensive commercial currency in Europe in the 1880s, it was not put into

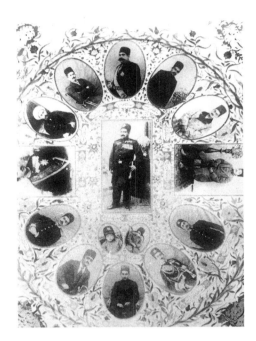

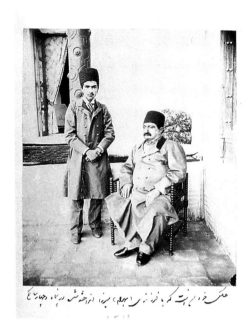

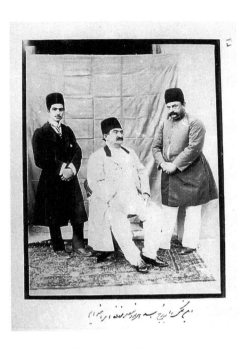

8. Zell al-Sultan's family tree, constructed from photographs. Mounted by Abdolhossein Nayeb al-Sadr, 1906.

9. Zell al-Sultan and his son, Bahram Mirza. Abdolkhaleq Khan, 1901. Original caption: 'Photograph of myself, taken with my son Bahram Mirza, aged fifty-four, 1319 (Lunar).'

10. Zell al-Sultan, his son Bahram Mirza and a court steward. Abdolkhaleq Khan, 1901. Original caption: 'We took this photograph in the month of Assad 1319 (Lunar).'

practical use in Iran until the first decade of the 20th century[11] and Zell al-Sultan's photographers still had to use the difficult wet collodion method to sensitize their own glass plates. When the prince travelled to various places around Isfahan, they would carefully wrap up their bulky, heavy and fragile equipment to protect it from damage on the uneven surfaces of the unpaved roads. Wherever the prince ordered camp to be set up, they would prepare one of the tents for use as a darkroom.

Many of Zell al-Sultan's family portraits include images of his male offspring, taken with their father, with the retainers and courtiers or on their own. Usually the photographs show Zell al-Sultan seated at the centre of the group, with everyone else standing, thus highlighting the prince's superior position.

It was customary at this time to hang a simple black cloth or a cloth with some kind of design behind the subject or to include part of a garden or porch in the background of the picture. Only a few photographers, who

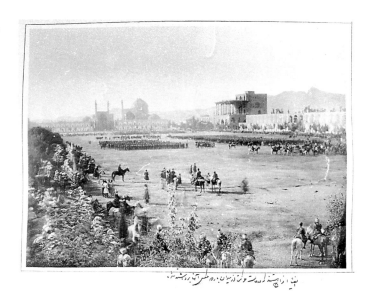

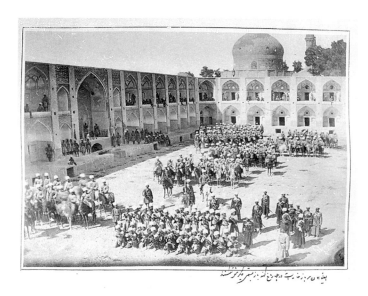

11. *Military exercise by Zell al-Sultan's Jalali Regiment. Antoin Sevruguin, 1900s. Original caption: 'Ditto, the regiments, two photographs taken of them as they left the parade ground.'*

12. *Military exercise by Zell al-Sultan's Caucasus Regiment. Antoin Sevruguin, 1900s. Original caption: 'Ditto, the same garrison in Chahar-Bagh, performing some other training manoeuvres.'*

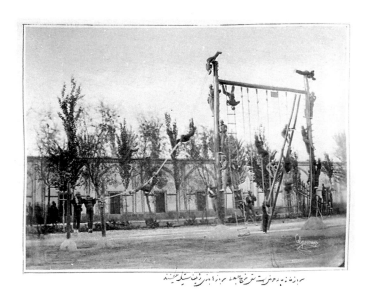

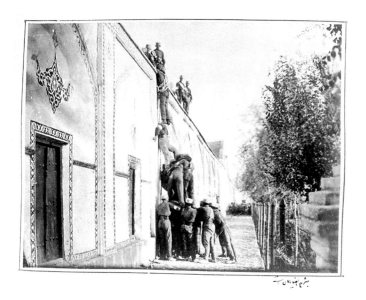

13. *Gymnastics exercise by Zell al-Sultan's Jalali Regiment. Antoin Sevruguin, 1900s. Original caption: 'The Chaleh-Howz Garrison. Training exercise by Jalali Regiment. Soldiers performing gymnastic games.'*

14. *Gymnastics exercise by Zell al-Sultan's Jalali Regiment. Antoin Sevruguin, 1900s. Original caption: 'Ditto, same details.'*

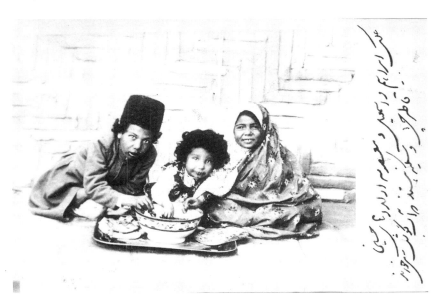

15. *Servants' children at Zell al-Sultan's court. Abdolkhaleq Khan, 1900. Original caption: 'Photograph of Ebrahim, Esma'il and Ma'soumeh, children of Hossein, the muleteer, and his wife, Sakineh, eating meat stew.'*

16. *Haji Yaqut Khan's maids. Abdolkhaleq Khan, 1900. Original caption: 'Two of Haji Yaqut's wife's maids, taken in Qameshlou in 1318 (Lunar).'*

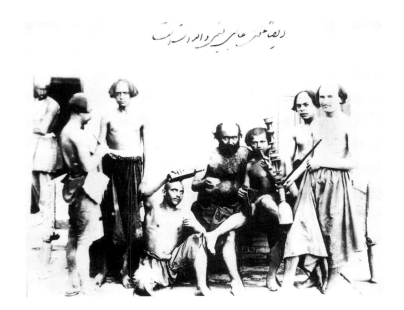

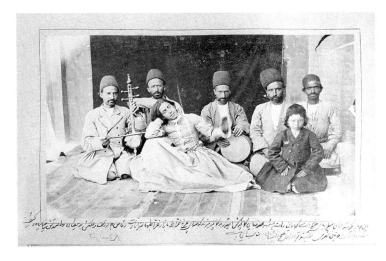

17. *Abbas Pashmi, a court jester. Abdolkhaleq Khan, 1900. Original caption: 'Ditto, a photograph of Abbas Pashmi and the jesters.'*

18. *Village minstrels. Anonymous, 1900. Original caption: 'This is another bunch of the pathetic minstrels that you find in these villages. The kamancheh [a stringed instrument played with a bow] player in particular plays so badly that the sound of the lathes in the turners' market is more melodious. The dancer does not look too bad but his face is very black and dirty.'*

19. *Men from the Hamavand tribe. Abdolkhaleq Khan. Original caption: 'This is a photograph of Javanmir from the Chalabi tribe. The Hamavand say that this Javanmir and his cousin, Faqih Qader, with two thousand men on horseback, went off to the camp of Isma'il Haqqi Pasha, who was Bayazid's man, and served him in the Ottoman camp [illegible] Isma'il Pasha from the Russians. With Martin rifles and thousands of bullets, they set upon the Iraqi border inhabitants and, for about ten years, they harassed the ruined Ottoman government with thievery and banditry, shedding so much blood and breaking up so many camps, until the government of Kermanshahan and Kurdistan was entrusted to me. Thanks to the good fortune of my master, the Shahanshah, may our souls be sacrificed to him, what security [illegible] I brought him to Isfahan, then took him to Tehran. Since he broke his pledge and set about his banditry again, I punished him with the utmost might. Since it would not be modest, I refrain from describing it here. Suffice it to say that God metes out retribution to all [illegible] services of true servants be noted by their master.'*

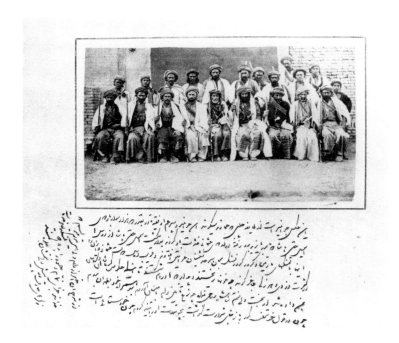

were able to purchase cloths depicting scenery and landscapes on their travels to Europe, Russia or India, used drapes of this kind as backdrops. Among Zell al-Sultan's photographs there are also portraits of subordinates and peasants, harem retainers, jesters and minstrels, poets and stewards and even Zell al-Sultan's captured enemies. It was the link with the court that produced these rare instances of portraits of ordinary people during this time.

Although the photographs in Zell al-Sultan's albums were the first examples of portraits taken by Iranian photographers in Isfahan, photography in this city in the 1880s and 1890s was not confined to these pictures. Europeans who travelled to Iran to see the country or on religious, political or scientific missions also took photographs of the scenery and historical monuments and portraits of the people.

Ernst Hoeltzer (1835–1911), the German telegraph engineer, came to Iran in 1863 with the British engineering team that was setting up the

20. *Ernst Hoeltzer, printed photograph on tile (Vank Cathedral Museum in Julfa-Isfahan). Ernst Hoeltzer, 1890s.*

21. *Thooni Johannes, photographer. Anonymous, 1890s.*

London-India telegraph line, which passed through Iran. After a short stay in the capital, where he taught Iranian engineers at the Dar-al-Fonun Polytechnic to use the telegraph and Morse code, he went to Isfahan to establish the telegraph line there.[12]

He took up residence in the Armenian district of Julfa, married an Armenian girl and became assistant superintendent of the Julfa telegraph office.[13] Hoeltzer lived in Isfahan for the rest of his life and took many pictures of the monuments, historical buildings and scenery of Isfahan and its environs, as well as portraits of the people and their customs and traditions. These portraits include photographs of Zell al-Sultan and his courtiers, various professionals and ordinary people. They remain an honest record of the social visage of the people of Isfahan.[14]

Thooni Johannes (known as Thooni Khan; 1864–1946) opened the first public photographer's studio in Isfahan in the late 1880s. He had been born in the village of Faridan in Isfahan and had migrated to Julfa with his mother

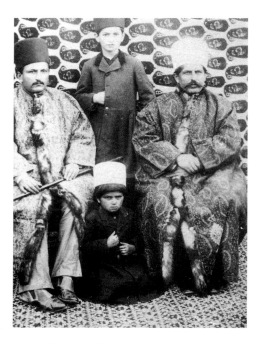

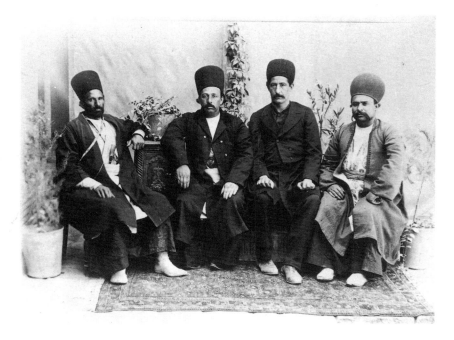

22. *Bakhtiari tribal leaders. Thooni Johannes, 1890s.* 23. *Untitled. Thooni Johannes, 1890s.*

when he was three years old and at a time of great poverty and hunger. In his youth, he began working for a German merchant by the name of Gaier. When Thooni Khan was 24, Gaier left Iran and, being pleased with Thooni's progress, gave him his camera before leaving. Having learnt the basic principles of photography from Gaier, Thooni pursued the craft with diligence and was soon a celebrated practitioner. He opened a small photographer's studio in Julfa in the hope of earning a living. In those days, photographs were still not affordable for the majority of the people, and the shop's customers were uniquely the city's wealthy residents and aristocrats. Thooni also took portraits of Zell al-Sultan.

Visitors to Isfahan in the closing years of the 19th century painted a picture of a declining and crumbling city.[15] Having been chosen as Iran's capital during the reign of the first Safavid kings, Isfahan had, in its day, experienced the height of magnificence and splendour, as well as flourishing trade, learning, art and architecture. It had become known as 'Half the World'.

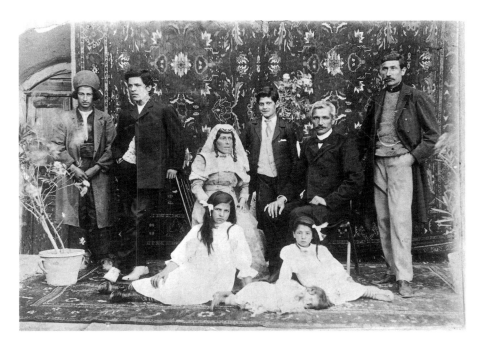

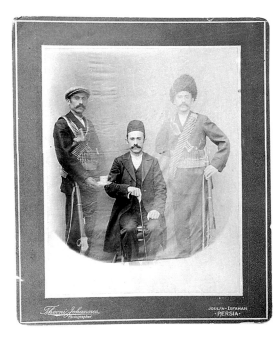

24. *Gregor Stepanian's family in Julfa. Thooni Johannes, 1890s.*

25. *Three portraits of Minas Hakoupian, known as Minas the Draper. Thooni Johannes, 1913.*

After this period, however, good fortune had turned its back on the city. With the invasion of the Afghans towards the end of the reign of the Safavids, famine claimed the lives of the bulk of the population of Isfahan and the city started to fall into ruin. During the reign of the Zands, the capital was moved to Shiraz. The Qajar kings, for their part, lived in northern Iran and chose Tehran as their capital. Many people migrated away from Isfahan, and its vast palaces and houses were left abandoned. Although the granting of concessions to European merchants had a considerable impact on learning, culture and trade in Isfahan, it gradually reduced Isfahan's merchants to middlemen in the buying and selling of European goods.[16]

Although Isfahan's situation started to improve somewhat in the 1890s, ordinary people still lived in difficult economic conditions. Having one's photograph taken remained a luxury. Shortage of the required equipment and instruments, the high cost of the materials involved and the complexity of the process of sensitizing the glass plates kept the price of

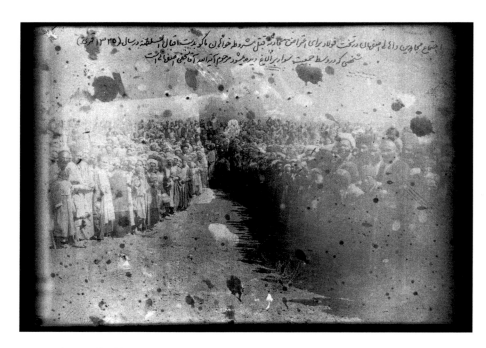

26. 'Gathering of Isfahan's inhabitants and mujahedin at Takht Fulad, protesting against the killing of constitutionalists in Maku by Eqbal al-Saltaneh in 1325 (Lunar); the person seen astride the donkey in the middle of the crowd is the late Ayatollah Aqa Najafi-Esfahani.' Anonymous, 1906.

photographs out of most people's reach. The price of three copies of a one-*gereh* (knot) picture was 13 *qarans* and three copies of a two-*gereh* picture cost 22 *qarans*.[17] Added to this could be the cost of the visit, if the photographer had to go to the customer. He would charge an extra *toman* if the location was in the city and an extra 2 *tomans* if it was outside the city.[18] In order to supplement the income he received from his small coterie of clients of his pioneering photography studio in Isfahan and Julfa, Thooni also ventured out into other fields. He established the first carriage house, the first lemonade-making factory, the first cinema and the first modern-style inn in Isfahan.

Growing unrest and manifold changes marked the beginning of the 20th century in Iran. The Constitutional Revolution, the Constitutional Decree of 1906 and the establishment of the first parliament brought an end to Muzaffar al-Din Shah's short reign (1898–1906). Crisis gripped Isfahan and a number of other Iranian cities. With their homilies, Isfahan's renowned

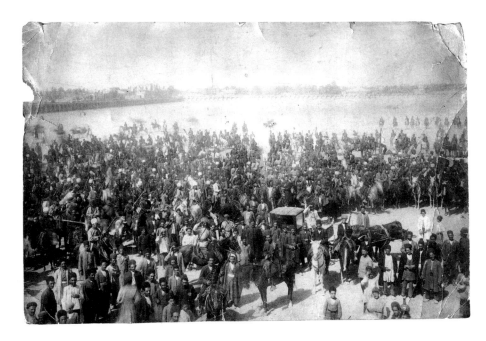

27. *Conquest of Tehran. Anonymous, 1906.*

preachers played an important role in enlightening the public and encouraging them to attain their national rights. Although Muhammad Ali Shah signed the Supplement to the Constitution after ascending the throne, he was fiercely opposed to the constitutionalists and in 1908 sanctioned a cannon attack on Parliament and the killing of its defenders. But the people of Tabriz, Rasht and Isfahan rose up against this act, attacked Tehran, removed Muhammad Ali Shah from the throne in 1909 and installed Ahmad Mirza, the last Qajar king, in his place.

Some Isfahan photographers recorded the events of the constitutional movement. Some photographs – for example, showing hanged constitutionalists in Tabriz and the conquest of Tehran – were brought to Isfahan, where photographers made copies of them. During this decade, apart from Thooni Johannes, a small number of other photographers, including Mirza Mostafa Golestaneh and Mirza Muhammad Ashtiani, were also active in Isfahan. Unfortunately we know very little about their lives. What is certain is that

28. *Medallion for pinning on clothes. Minas Patkerhanian Mackertich, 1918.*

29. *Minas Patkerhanian Mackertich, photographer, in the front. Anonymous, Tehran, 1930s.*

these photographers remained in the service of the affluent class, aristocrats and the elites of Isfahan.

Minas Patkerhanian Mackertich (1885–1972), an Armenian photographer who learnt the craft in India, returned to Isfahan in the early 1910s and opened a photographer's studio in his house in Julfa.[19] Having gone to live with his maternal uncle in India at the age of 15 with the aim of furthering his education, he learnt photography from an Indian photographer and worked as a photographer there himself for four years. Taking photographs of the project to build the railway, an alcohol-manufacturing plant and a gunny-sack weaving factory kept him occupied for several years in the jungles and far-flung regions of India. When he returned to Iran, he brought all the equipment he needed to open a photographer's studio. This included several cameras, one enlarger, several pictorial drapes for use as backdrops and a button-making machine, which soon became the talk of the town in Julfa and Isfahan. The sign outside Minas's shop said: 'Minas Mackertich, photographer. A button-making factory

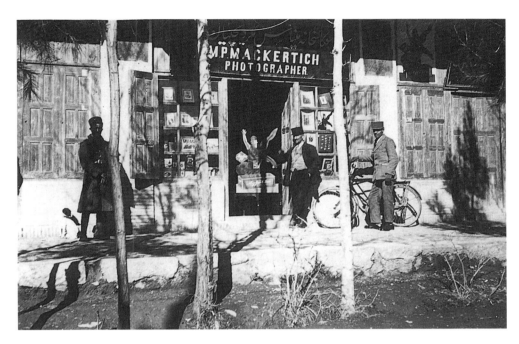

30. *Minas Patkerhanian Mackertich's photographer's shop on Chahar-Bagh Avenue. Anonymous, late 1910s.*

that is one of a kind in Iran.' His specialty was to turn buttons into medallions featuring the portraits of his clients. He would place the photographs on buttons and press them between two laminated sheets. Then he would put them under the pressing machine. The resulting medallions had pins on the back so that they could be attached to clothes. These decorative medallions soon became popular among the rich, and orders came even from Tehran. In Julfa Minas's clients were exclusively wealthy Armenian residents. Later he moved his studio to Isfahan's Chahar-Bagh Avenue.

The colony of Julfa, which, from the 17th century onwards had been a dwelling place for Armenian Christians and the seat of the Armenian archbishopric of Iran and India, was years away from its era of prosperity and progress under the reign of the Safavid king Shah Abbas.[20] His successors imposed high taxes on Armenian merchants and treated them badly. Hence, all those who could migrated away in droves and the remaining residents of Julfa, who numbered only 3,000 in the 1850s, were impecunious people who could

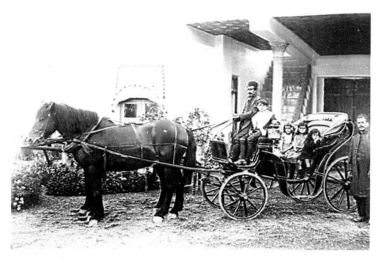 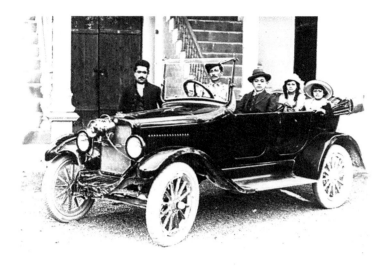

31. Children of the Karapet Banco family in Julfa. Minas Patkerhanian Mackertich, late 1910s.

32. Children of the Karapet Banco family in Julfa. Minas Patkerhanian Mackertich, 1921.

not afford to leave. Most of them received financial assistance from rich Armenian merchants who had migrated to India. Nevertheless, Julfa residents' contact with Europeans, who visited the district as leisure travellers or on political, military, religious or trade-related missions, and the return to Julfa of Armenians who had been working or studying in India, led to an improvement in the living conditions of this small colony towards the end of the 19th century. Both the presence of Europeans and the link with India also contributed to growing familiarity with photography among the people of Julfa.

It became customary among some Julfa families early in the 20th century to have portrait albums of family members. Two photographs from the Karapet Banco family album, which were taken by Minas in the late 1910s and early 1920s, show clearly the elevated social class of those who commissioned such family photographs. The stylish European clothes worn by the children of the Karapet Banco family in the photograph, part of the façade of an aristocratic two-storey residence in the background, a carriage and a car, the carriage driver

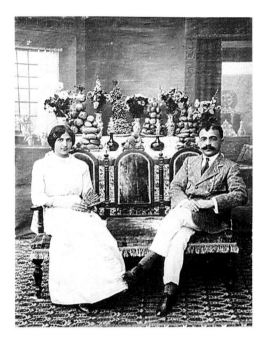

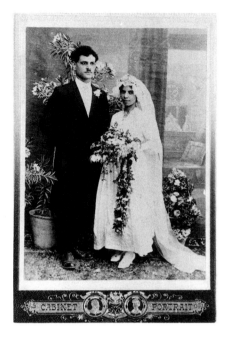

33. An Armenian couple in Julfa. Minas Patkerhanian Mackertich, 1913.

34. An Armenian bride and groom in Julfa. Minas Patkerhanian Mackertich, 23 September 1919.

and a chauffeur, a servant and even the photographer – all at the service of the photograph's principal subject – are assembled on the scene.

One of the oldest photographs from Minas is the portrait of a wealthy young Armenian couple taken in the early 1910s. The photograph's creative use of a strong symmetrical composition and accessories that are in keeping with the social status of the subject highlight the couple's distinguished standing. In the background, a painted European drape, brought back from India – depicting the interior of an aristocratic house, a French window and flower-filled vases on one side and a luxuriously furnished anteroom on the other – is beautifully coordinated with the lavish accessories placed behind the subject. Everything has been laid out on the table behind the young couple with care and a sense of symmetry: crystal wine vessels, a delicate china vase filled with flowers and fruit bowls. A settee, with fine woodwork and a velvet cover, and a carpet with a repeating Iranian pattern under the couple's feet, can be seen in the photograph. By leaving a seat empty in the

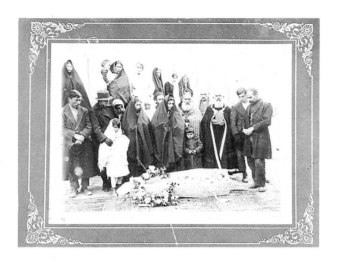

35. Burial ceremony for young Mary Davitian. Minas Patkerhanian Mackertich, 1921.

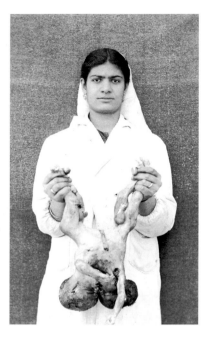

36. Conjoined twins who died after birth. Minas Patkerhanian Mackertich, early 1920s.

37. Head of bandits after their execution. Minas Patkerhanian Mackertich, 1924.

middle and creating a space between the man and the woman, the photographer has further underlined the symmetry of the picture, as well as conforming to the custom of portraying a couple at a respectful physical distance, with formal pose and decorum peculiar to the portraiture of the time.

The wedding picture of an Armenian couple (photo 34), dating from the late 1910s, is considered to be one of the first photo-portraits of a bride and groom taken in a studio. Wearing European-style wedding costumes, the couple undoubtedly hail from Julfa's wealthy families, since this kind of portraiture did not gain general currency until the late 1940s and 1950s.

The trilogy of death – the funeral of Mary Davitian, the nurse and the conjoined twins who have died soon after birth and the impaled heads of a group of bandits – as well as the photos of the birth of the photographer's child and the prayer for rain, reveal Minas's talent for being in the right place at the right time when it came to photographs taken outside the studio.

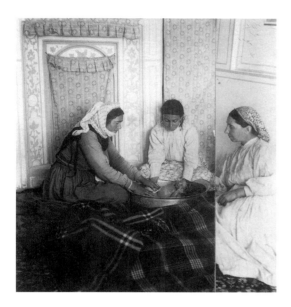

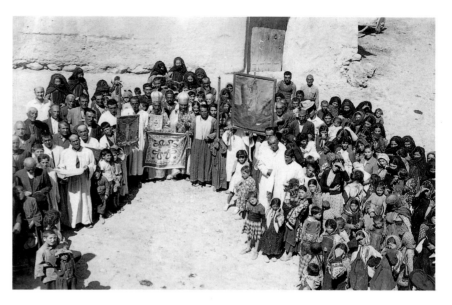

38. *Photographer's child moments after birth. Minas Patkerhanian Mackertich, 1916.*

39. *Prayer for rain in the Sangbaran village of Faridan. Minas Patkerhanian Mackertich, 1920s.*

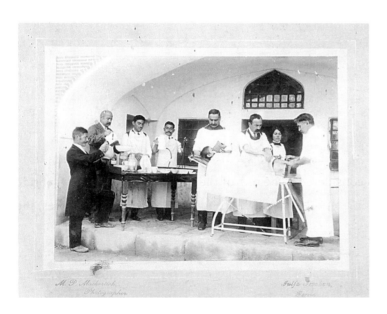

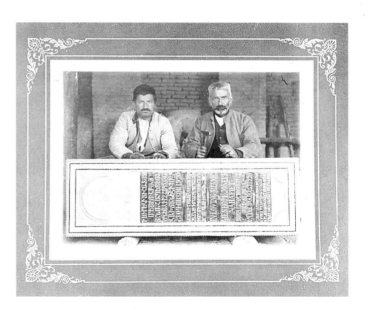

40. *Boghozkhanian Hospital in Julfa. Minas Patkerhanian Mackertich, 1918.*

41. *Hovanes Alexandrian, stone carver in Julfa's Sang-Tarashan (stone carvers') district. Minas Patkerhanian Mackertich, 1920.*

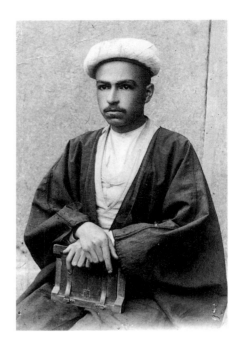

42. *Mirza Mehdi Khan Chehreh-Nama, photographer. Anonymous, 1914.*

In all likelihood the enlarger that Minas brought back from India was Isfahan's first photo enlarger. The device was equipped with a mantle burner. This alcohol-fuelled lamp made it possible to enlarge photographs even in the dark. Enlargement reduced the resolution of a photograph and necessitated some touching up on the print, especially on the face and the hands in portraiture (later on, the touching up was done on the negative using a pencil, with better results). Touching up the final print required considerable expertise in executing very subtle pen work on the face and was not something that could be done by just any photographer. One of Isfahan's first photo-portraitists, who turned from painting to photography and became famous in Isfahan for his skill in touching up photographs, was Mirza Mehdi Khan (1891–1979). Late in life he adopted the surname 'Chehreh-Nama', meaning 'portrait painter' or 'sketcher of faces' in Farsi.

When Mirza Mehdi Khan was 12 years old, his father sent him to Haj Mirza Muhammad, the Isfahani painter, for his apprenticeship. Isfahan

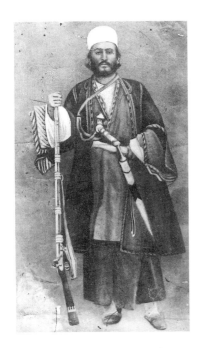 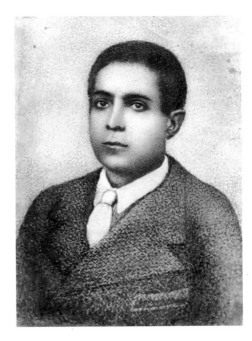

43. *Painting from a photograph, man from the Bakhtiari tribe. Hassan Shams.*

44. *Enlarged and retouched photograph. Mirza Mehdi Khan Chehreh-Nama.*

boasted many painting masters,[21] most of whom worked in small stalls in the bazaar. Towards the end of the Qajar period, with the decline of traditional Iranian painting, the imitation of European art and the migration of many celebrated traditional painters from Isfahan to the court of the Qajar kings in Tehran, Isfahan's school of painting was scarcely distinguishable from those of other cities, but the quality of Isfahan painting remained better than that of Tehran's.[22] Skilled and versatile painters had training in a variety of forms of drawing and painting such as black-ink drawing, oil painting, painting scenes from everyday life, landscape painting, painting flowers, portraiture and painting of miniatures. However, professional painters largely used their skills in the service of the bazaar. Painted products sold in the bazaar included illuminated manuscripts, decorated pen holders and hookah parts, canvas paintings, enamel work, wood paintings and wall paintings.[23] Without doubt, the appearance in Isfahan of photography, as a new method of image making and portraiture, had an impact on painters' work. Photography

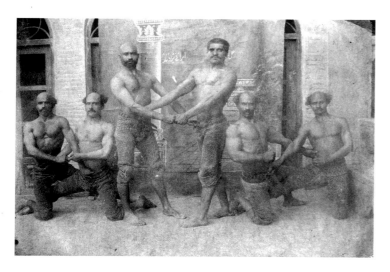

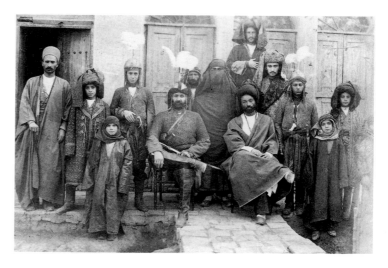

45. *Pahlavanan (traditional sportsmen). Mirza Mehdi Khan Chehreh-Nama.*

46. *Taziyeh (Passion play) actors. Mirza Mehdi Khan Chehreh-Nama, 1910s.*

greatly aided painters, encompassing as it did landscapes, portraiture, the use of light and shade and the application of the laws of proportionality.[24] Photographs found their way into painters' small stalls. Painting portraits from photographs and tinting photographs were among the resulting activities taken up by some painters.

It was these photographs that made the young painter – after learning the preliminaries of painting – leave the master's stall, go to Tehran to learn the craft of photography and, on return to Isfahan in 1913, open his own photographer's studio. World War I had an adverse effect on economic conditions and the resulting shortage and high cost of essential goods such as glass, which was imported from Russia, created difficulties for Mirza Mehdi Khan. However, the fact that his shop was located in the city centre, making it more accessible to Isfahan's Muslims, some of whom did not like to go to the Christian district of Julfa to have their photographs taken by Armenian photographers, contributed to Chehreh-Nama's success.

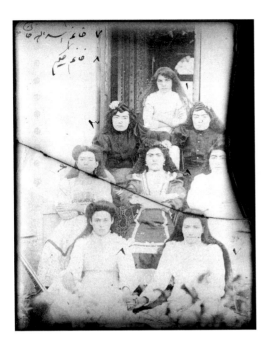

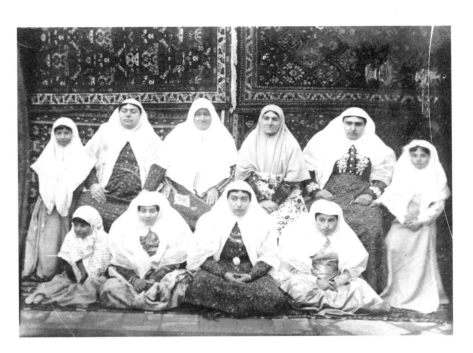

47. *Mrs Assadollah Khan and Mrs Hakim. Mirza Mehdi Khan Chehreh-Nama, early 1920s.*

48. *Women in house's inner sanctum. Anonymous, 1910s.*

Chehreh-Nama also liked to take photographs of more traditional subjects. Passion-play actors staging religious dramas during the annual mourning period for Imam Hussein and *Pahlavanan* (traditional sportsmen) engaged in ritualistic, classical Iranian physical exercises were the subjects of some of these portraits.

The photo taken by Chehreh-Nama towards the end of the Qajar period of a group of women without the traditional Islamic coverings in the inner sanctum of an aristocrat's house in Isfahan shows the privileged access that the photographer enjoyed to the private spaces in people's lives. Perhaps it was the fact that Chehreh-Nama stemmed from a religious family and could thus be trusted, and that these women belonged to a progressive household, that made this photograph possible. There can be no doubt, however, that during the Qajar period women had to observe the full Islamic *hijab* in public places and were segregated from men. Even in the inner sanctums of their houses, they usually wore a scarf or some other head covering.

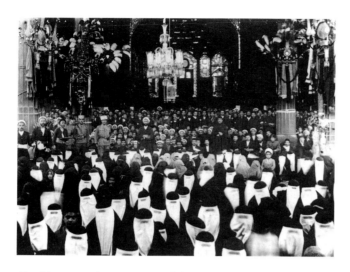

49. *Women attending a sermon at Chehel-Sotun Palace. Anonymous, 1920s.*

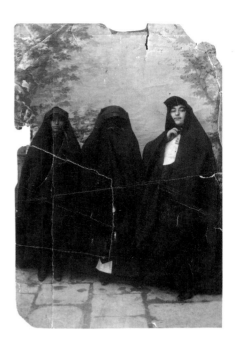

50. *Taj al-Saltaneh, Nasir al-Din Shah Qajar's daughter (right); this photograph was presented as a gift to her beloved, a Bakhtiari chieftain. Anonymous, 1906.*

The 1920s were an important transitional period in Iranian history and spawned great changes in social conditions. With the departure of Ahmad Shah, the last Qajar king, and the coming to power of the Pahlavi regime, the Qajar dynasty expired in 1925. Reza Shah Pahlavi, who had come to power with military backing and harboured dreams of linking Iran's traditional society to the modern world, embarked on fundamental reforms, establishing such institutions and facilities as factories, schools, a national railway, universities and hospitals, all aimed at improving the lives of Iranians. The outer appearance of Iranians was also instituted by force. For the first time, women had to do without their traditional Islamic coverings when they stepped outside their homes and to attend public functions in European-style clothes. Men, too, were forced to abandon traditional outfits, wear modern suits and don the Pahlavi cap.

Isfahan was affected by these developments and reforms just as much as other Iranian cities. Local bandits, who had made travel unsafe, were

arrested and hanged. New industries and factories, especially big textile plants modelled on German factories, were established in the city and the number of government departments multiplied. These and a host of other changes meant that Isfahan's urban society underwent great upheaval.

Photography was moving on at the same time. Portraits taken during this period are clearly distinguishable from those taken under the Qajars, thanks to the change in people's clothing and appearance. This provides us with a means of identifying photo-portraiture from the reign of the Pahlavis.

Many more people had gone to a studio to have their photographs taken, either individually or with relatives or friends, by the end of the 1920s than a decade earlier. By the middle of the decade, there were 12 shops in Isfahan dedicated to photo-portraiture,[25] significantly more than in other Iranian cities.[26]

The direct import from Europe to Isfahan – by European merchants – of the material required for photography played an important part in the growth of the art. Max Schunemann,[27] the German industrial engineer who travelled to Isfahan in 1920 to supervise the construction of textile factories, established a commercial firm called Taraghi (Progress) in Darvazeh Dowlat Square. This firm, which held the franchise for the import and sale of German products and machinery in Isfahan, incidentally also imported the material and equipment used in photography. The use of dry gelatino-bromide had gained general currency in Europe in the 1880s. The high speed and sensitivity of this type of film had made photo-portraiture easier, and factories had started producing it with standard quality and in a pre-packaged form. In view of the fact that photographers in Isfahan were still sensitizing their own glass plates, they welcomed these new products that they could obtain from Taraghi. The Russians and French also established commercial firms in Isfahan. The firm of Brasseur on Chahar-Bagh Avenue sold sensitive Lumière photographic substances and French cameras. In 1924, Manook Martin, a Julfa Armenian, inaugurated the representative office for the sale of Agfa products on Chahar-Bagh Avenue.

It was the aim of all these businessmen to trade in handicrafts and export them from Isfahan in exchange for imported foreign goods and

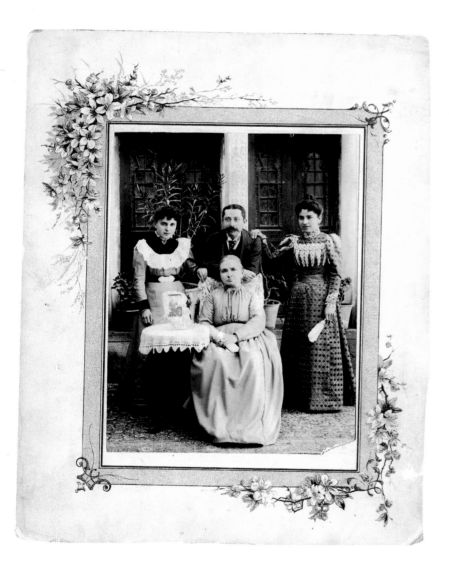

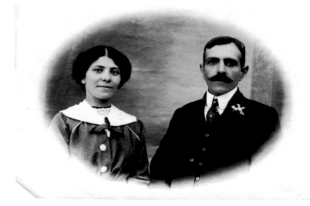

51. An Armenian family in Julfa. Ernst Hoeltzer, 1890s.

52. An Armenian couple in Julfa. Minas Patkerhanian Mackertich, 1910s.

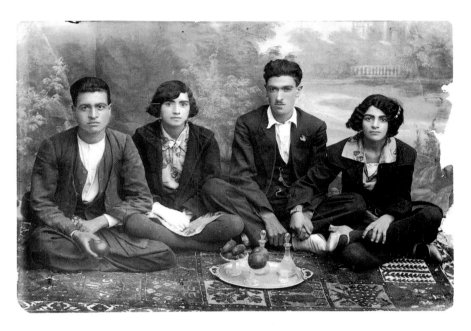

53. Untitled. Mirza Mehdi Khan Chehreh-Nama.

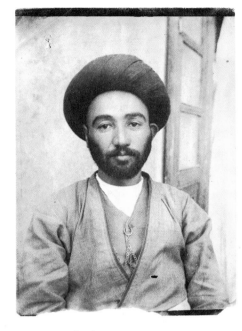

54. An example of a cyanotype print. Mirza
 Mehdi Khan Chehreh-Nama.

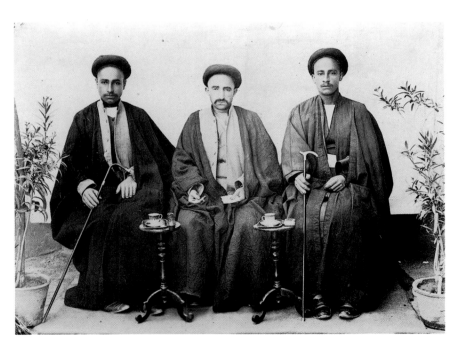

55. Untitled. Mirza Mehdi Khan Chehreh-Nama, 1920s.

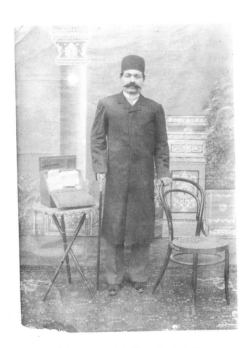

56. Untitled. Mirza Mehdi Khan Chehreh-Nama,
 1920s.

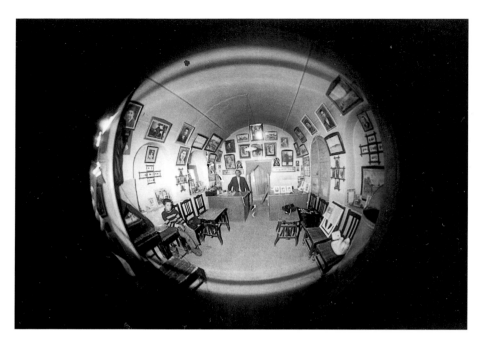

57. Gholamhossein Derakhshan's photographer's shop on Hafez Avenue. Amanollah Tariqi.

photographic equipment. Schunemann established a big workshop for enamel work in Isfahan. Brasseur, the French businessman, who had lived in Isfahan for years and taught French at the Jewish community's school, had a workshop in which women produced traditional Iranian embroideries. Manook Martin, for his part, exported engraved silver- and copperware to Germany.

Photo-portraiture, which took a leap forward in the 1920s, reached its peak of popularity by the late 1940s and early 1950s. For the first time, photo-portraiture gained currency among the labourers and middle-income inhabitants of Isfahan. While photography had spread rapidly to the general public in the 1850s in Europe, ordinary people in Iran had to wait almost another century before they could finally lower themselves onto the studio chairs in front of photographers' cameras.

The new photography shops were on Isfahan's most-frequented streets. Shams, Chehreh-Negar, Sharq, Leon, Matus Aqa-Khan, Derakhshan, Emami and Hollywood were among the best-known photography shops in

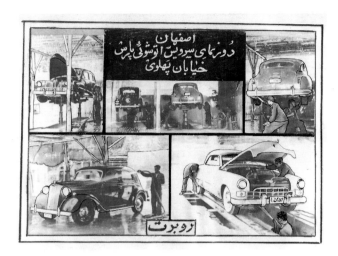

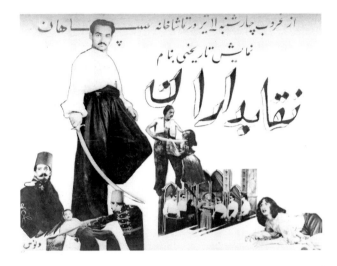

58. *Advertising with photographs – 'Isfahan, view of Pars car wash, Pahlavi Avenue. Robert.' Minas Patkerhanian Mackertich, 1945.*

59. *Advertising with photographs – 'Starting on the evening of Wednesday 11 Tir [2 July], at the Sepahan Theatre, a historical play called* The Masked Venus.*' Minas Patkerhanian Mackertich, 1945.*

Isfahan and had many customers. In the mid-1930s, the first photographer's studio with electricity was established by Gholamhossein Derakhshan (1907–75) on Hafez Avenue near Naqsh Jahan Square. Such shops, which were also able to take photographs in the evening and could experiment with different types of lighting, thanks to their modern electrical appliances, played an important part in making studio photo-portraiture more commercially viable. Once national identification documents became officially required and cards carrying holders' photographs for identification purposes gained currency, it became common for individuals to have small photos taken, which generated more business for commercial photographers. In the 1940s and 1950s, there was unprecedented growth in the newspaper and magazine sector. Nearly 50 titles were being published in Isfahan during this period. The use of illustrations in these publications led to the growth of photo-journalism as well as photography for advertisements.

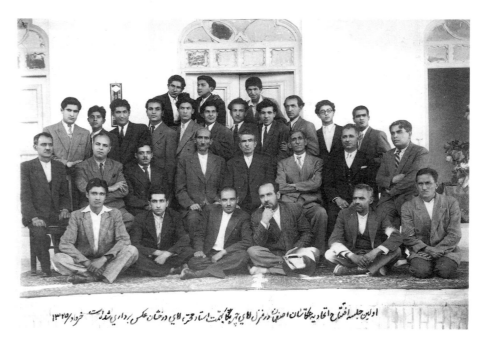

اولین جلسه افتتاحیه اتحادیه عکاسان اصفهان در منزل آقای چهره‌نگار ثبت استاد محترم آقای درخشان عکس برداری شده است خرداد ۱۳۲۵

60. *Studio photographers. Gholamhossein Derakhshan, 1946. Handwritten note: 'The inaugural meeting of Isfahan's union of photographers at Mr Chehreh-Negar's house, taken by the esteemed master, Mr Derakhshan. Khordad 1325 [June 1946].'*

In 1946, Isfahan's union of photographers was formed to provide a cohesive framework for pursuing photographers' trade-related concerns. It drew up regulations for the welfare of photographers and the protection of their customers.

Customers who went to studios to have their photographs taken would usually put on their best clothes, which now meant the new European-style clothes that had taken the place of the traditional garments and the *hijab*. Many of the photographs taken in the mid-1920s show people so dressed. Some reveal the individual's profession or social standing, for example, military uniforms, which were particularly widely worn during the reign of the first Pahlavi, or clerics' robes or school uniforms.

Photographers would occasionally hang a plain black drape or a cloth with some kind of design on it, or a carpet or rug, behind the subject as a backdrop. Studios that had European drapes or cloths with scenes painted by Isfahani painters were considered more prestigious. In addition to

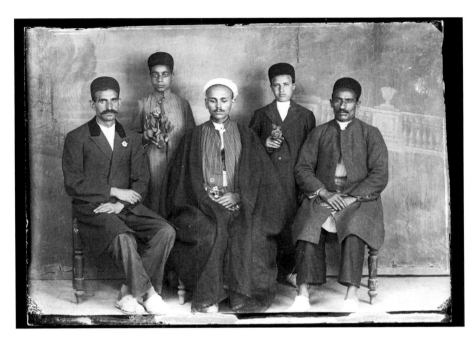

61. *Untitled. Mirza Mehdi Khan Chehreh-Nama.*

eliminating superfluities from photographs, these drapes were used for decorative purposes; drapes with scenery painted on them lent a three-dimensional aspect to the image. Sometimes photographs would be taken in a corner of the shop's yard or garden instead. In the studio, it was customary to spread a carpet or rug on the floor, although there are photographs in which the crude sun-dried bricks of the floor are visible.

The photographer would usually advise the customer to strike a formal, dignified and serious pose. Muhammad bin Ali Meshkat al-Molk wrote a tract, published in the early 1890s, likening the power of the camera to God's photographic power and His ability to observe His creatures everywhere, to record every being's good and bad deeds and beauty or ugliness. On Judgment Day, he argued, no lies or justifications of unacceptable conduct would be accepted. Hence, just as people must always try to be good and beautiful in the sight of God, so too must they present themselves in a good and dignified light in photographs.[28] Of course, by the

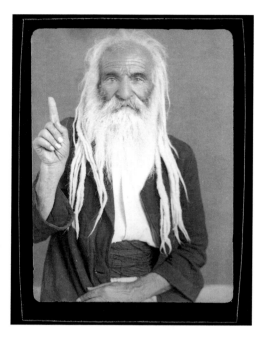

62. *Untitled. Minas Patkerhanian Mackertich, 1952.*

middle of the 20th century, this idea had been much moderated, and people appeared in photographs in more relaxed poses. Photographers were even using their imaginative powers to propose more creative or staged – and even occasionally comic – poses.

The most commonly used accessories in photo-portraiture were china vases filled with flowers; pot plants – especially geranium – which could easily be found in Iranian gardens; a hookah, which, apart from its decorative quality, lent dignity and stature to the person using it; the paraphernalia for serving tea, which in Iran included a samovar, a teapot and a brazier; a jug and beaker for wine or *arrack*; decorative handicrafts produced in Isfahan, such as printed calico tablecloths; a table, a chair and even a bed; a single flower or bunch of flowers placed in the subject's hand; and foreign dolls for women and toys for children. Sometimes the photographer allowed studio lamps to be visible in the photographs. Some people would bring objects of their own choosing to the studio for use in the photographs – tools of their trade or profession or

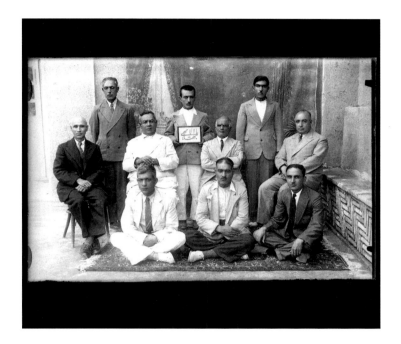 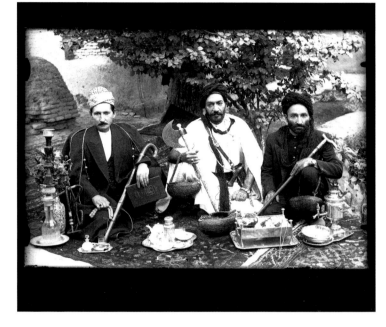

63. *Members of the Baha'i sect. Gholamhossein Derakhshan.* 64. *Dervishes. Gholamhossein Derakhshan.*

instruments that displayed their skills or artistic talents. In the photo that shows a group of people belonging to the Baha'i sect, a small board bearing the name of the group's religious leader establishes the identity of the individuals in the photograph. In photo 64, apart from the special headbands, a *tabar-zin* (battle-axe) and a *kashkoul* (dervish's drinking bowl) in the hands of the person in the middle and a book of annotations to the *Nahj-al-Balaghah* held by the person on the left show that the subjects are members of a dervish sect.

Group portraits were taken for a variety of reasons, such as to mark ceremonies and rites, picnics, celebrations, the inauguration of a factory, a protest strike or a meeting. Or else a number of individuals belonging to a club, school, family or circle of friends would go to a photographer to have their photograph taken. The photographer's duty, apart from ensuring that all the individuals' faces were clearly visible, was to present a suitable arrangement of the group. People who enjoyed a superior position in the group were usually placed at the centre of the photograph.

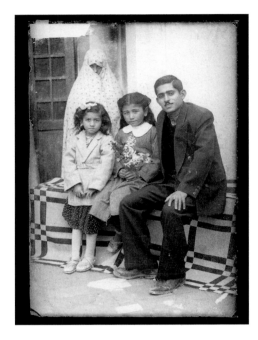

65. Untitled. Mirza Mehdi Khan Chehreh-Nama.

One of the most common types of group photographs was the family portrait, which stressed the relationship between family members. The mother was rarely present, and in most instances the father, as the head of the family, was portrayed surrounded by his children. From the late 1940s onwards, mothers began to be included in family photographs. Father-and-son portraits – in view of the importance of male children in traditional Iranian families – were more common during this time. Gradually it also became customary to take pictures of children without their parents.

In the studios, women totally complied with the poses that were assigned to them by the photographers, who were all men. Whilst being submissive, it is clear that it was the choice of these women themselves to go to the photographer's shop and to sit in front of the camera, and that they had chosen their own garments, makeup, appearance and image. In some cases, displaying new outfits could serve as a reason for women to go to the studios.

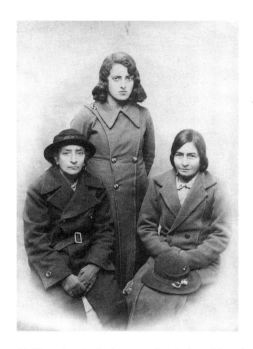

66. *Women's attire in the years after the imposition of the ban on Islamic coverings and veils. Mirza Mehdi Khan Chehreh-Nama, 1920s.*

The ban on Islamic coverings for women at the beginning of the reign of the first Pahlavi, and women's increased presence in social settings, gave new opportunities to studio portraitists. Photo 66, which was taken in the years after the ban was imposed, shows very prim garments, with long sleeves and fastened collars, and heads covered by hats in imitation of European customs. Studio portraitists achieved interesting results in terms of feminine poses in their attempts to capture their new-look subjects. The photographers sensed themselves closer to a subject that had once been out of bounds and had previously been notable for its absence in most family photographs, although they still tried to present a demure, gentle and serious image of women. Women, who only a few decades earlier were visible in public as vague forms covered by *chadors* and veils, now deliberately put on clothes made of see-through material and with low necklines – even swimsuits, nightgowns and lingerie – to have their photographs taken.

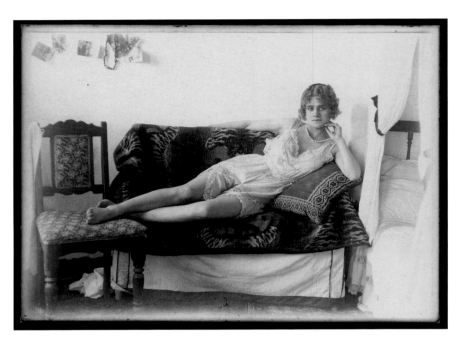

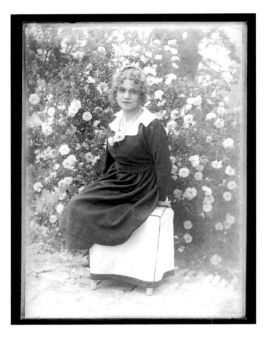

67. Madame Juliet, the Russian prostitute. Minas Patkerhanian Mackertich.

68. Madame Juliet, the Russian prostitute. Minas Patkerhanian Mackertich.

The portraits that were taken of prostitutes were mostly for advertising purposes. In photo 67 we see Madame Juliet, the Russian prostitute, seductively clad, reclining on a couch in her workroom on Chahar-Bagh Avenue with her head resting on her hands. Above her, there are photographs on the wall, which are probably portraits of her and her lovers. Madame Juliet's bed is visible in a corner of the room. The reclining woman on a couch, which was one of the familiar feminine poses in the Middle East and Iran,[29] is a recurring feature in the work of Isfahan photo-portraitists. Because the couch is so short, the photographer has posed the Russian lady with her dainty legs on a chair. In another portrait, which shows her in the garden of her house with an eglantine plant in full bloom in the background, the photographer has presented a different feminine vision. Juliet here wears a long-sleeved dress and her legs, extending beyond the curve of her hemline, are hidden behind a stool.

Previously, in the photographing of couples, physical distance between them had been observed. Now a distinct change occurred, and it became

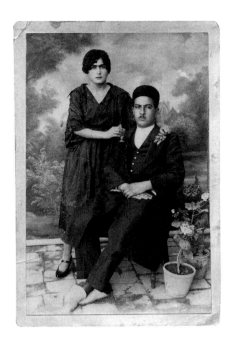

69. Untitled. Mirza Mehdi Khan Chehreh-Nama.

common to depict the couple touching in some way. In a favourite pose the man was seated and the woman stood alongside him, resting a hand on his shoulder.

In photo 69, the woman is offering a beaker of *arrack* to the man. The theme of a woman proffering wine to a man, which was a metaphor for spiritual and otherworldly ecstasy, was familiar in Iranian miniature painting. However, the element of movement captured in miniatures is absent here. Instead of gazing into each other's eyes, they are looking at the camera with serious expressions and the man's hands, which lie motionlessly together, display no zeal to take the ecstasy-bearing beaker.

Wedding portraits were among the photographs that became more popular in the 1930s and 1940s, and people regarded them as an important record of a special occasion. People from lower-income families usually confined themselves to having one photograph taken of the bride and groom, and would go to the studio themselves. More affluent families were able to have a series of portraits taken, including photographs of the bride and groom

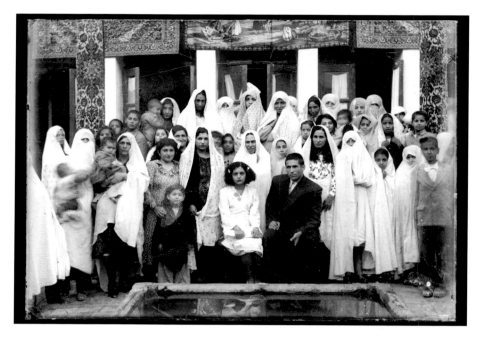

70. Women's section of Ahmad Aqa's wedding ceremony. Mirza Mehdi Khan Chehreh-Nama, 1948.

with family members and friends, and would usually invite the photographer to go to the wedding venue.

In the 1950s and 1960s, wedding albums became popular. Here photos show two scenes from the same wedding ceremony. The photographer has gone to the venue to take the photographs. Photo 70 shows the bride and groom among the women of the family. In traditional Iranian weddings, the women's section and the men's section were separate. In the early years of the reign of the second Pahlavi, when the ban on Islamic coverings for women was eased, women from religious families resumed the habit of covering themselves in public, although in a more relaxed way and without using the veil that covered the face. At public gatherings, they could remain in the company of women in an area segregated from the men. Although the groom is the only other man present besides the photographer, the women are wearing their *chadors*, which are light-coloured, befitting a happy occasion. Apart from the bride, only one woman, who is probably the groom's sister, is without a

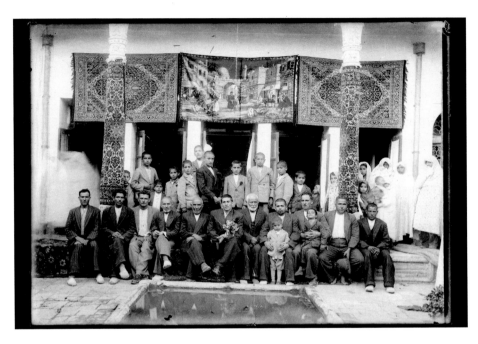

71. *Men's section of Ahmad Aqa's wedding ceremony. Mirza Mehdi Khan Chehreh-Nama, 1948.*

chador. In photo 71, the groom has left the bride behind in the women's section and joined the men. The two elderly men flanking the groom are probably the bride's and groom's fathers. The photograph has been taken in the outer area of the house, on a porch. In the background, open doors lead to a big, traditional, Iranian, five-door sitting room, decorated with rugs. Several women are standing on the right-hand side, slightly at a remove from the photograph's masculine focus. On the left we see a woman who has decided to depart at the last moment.

The outbreak of World War II and Iran's unwanted involvement in the war had an adverse effect on people's livelihoods and, not surprisingly, photographers' studios were less frequented. This did not, however, prevent Iranians from welcoming thousands of unexpected guests into their country. At the beginning of the war, on the strength of an agreement between the Soviet Union and Germany, Poland was divided in two and some of the inhabitants of the eastern part were taken to the Soviet Union and put to

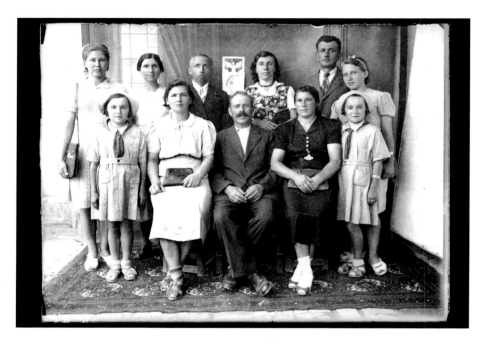

72. *Polish refugees. Abolqasem Jala, 1942.*

forced labour in terrible conditions in Siberia. When Germany attacked the Soviet Union in 1941, some of the Poles were moved from the Soviet Union to Iran in a mass transfer. As a result, more than 400,000 Poles came to Iran by ship via the Caspian Sea. These immigrants, who were in very poor health, were sent to various Iranian cities. The mass immigration lasted until 1943.[30] Thousands of Christian and Jewish Poles, most of them women and children, were transferred to Isfahan, whose people warmly welcomed them and housed them in the Christian district of Julfa. Although their stay in Iran was short and they migrated to various countries after the war, for many of the Polish children who had experienced the war and constant displacement, these years were a happy time. The 1,118 portraits of Polish refugees taken at Sharq Studio by Abolqasem Jala (1915–79) are mementos of the emigrants' sojourn in Isfahan. In the expressions on their faces, the happiness and security of these short years are clear, although the traces of the painful memories of war, forced exile and the loss of loved ones still cast a shadow.

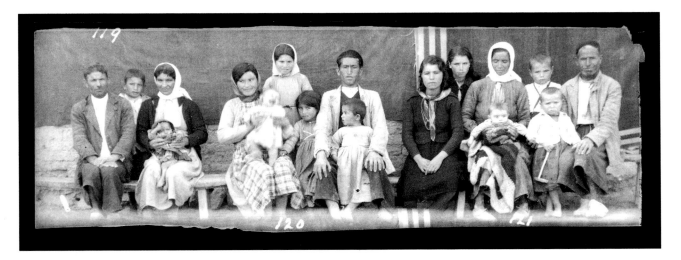

73. *Armenian migrants. Minas Patkerhanian Mackertich, 1946.*

Portraiture by studio photographers was not confined to within the walls of a studio. More affluent families would pay extra to have the photographer visit them at home. Some wanted to have their photographs taken standing outside their houses or by their cars. Some wanted to be captured at their workplace or at some other location. In 1946, when the Armenian government invited nationals living in other countries to return to their native land, thousands of Armenians left Isfahan for home. Photos were taken for the purpose of being attached to the exit papers of Armenian families. The photographer has gone to the customers and placed three families alongside one another, then cut up the photographs, thus speeding up his work in the hurried process of group migrations.

With the change from the traditional to the modern system of education and the promotion of universal education, new schools opened in Isfahan. The annual class photograph, a tradition that had started in Europe in 1880, became popular in Iran in the 1940s. Schools would use these

photographs for their administrative reports. The children all wanted to be included in the group pictures with their classmates, so the photographer was at pains to ensure that every child was visible. He would place the children in rows: the front row sat on the ground, the second row on chairs, the third were standing up and those in the back rows stood on benches. In this way the photographer would assemble a large number of people. The photos were usually taken in the yard in front of the main school building, and boards bearing the name of the school would be included in the composition. School administrators, teachers and even janitors were often included in these photographs.

The years 1920 to 1950 were important – a transitional period in which Iran was transforming itself from a traditional to a modern, industrial society. Photography, which had arrived in Iran in the 1840s at almost the same time as in Europe, now belatedly became popularized. The ordinariness of having one's photographs taken, plainly seen in people's facial expressions and poses, is the distinguishing feature of photo-portraiture after the 1950s.

The expansion of Iran's international relations in the second half of the 20th century speeded up imports of photographic material and equipment. Glass plates became obsolete and were superseded by high-sensitivity laminated films. Medium-sized cameras and roll films appeared on the market. The availability of inexpensive cameras augmented the number of amateur photographers and the price of photographs decreased dramatically.

Although Isfahan is only one limited locality, it undoubtedly serves as a good example for the study of the distinguishing features of Iranian photo-portraiture in this transitional period.

Notes

1. The first public photographer's studio in Tehran was established in 1868 by Abbas'ali Beyg under the direction of Eqbal al-Saltaneh, Nasir al-Din Shah's court photographer and Iran's first professional photographer. *Dolati* [Government] newspaper (Tehran: 1285 Lunar Hegira/1868), p. 7.

2. Yahya Zoka, *Tarikh Akasi va Akasan Pishgam Iran* [History of Photography and Pioneer Photographers of Iran] (Tehran: Elmi–Farhangi Publications, 1376 Solar Hegira/1997) pp. 189–224.

3. Mehdi Bamdad, *Sharh Hal Rejal Iran* [Chronicle of Iran's Notables] (Tehran: Zavvar, 2nd edition, 1357 Solar Hegira/1978), Vol. 4, pp. 83–5.

4. Hossein Sa'adat-Nuri, *Zell al-Sultan* (Tehran: Vahid, 1347 Solar Hegira/1968), p. 235. See also Muhammad Ali Jinab, *Al-Isfahan*, translated by Muhammad Reza Riazi (Tehran: Cultural Heritage Organization, 1376 Solar Hegira/1997), pp. 82 and 142.

5. More than 800 photographs relating to Zell al-Sultan are currently held in Tehran at the Institute for Studies on the Contemporary History of Iran, affiliated to the Foundation for the Deprived and Disabled. Many of these photographs are laid out in 16 albums, most of which have velvet- or leather-bound covers with the name 'Zell al-Sultan' stamped in relief in the centre.

6. Also acquainted with medicine, he became Zell al-Sultan's special steward, secretary and photographer in 1887. He acquired considerable wealth at Zell al-Sultan's court and, fearing that the prince might have him killed, he went to Iraq on the pretext of making a pilgrimage. From there he travelled to Egypt, where, in 1891, he became Iran's first commissionaire. Muhammad Ali Sadid al-Saltaneh, *Safarnameh Sadid al-Saltaneh* [Sadid al-Saltaneh's Travelogue], edited and annotated by Ahmad Eqtedari (Tehran: Behshahr, 1362 Solar Hegira/1983), p. 80.

7. Under a photograph of him that Zell al-Sultan took personally in 1901, the prince described him as an intelligent and shrewd youth and his own special photographer. Abdolkhaleq Khan remained in this position from the 1890s to the end of Zell al-Sultan's rule in 1907. He was one of the Iranians who had studied in Europe and was not only a master of photography but also a skilled hypnotist and player of the *ney*, a kind of Persian wind instrument.

8. Jean Dieulafoy, *Iran, Kaldeh va Shush* [Iran, Chaldea and Susa], translated by Ali Muhammad Farreh-Vashi (Tehran: University of Tehran, 1364 Solar Hegira/1985), p. 268.

9. In his memoirs, Zell al-Sultan wrote: 'What I wanted and sought were in fact the sweetest three things in the world to me ... good horses, good rifles and hunting, which were available to me every single day ... I have to say here that being the king's son, young and irresponsible, makes for a very pleasant state of being ... Yet my youth, the hunting and my reluctance to work were the source of one of my greatest blunders, namely, not to seek to perfect myself. I squandered dear life in dissoluteness and indolence. Alas. Alas. A thousand times alas.' Mas'ud Mirza Zell al-Sultan, *Sargozasht Mas'udi* [Mas'udi Annals], edited by Hossein Khadiv-Jam (Tehran: Asatir, 1368 Solar Hegira/1989), p. 20.

10. Antoin Sevruguin (c. 1840–1933) was born in the Russian embassy in Tehran and spent some of his early years in Iran. After training as a painter and following a course of photography with the famous Russian photographer Dimitri Iwanowitsch Jermakov in Tiflis, he decided to return to Iran to document all aspects of cultural life in Iran. He opened a photographic studio in Tehran, and thanks to his skill as a portraitist he became an official photographer at the court of Nasir al-Din Shah and his successors. Ferydoun Barjesteh, Gillian Vogelsang-Eastwood, Corien Vuurman and others, *Iran az negah Sevruguin* (Tehran/Rotterdam: Zaman/Barjesteh, 1999), pp. 169–171.

11. Yahya Zoka, *op. cit.*, pp. 396–97.

12. *Dolat Alliyeh Iran* [Government of Iran] newspaper, No. 551 (Tehran: 1280 Lunar Hegira/1863), p. 4. See also Ernst Hoeltzer, *Iran dar Yeksad va Sizdah Sal Pish* [Iran 113 Years Ago], prepared for publication and translated by Muhammad Asemi (Tehran: Culture Ministry's Centre for Anthropology, 1355 Solar Hegira/1976), introduction.

13. The Tehran-London telegraph line was put into operation on 13 January 1870. A year later, Hoeltzer was made the assistant superintendent grade I of the Julfa telegraph office and in 1880 he was promoted to assistant superintendent grade II. He retired in 1890. Jennifer Scarce, *Isfahan in Camera: 19th Century Persia through the Photographs of Ernst Hoeltzer* (London: AARP, 1976), Vol. 6, p. 2.

14. Hoeltzer's surviving relatives in Germany hold more than 1,000 glass plates of negatives of his works. Most of the photographs were taken between 1873 and 1897.

15. '… Finally, we approached the city walls and passed through the gate and over the moat. I stopped suddenly and involuntarily, as if in shock. I ran my eyes over the ruins around me and realized my ignorance. The joy and elation that I had been feeling turned into despondency and despair, for I could see that I had arrived at a pillaged ruin. The streets are all narrow and filled with filth. To the left and right, there are markets that are all empty, with the walls on the verge of tumbling down … Expensive tile work is broken everywhere and scattered on the ground … In a word, Half the World, heavenly trees in full bloom and the capital of the great Safavid kings is a ruin, and splendid palaces and monuments have been replaced by melon and cucumber farms.' Jean Dieulafoy, *op. cit.*, p. 229. See also H. Bruggsch, *Reise der K. Preussischen Gesandschaft nach Persien 1860–1861* (Leipzig: 1862), II, p. 49.

16. Whereas Isfahan's merchants had to pay duties at the Customs Houses at Bushehr, Shiraz and Isfahan, European merchants paid duties only once they reached the border. This meant that Isfahan's merchants occasionally had to sell their goods at a loss. Consequently, the local merchants often decided to work instead as representatives of European commercial firms. Muhammad Ali Jinab, *op. cit.*, pp. 14 and 143.

17. *Gereh* was one of the old Iranian units of length and was equivalent to 5.6 centimetres. However, it had its own particular meaning when used by photographers. The usual lengths of the glass and paper were as follows: half a *gereh* (5.6 x 9 cm); one *gereh* (9 x 12 cm); two *gereh* (13 x 18 cm); three *gereh* (18 x 24 cm); four *gereh* (24 x 30 cm). Paparian, *San'at Akasi* [Photography Industry] (Tehran: Farus, 3rd edition, 1347 Lunar Hegira/1928), p. 27.

18. Mansur Sane', *Peydayesh Akasi dar Shiraz* [Emergence of Photography in Shiraz] (Tehran: Soroush, 1369 Solar Hegira/1990), p. 18.

19. When it became compulsory for every Iranian to have a national identification document and a surname, he chose the surname Patkerhanian which, in Armenian, means 'someone who takes photographs'.

20. Early in the 17th century, the town of Julfa on the Aras River in Armenia was destroyed and 12,000 Armenian families were moved to Isfahan. These Armenians founded the new Julfa on the southern bank of the Zayandehroud River, naming it in memory of Armenia's Julfa, and with their industry they brought prosperity to Isfahan. Leon Minasian, *History of Faridan's Armenians* (Lebanon: Melitinetzi, 1971), pp. 26–31.

21. Mirza Hossein Khan Tahvildar, *Joghrafia-ye Esfahan* [Isfahan's Geography], prepared for publication by Manuchehr Sotudeh (Tehran: University of Tehran, 1342 Solar Hegira/1963), p. 112. See also Muhammad Ali Jinab, *op. cit.*, p. 79.

22. Alexis Soltikoff, *Mosaferat beh Iran* [Travelling to Iran], translated by Mohsen Saba (Tehran: Elmi–Farhangi Publications, 1365 Solar Hegira/1986), p. 79.

23. Willem Floor, Peter Chelokowski and Maryam Ekhtiar, *Naqqashi va Naqqashan Dowreh Qajar* [Art and Artists in Qajar Persia], translated by Ya'qub Azhand (Tehran: Il Shahsevan–Baghdadi Publications, 1381 Solar Hegira/2003), p. 20.

24. E'temad al-Saltaneh, *Ketab Al-Ma'aser va Al-Asar* (Tehran: n.p., 1306 Lunar Hegira/1889), pp. 26–125.

25. Muhammad Ali Jinab, *op. cit.*, p. 94.

26. Abdolkhaleq Khan, the Isfahani photographer, who was the director of the photographer's studio of the southern army in Shiraz for a time, said in a letter to Chehreh-Nama that the city had two photographers' studios in 1925.

27. Schunemann came to Iran for the first time in 1908. His mission then was to build a textile factory in Qazvin. Incidentally, until he returned to Germany in 1918, he also served as the German consul in Tabriz for ten years. During World War II, when the Allies entered Iran in 1941, he was deported to Australia.

28. Muhammad-bin-Ali Meshkat al-Molk, *Aksiyeh Hashriyeh* [Doomsday Photographs] (Tehran: n.p., 1307 Lunar Hegira/1889), p. 11.

29. This and other similar poses in fact had their origin in the Western view of the East and especially of Eastern women. The presentation of an erotic and exotic image of women, from the perspective of Europeans, is to be found in the Middle East and many other parts of the world, such as Africa and the Far East, in this particular genre of photography; the genre is itself a reflection of the subjects and poses of the Orientalist style of painting that became current in France and Germany in the first half of the 19th century. Sarah Graham Brown, *Images of Women: The Portrayal of Women in the Photography of the Middle East 1860–1950* (London: Quartet Books, 1988), pp. 39–40.

30. Ali Reza Karimi and Seyyed Ali Karimi, 'Migrant Poles in Iran', *Tarikh Mo'aser Iran* [Contemporary History of Iran (periodical)], No. 9 (Tehran: 1378 Solar Hegira/1999), pp. 7–40.

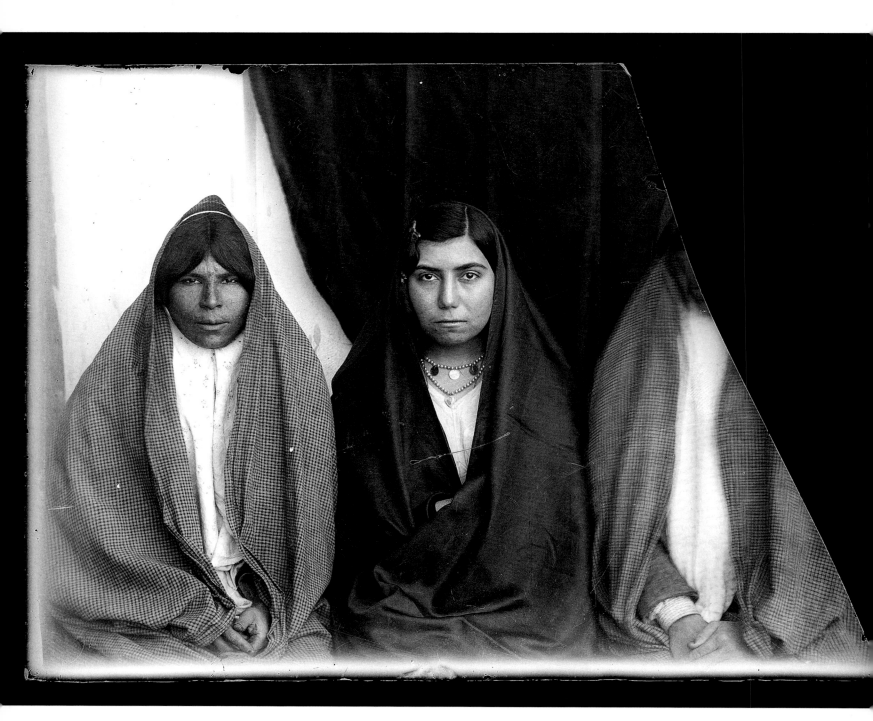

74. *Tribal women. Mirza Mehdi Khan Chehreh-Nama.*

Previous page: Cover of Photo Album, untitled. Gholamhossein Derakhshan.

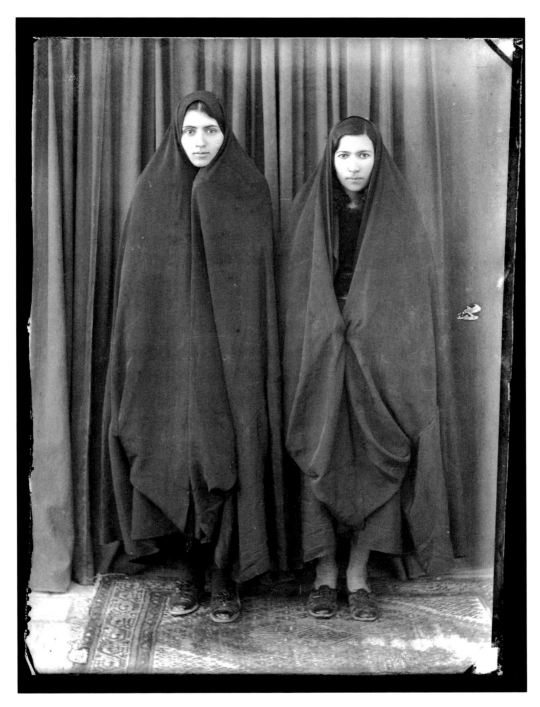

75. *Untitled. Gholamhossein Derakhshan.*

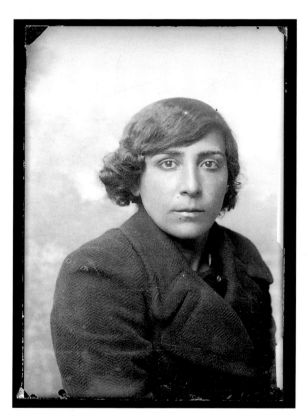

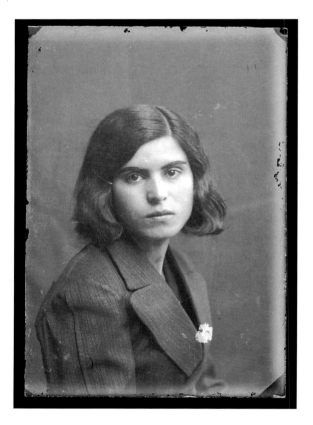

76. *Untitled. Mirza Mehdi Khan Chehreh-Nama.*

77. *Untitled. Mirza Mehdi Khan Chehreh-Nama.*

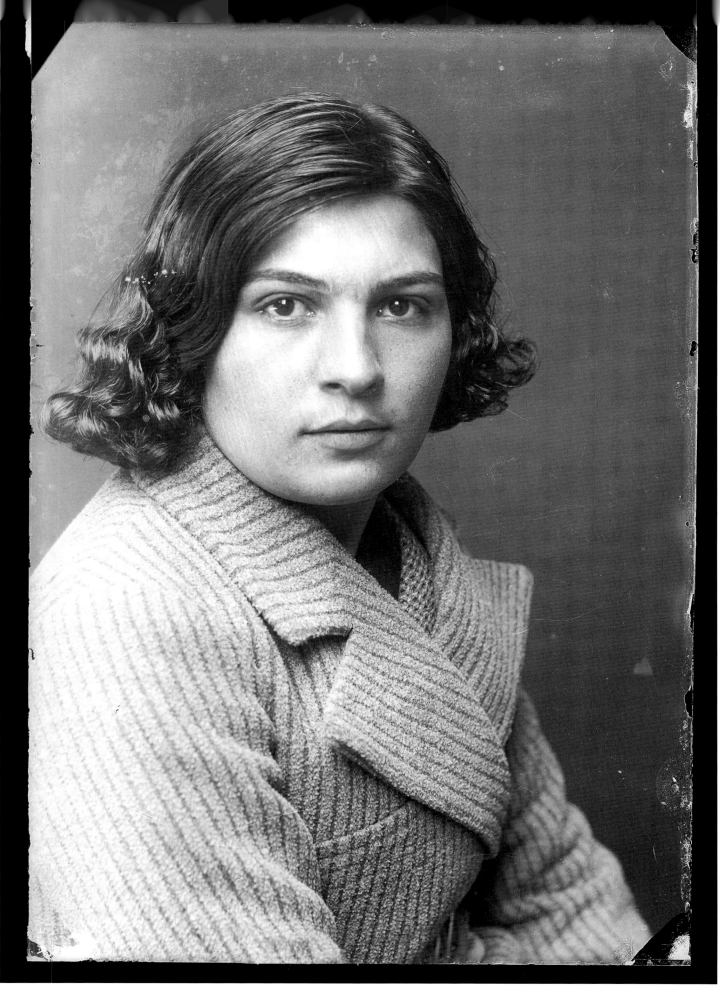

78. *Untitled. Mirza Mehdi Khan Chehreh-Nama.*

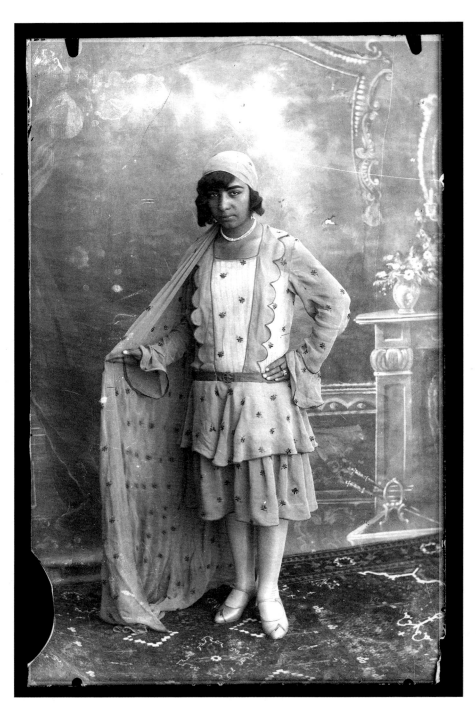

79–80. Untitled. Mirza Mehdi Khan Chehreh-Nama.

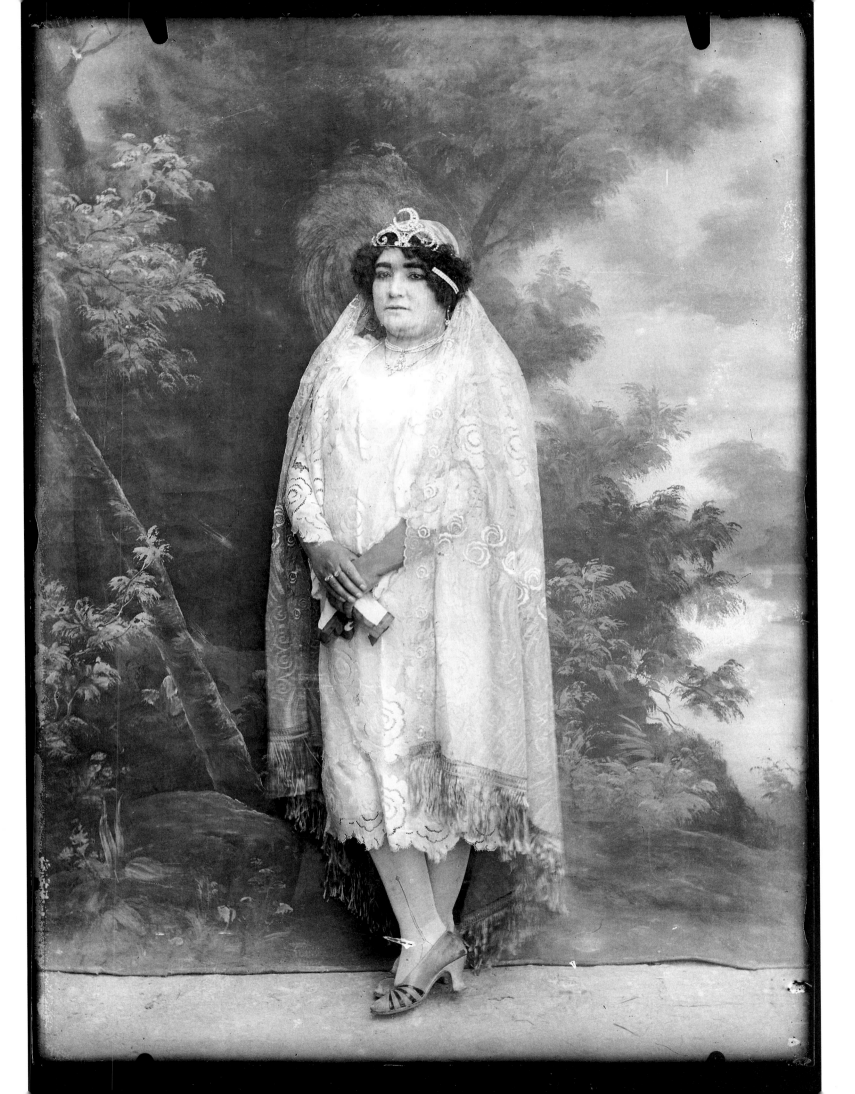

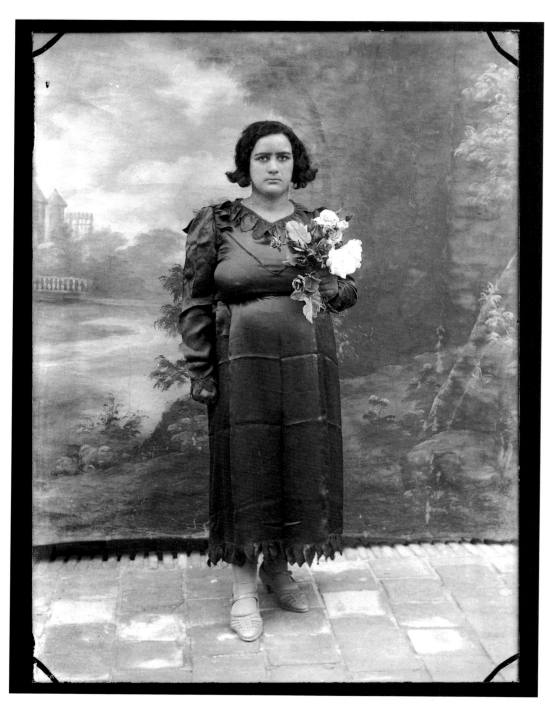

81. *Untitled. Gholamhossein Derakhshan.*

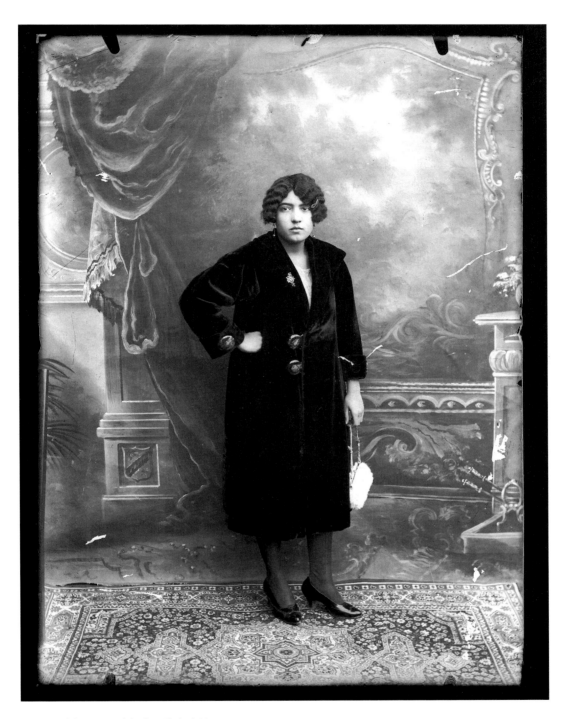

82. *Untitled. Mirza Mehdi Khan Chehreh-Nama.*

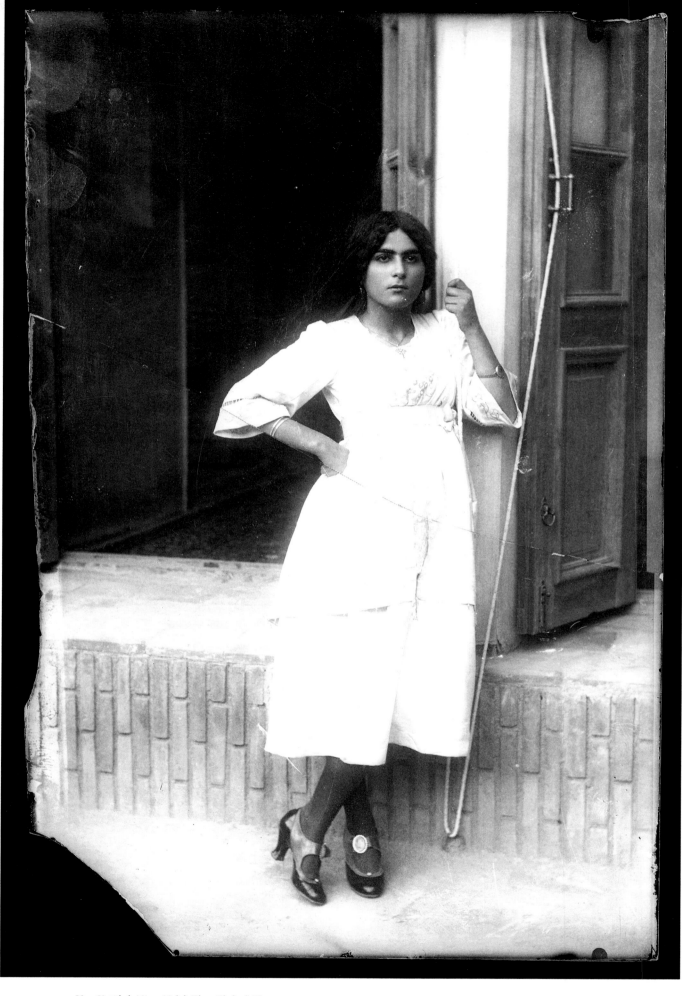

83. *Untitled. Mirza Mehdi Khan Chehreh-Nama.*

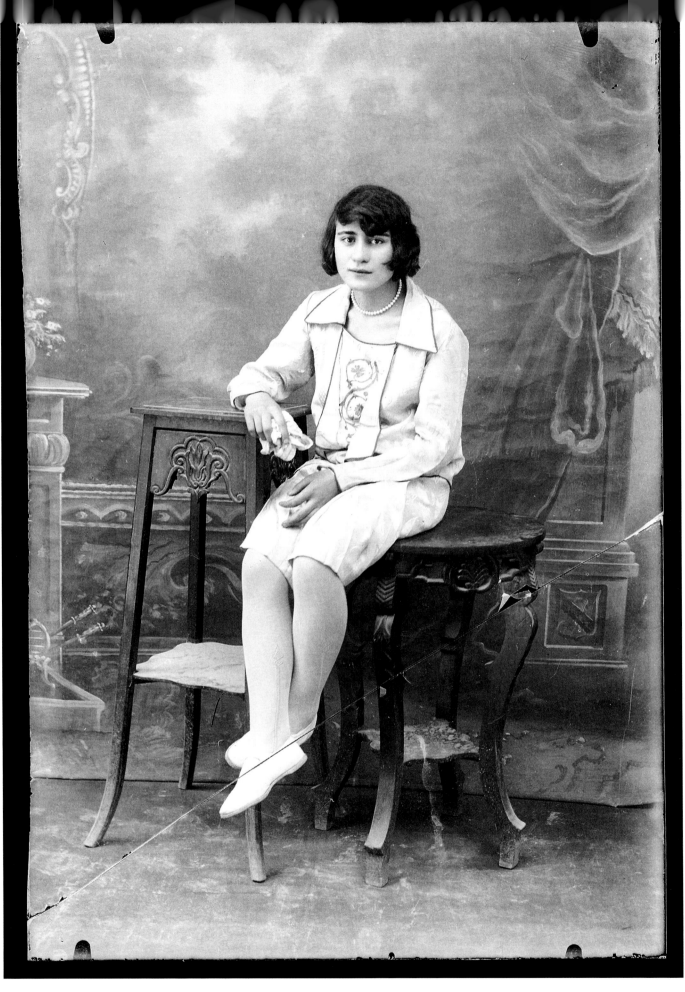

84. *Untitled. Mirza Mehdi Khan Chehreh-Nama.*

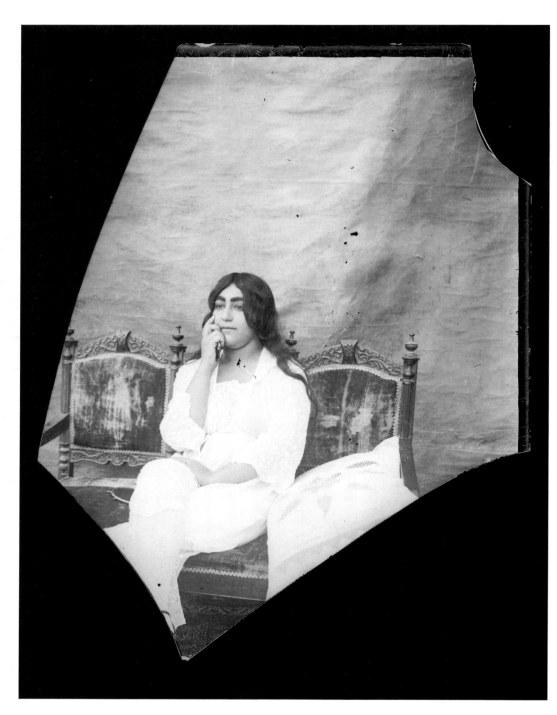

85. *Untitled. Mirza Mehdi Khan Chehreh-Nama.*

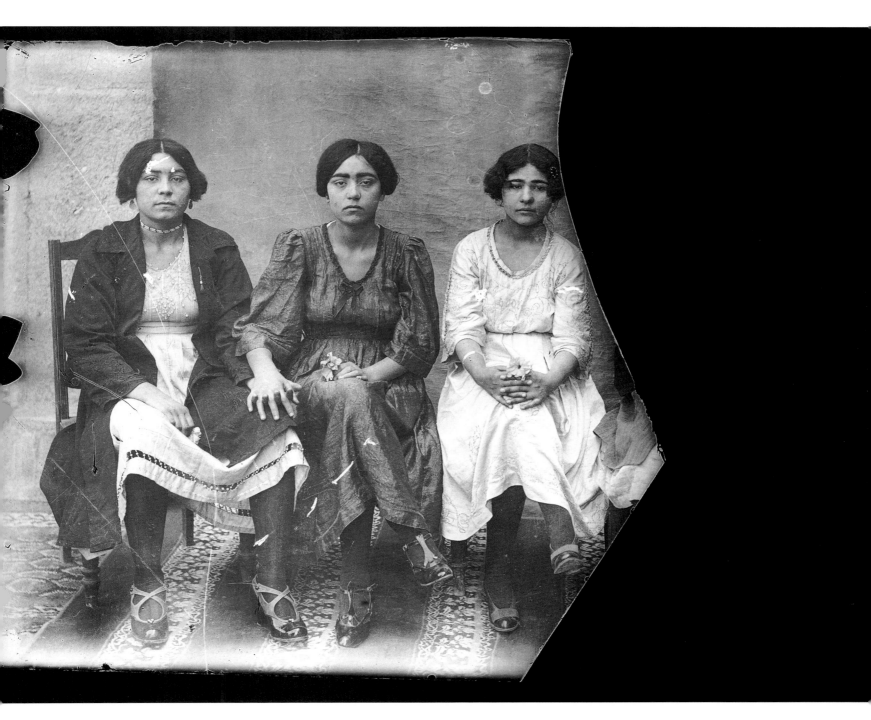

86. *Untitled. Mirza Mehdi Khan Chehreh-Nama.*

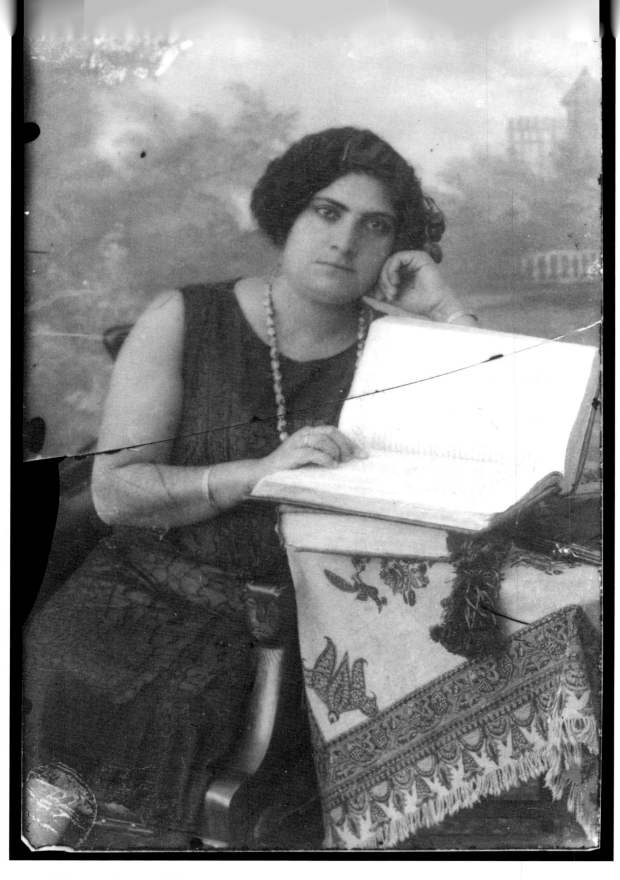

87. *Untitled. Mirza Mehdi Khan Chehreh-Nama.*

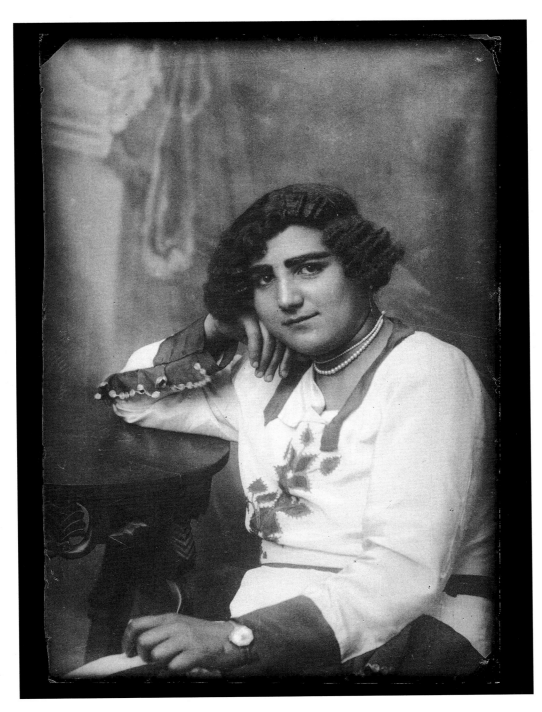

88. *Untitled. Mirza Mehdi Khan Chehreh-Nama.*

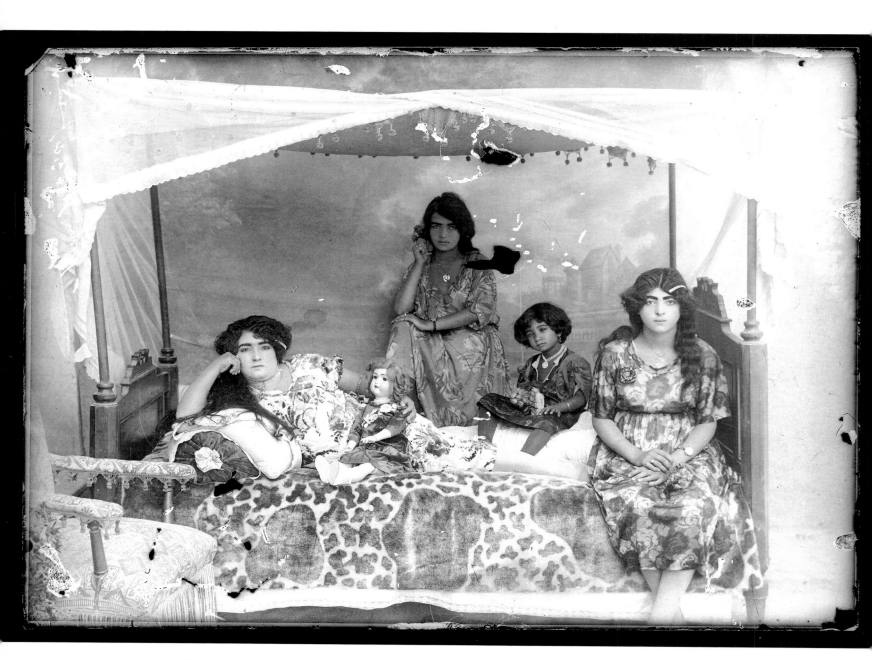

89. *Untitled. Mirza Mehdi Khan Chehreh-Nama.*

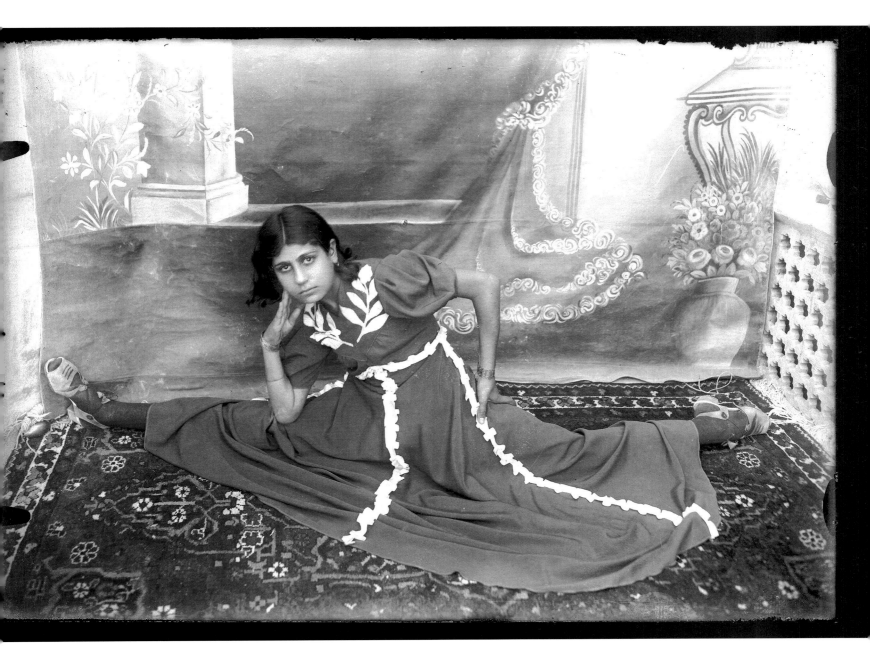

90. *Untitled. Gholamhossein Derakhshan.*

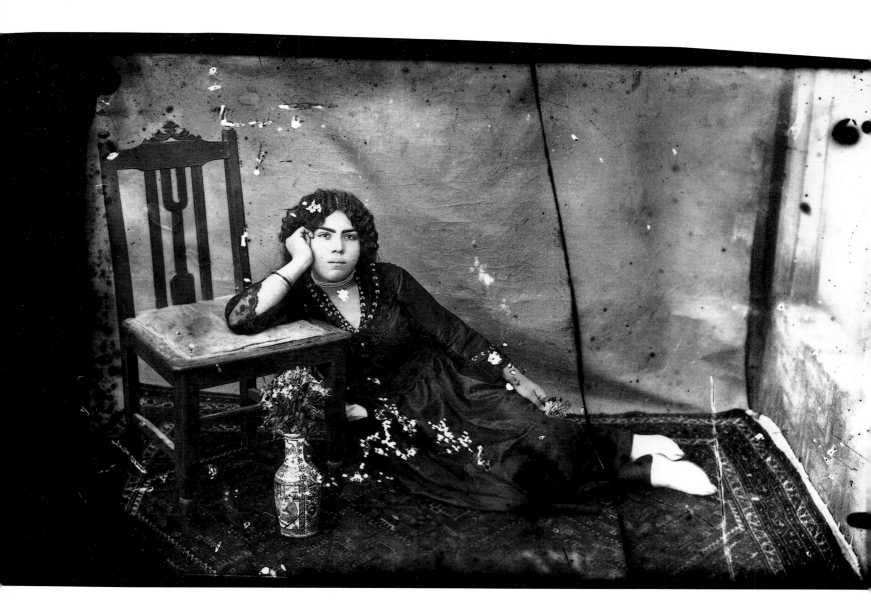

91. Untitled. Mirza Mehdi Khan Chehreh-Nama.

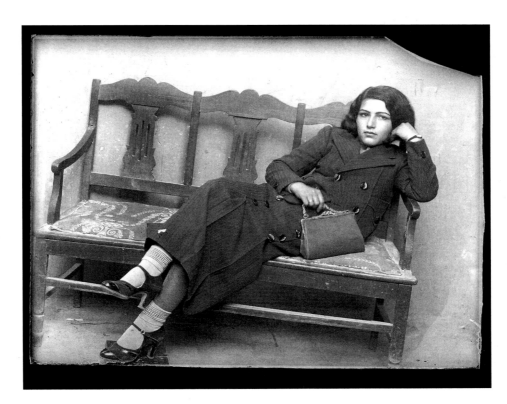

92. *Untitled. Mirza Mehdi Khan Chehreh-Nama.*

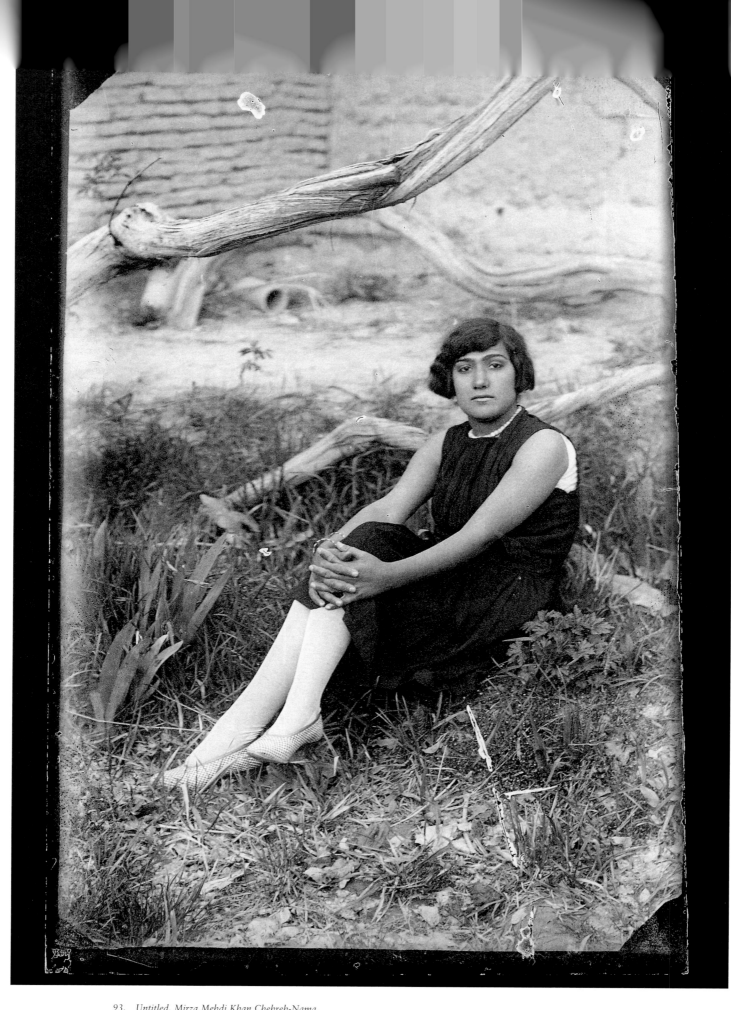

93. *Untitled. Mirza Mehdi Khan Chehreh-Nama.*

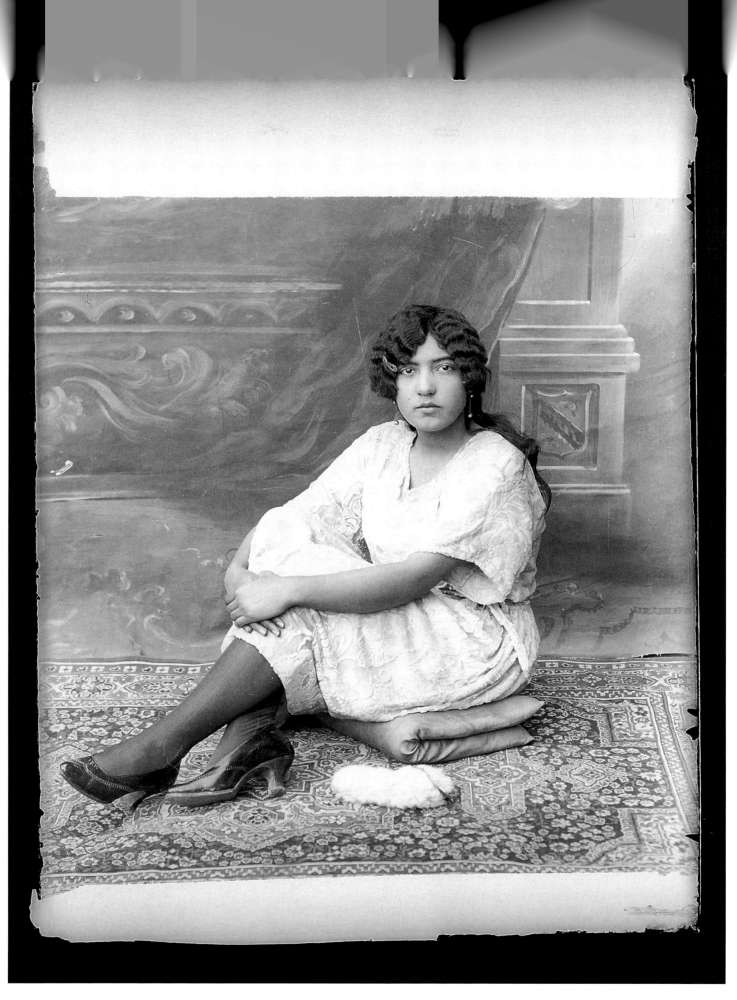

94. *Untitled. Mirza Mehdi Khan Chehreh-Nama.*

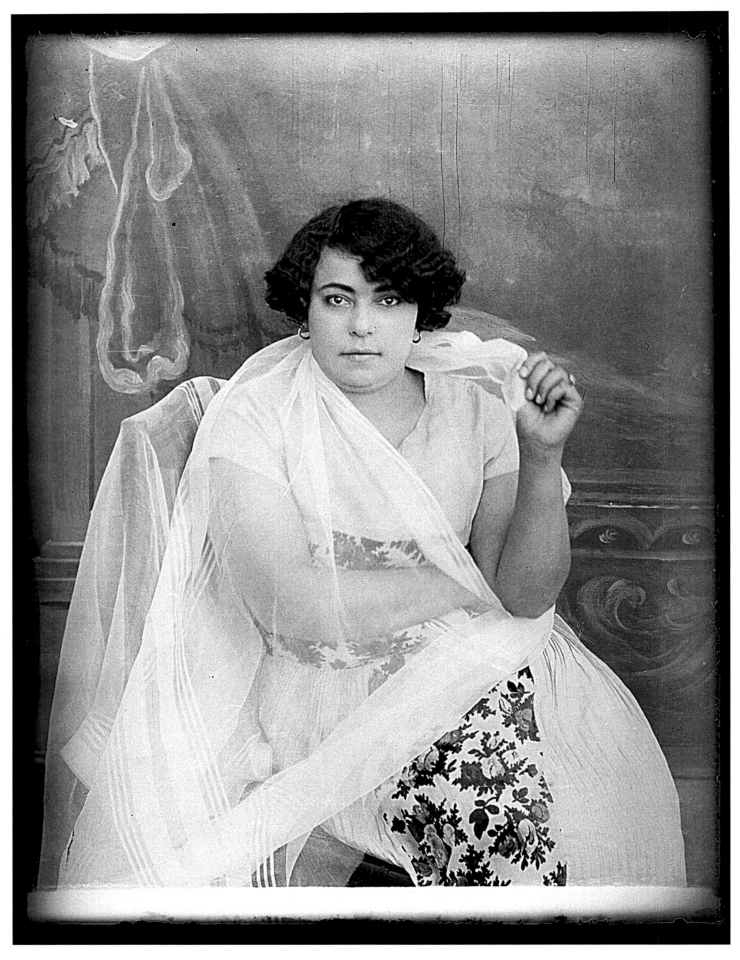

95. *Untitled. Mirza Mehdi Khan Chehreh-Nama.*

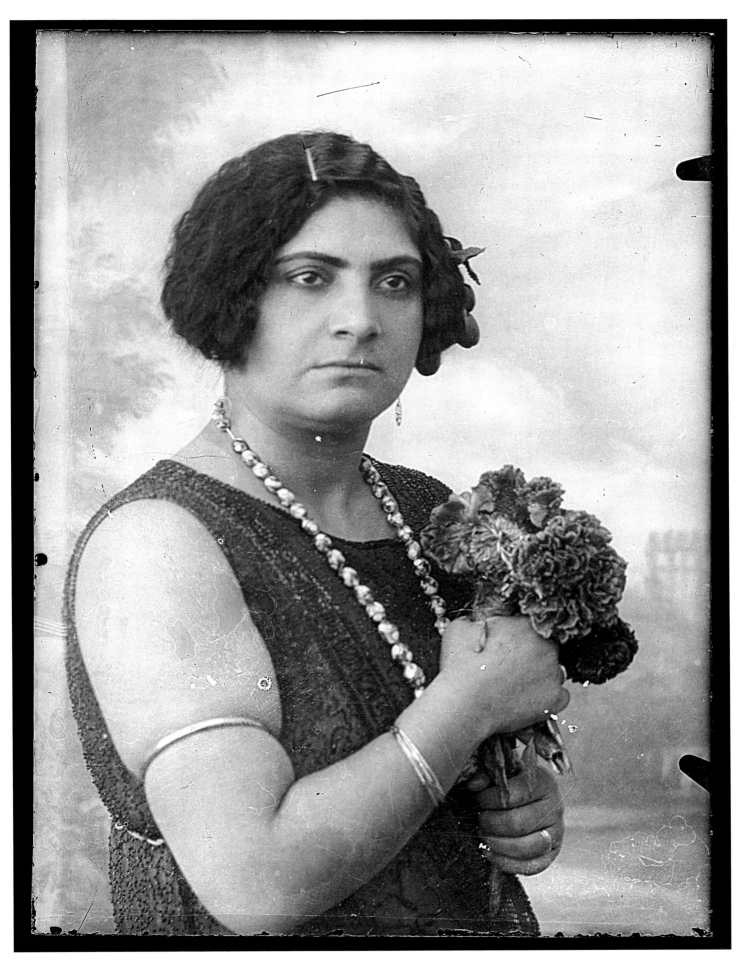

96. *Untitled. Mirza Mehdi Khan Chehreh-Nama.*

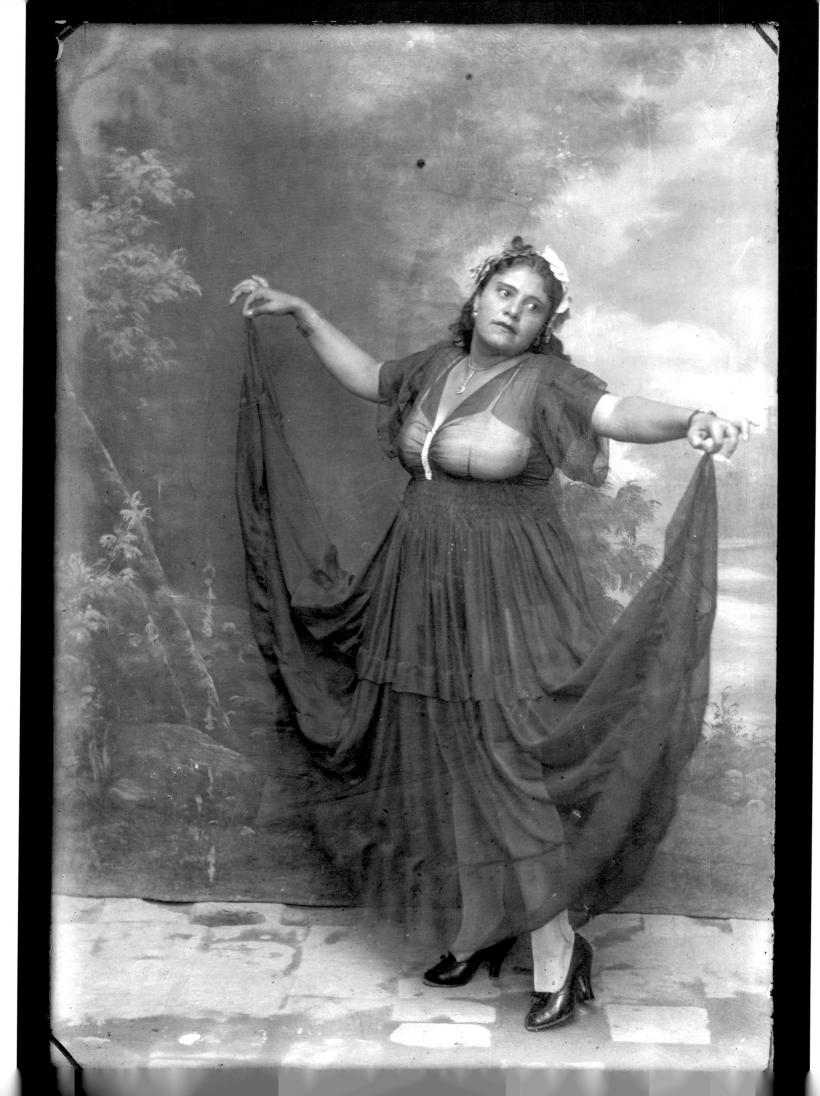

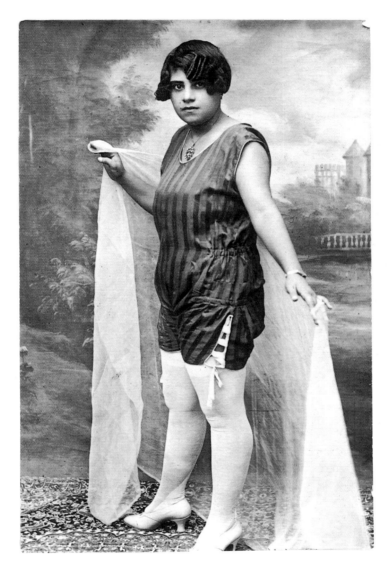

97–98. *Untitled. Mirza Mehdi Khan Chehreh-Nama.*

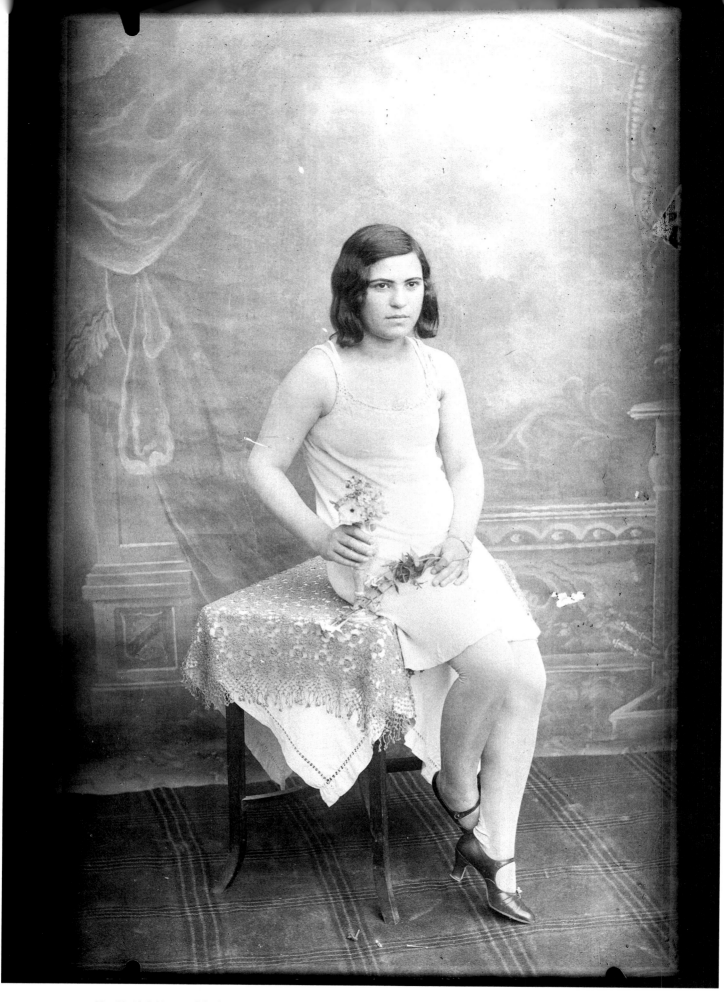

99. *Untitled. Mirza Mehdi Khan Chehreh-Nama.*

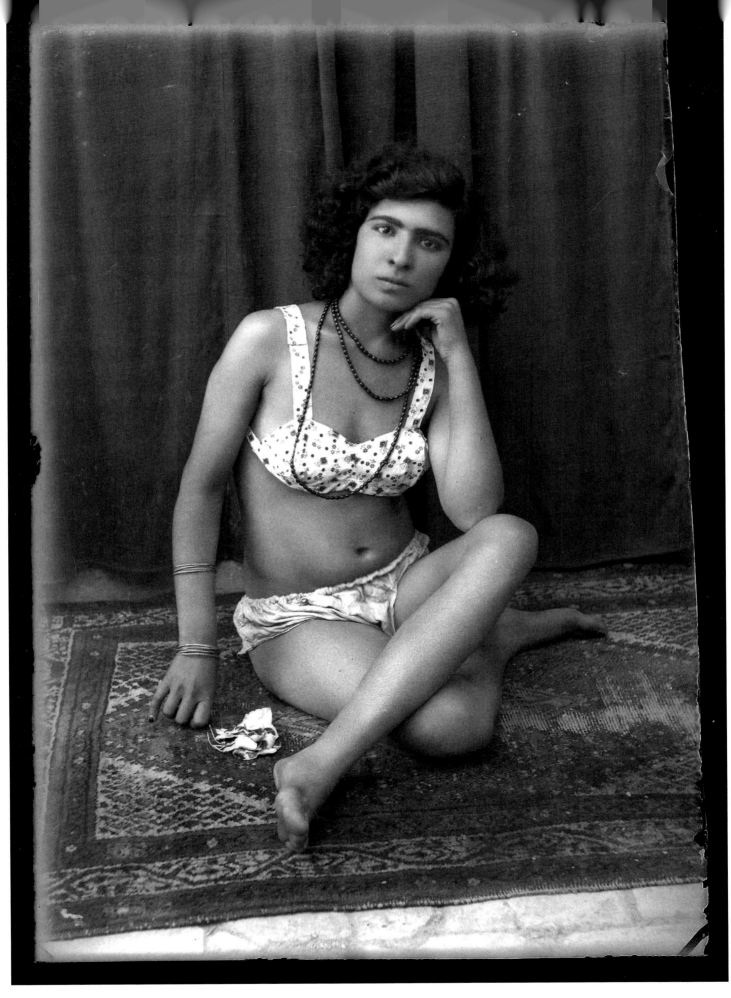

100. Untitled. Gholamhossein Derakhshan.

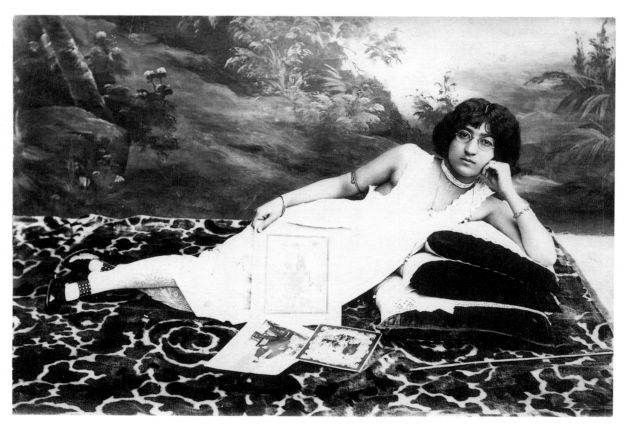

101. *Prostitute, Khanomchi Iran. Mirza Mehdi Khan Chehreh-Nama.*

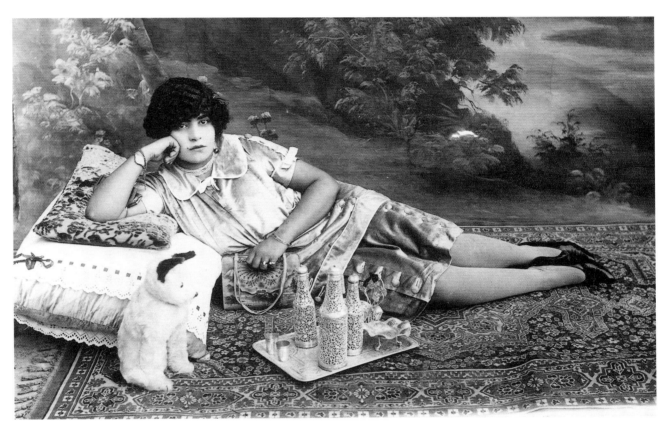

102. *Prostitute. Mirza Mehdi Khan Chehreh-Nama.*

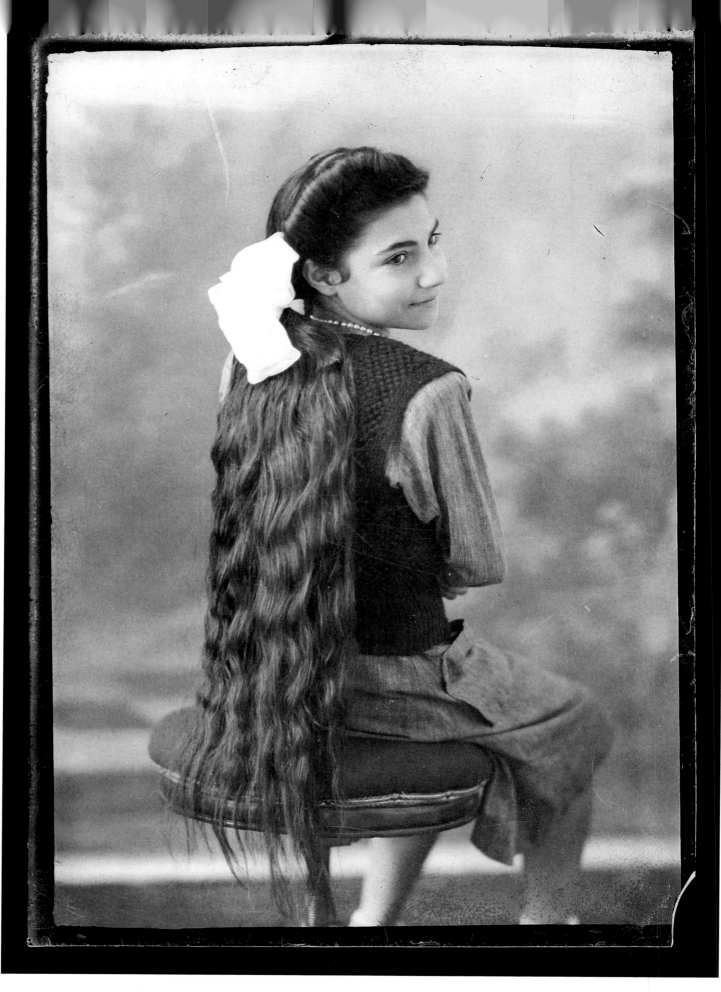

103. Untitled. Minas Patkerhanian Mackertich, 1953

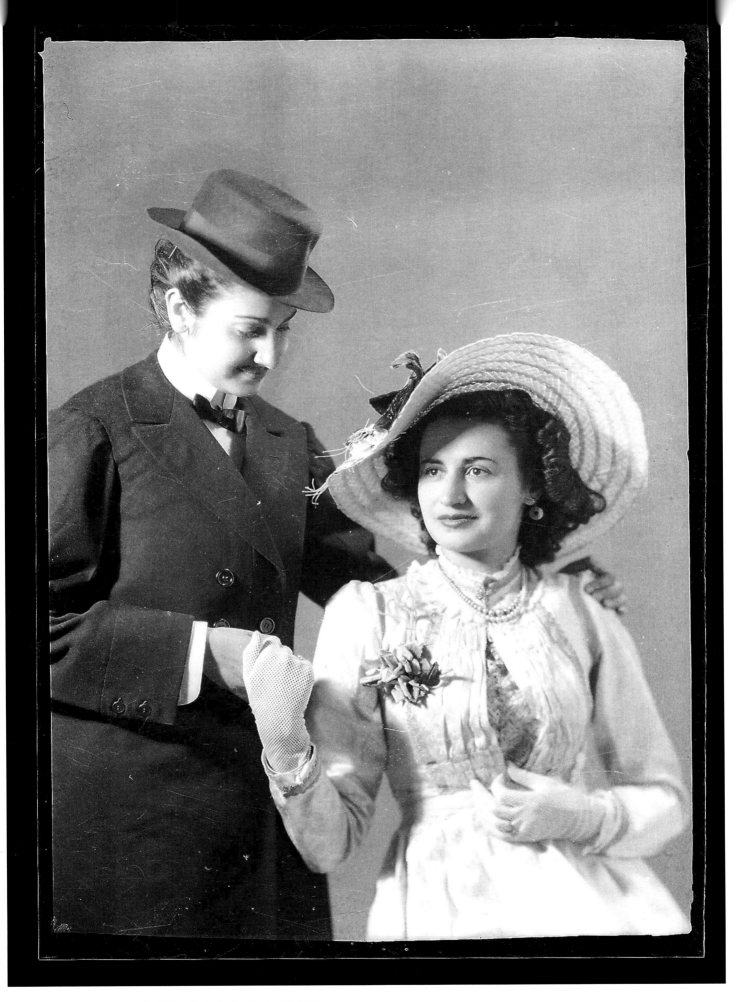

104. *Untitled. Vahan Patkerhanian Mackertich, 1950s.*

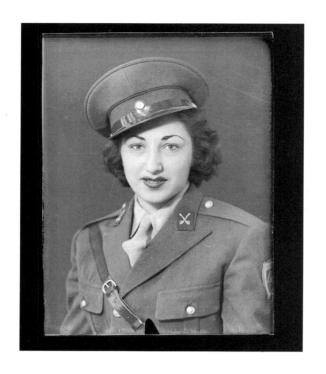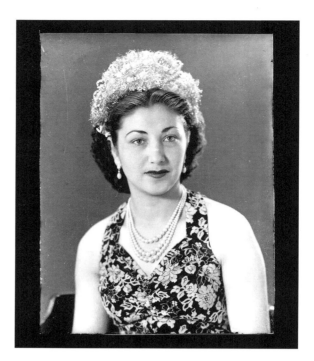

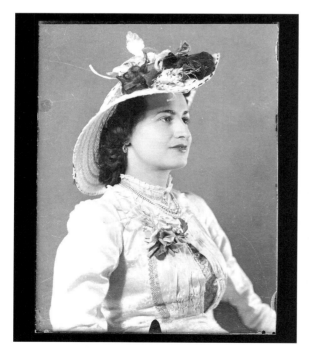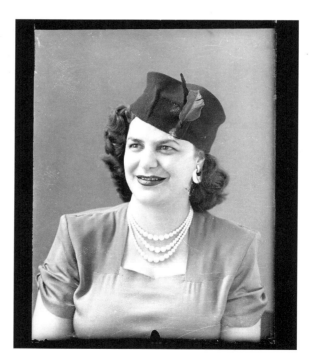

105–108. *Untitled. Vahan Patkerhanian Mackertich, 1950s.*

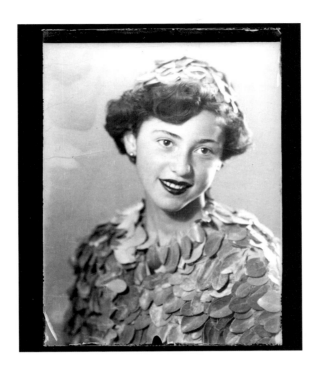

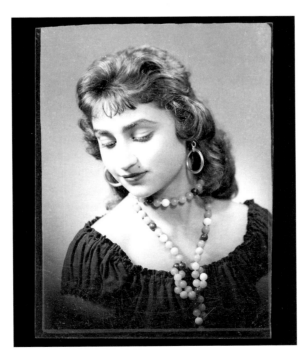

109–110. Untitled. Vahan Patkerhanian Mackertich, 1950s.

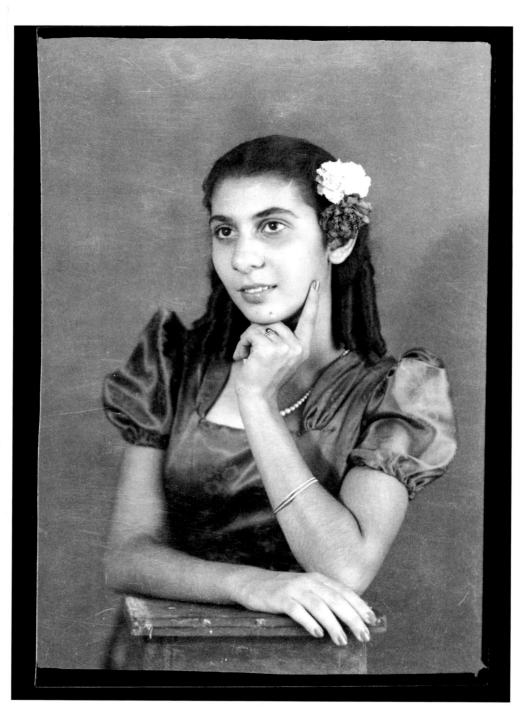

111. Untitled. Minas Patkerhanian Mackertich, 1950s.

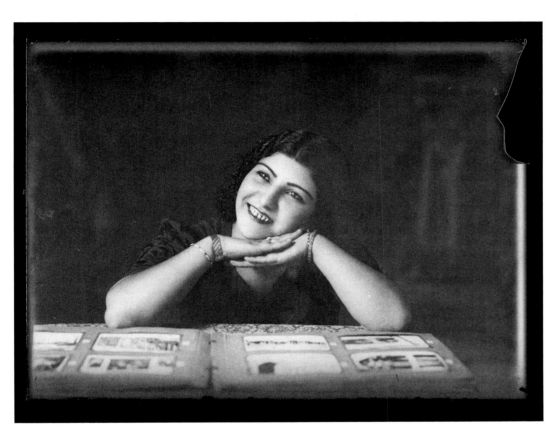

112. Untitled. Minas Patkerhanian Mackertich, 1950s.

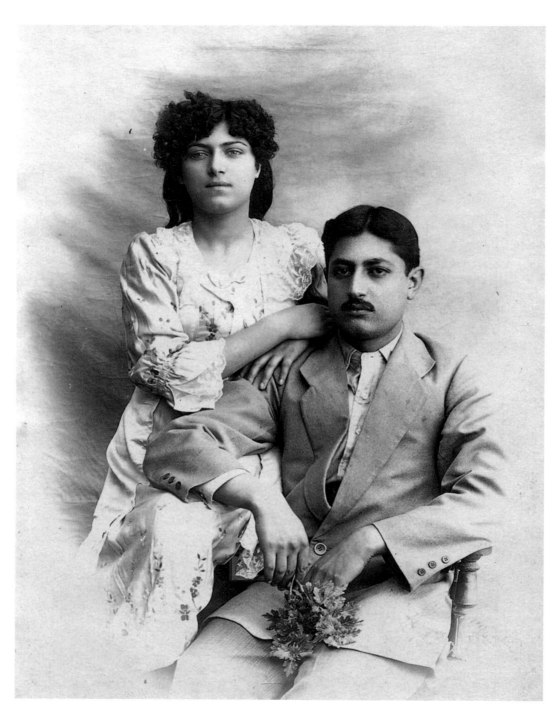

113. Untitled. Mirza Mehdi Khan Chehreh-Nama.

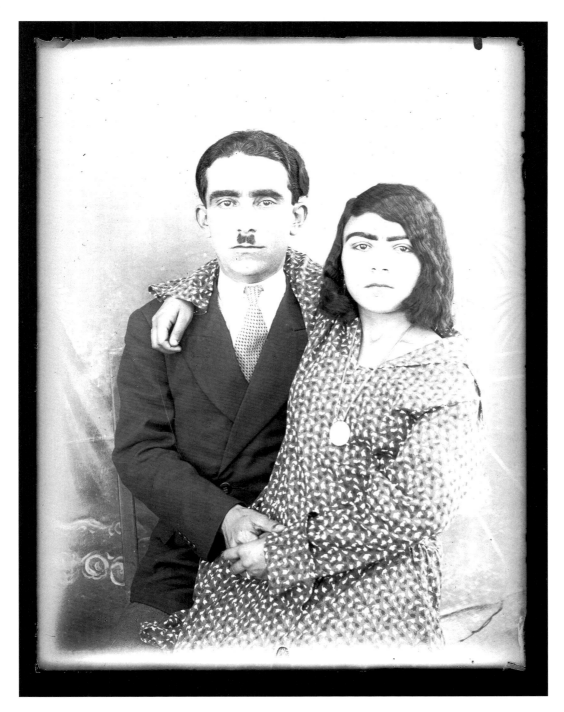

114. Untitled. *Gholamhossein Derakhshan.*

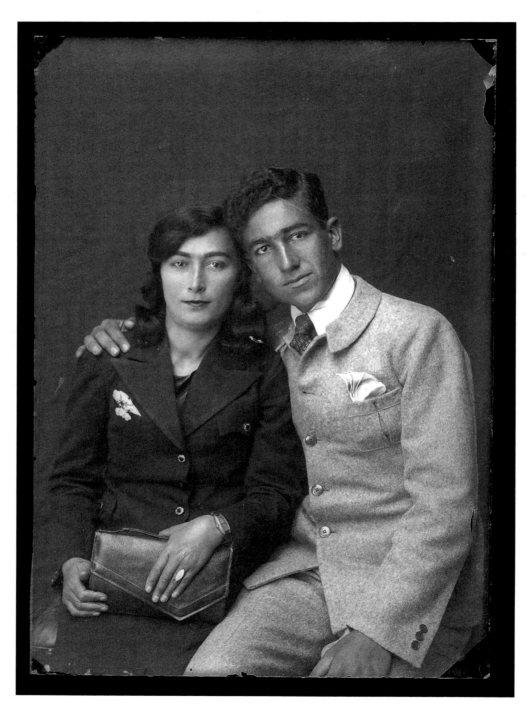

115. Untitled. Mirza Mehdi Khan Chehreh-Nama.

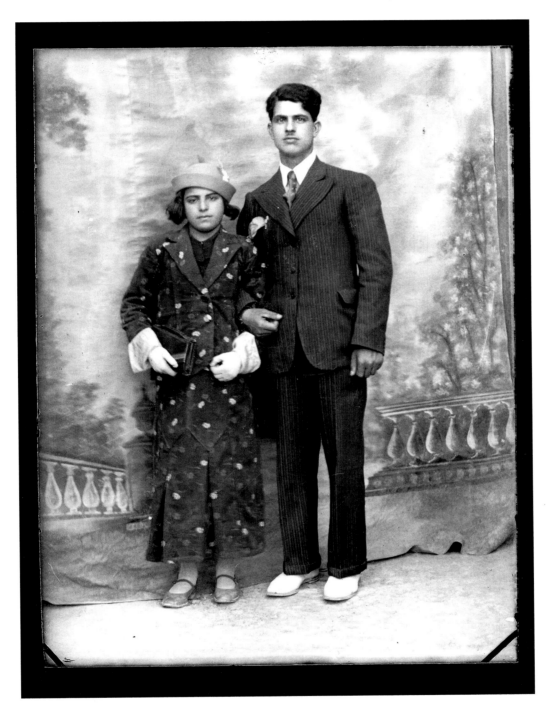

116. *Untitled. Abolqasem Jala, 1936.*

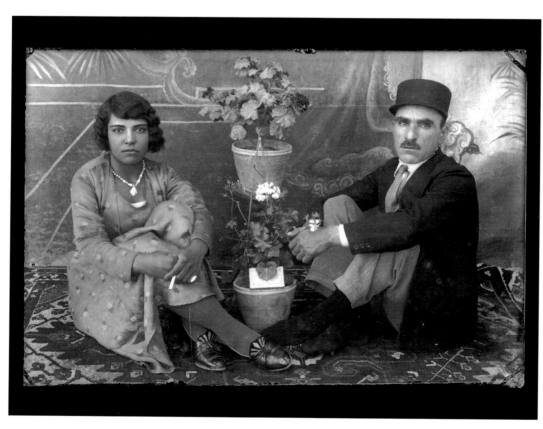

117. Untitled. Gholamhossein Derakhshan.

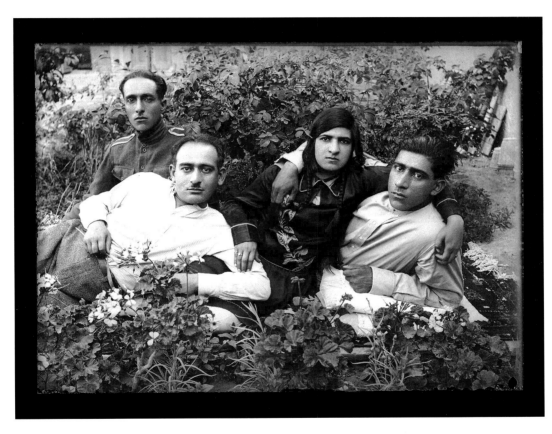

118. *Untitled. Gholamhossein Derakhshan.*

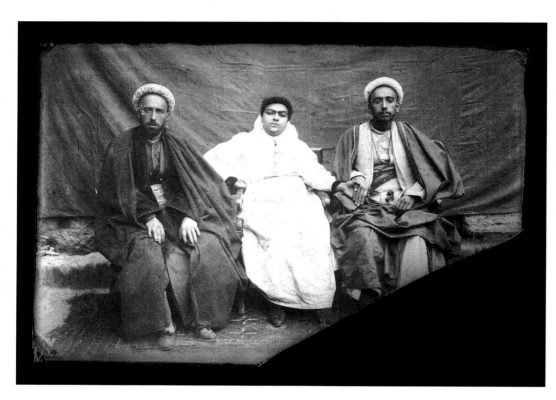

119. Untitled. Mirza Mehdi Khan Chehreh-Nama.

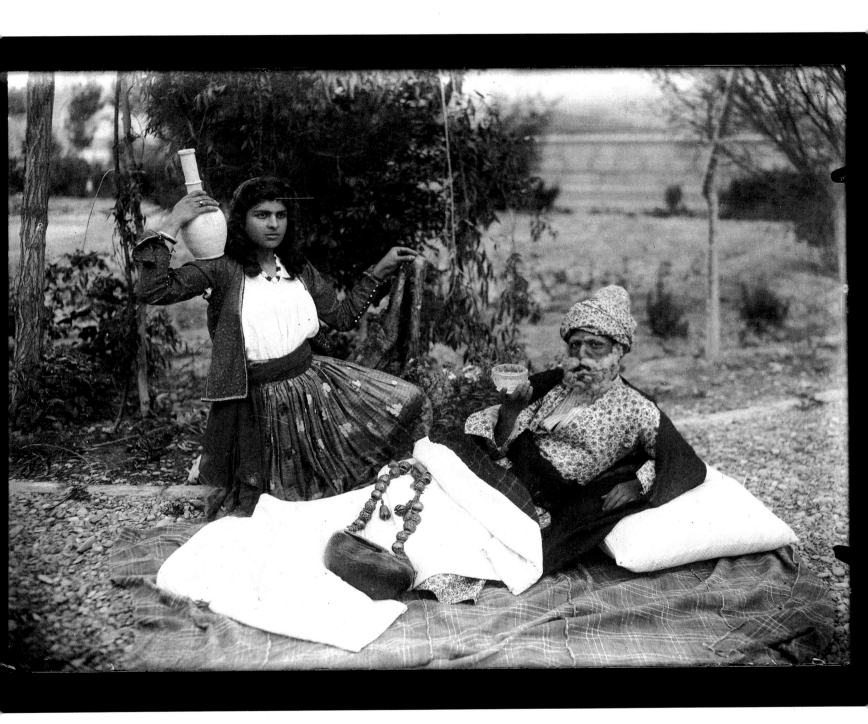

120. *Untitled. Gholamhossein Derakhshan.*

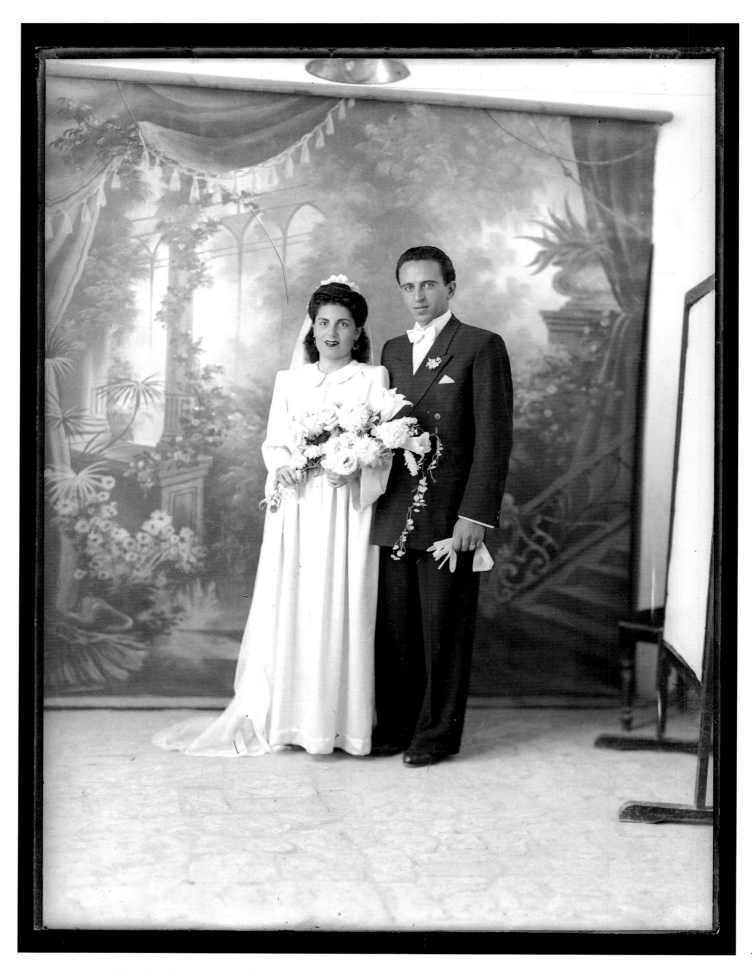

121. Bride and groom. Minas Patkerhanian Mackertich.

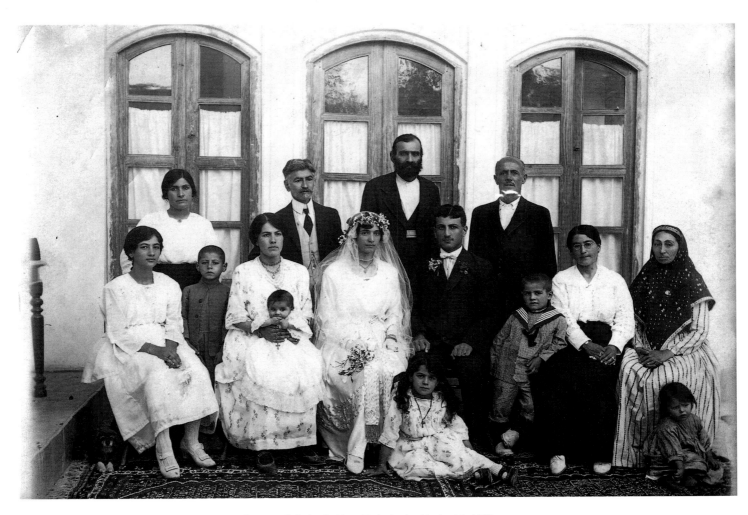

122. *Armenian bride and groom with Dr Randof's family. Minas Patkerhanian Mackertich, 1920.*

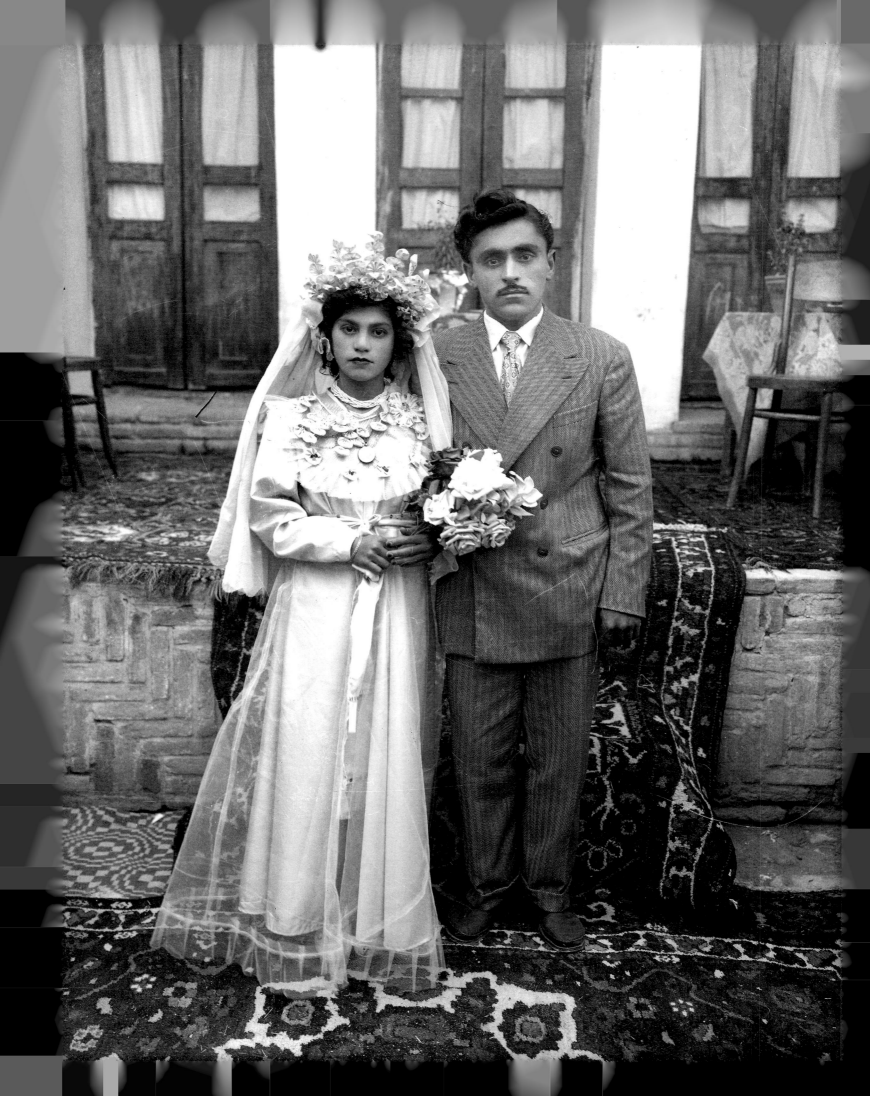

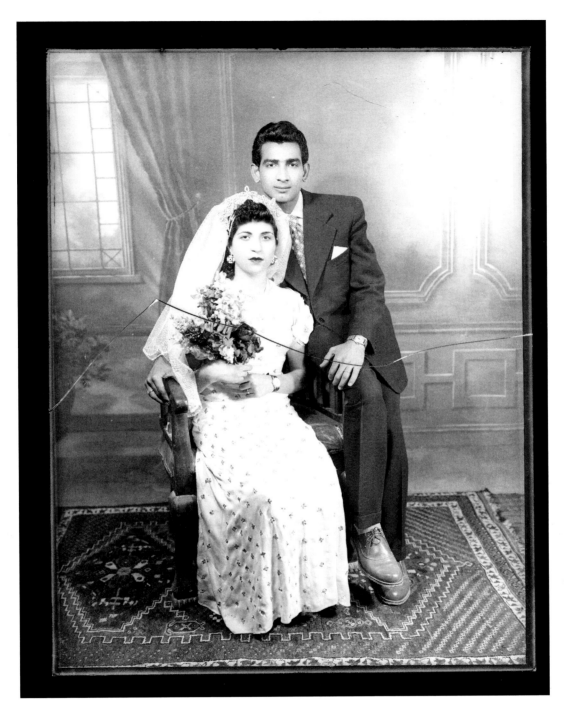

123–124. *Bride and groom. Abolqasem Jala.*

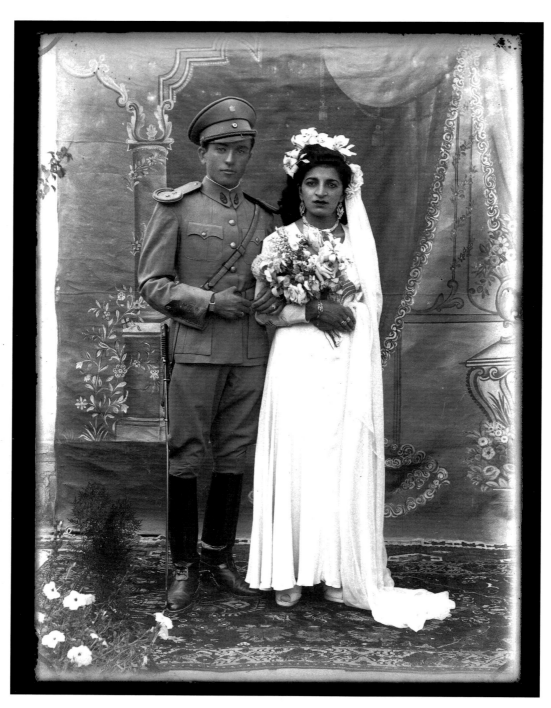

125. Bride and groom from military families. Gholamhossein Derakhshan.

126. Right: Bride and groom with family. Gholamhossein Derakhshan.

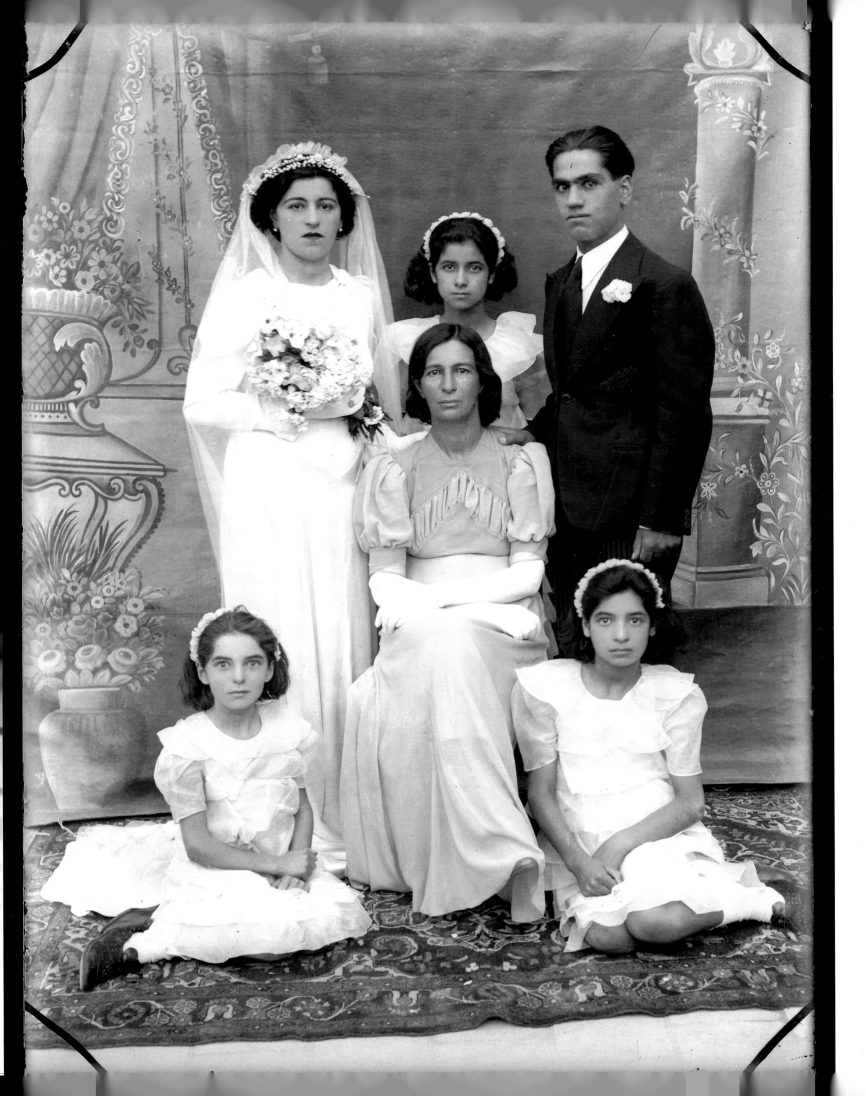

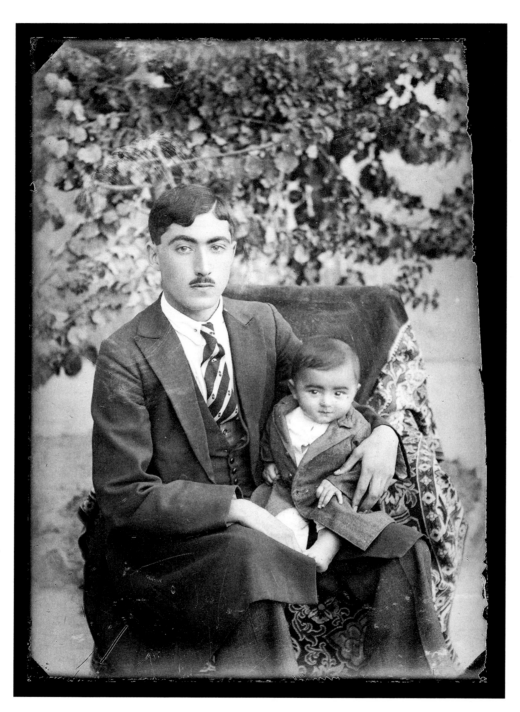

127. *Untitled. Mirza Mehdi Khan Chehreh-Nama.*

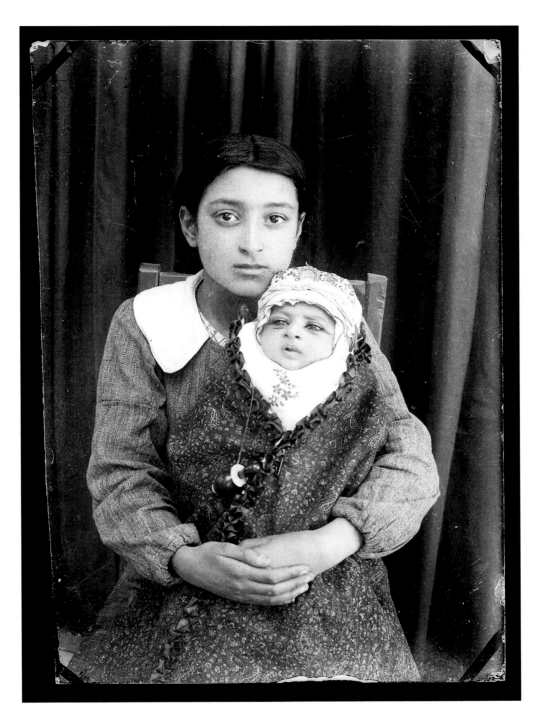

128. Untitled. Gholamhossein Derakhshan.

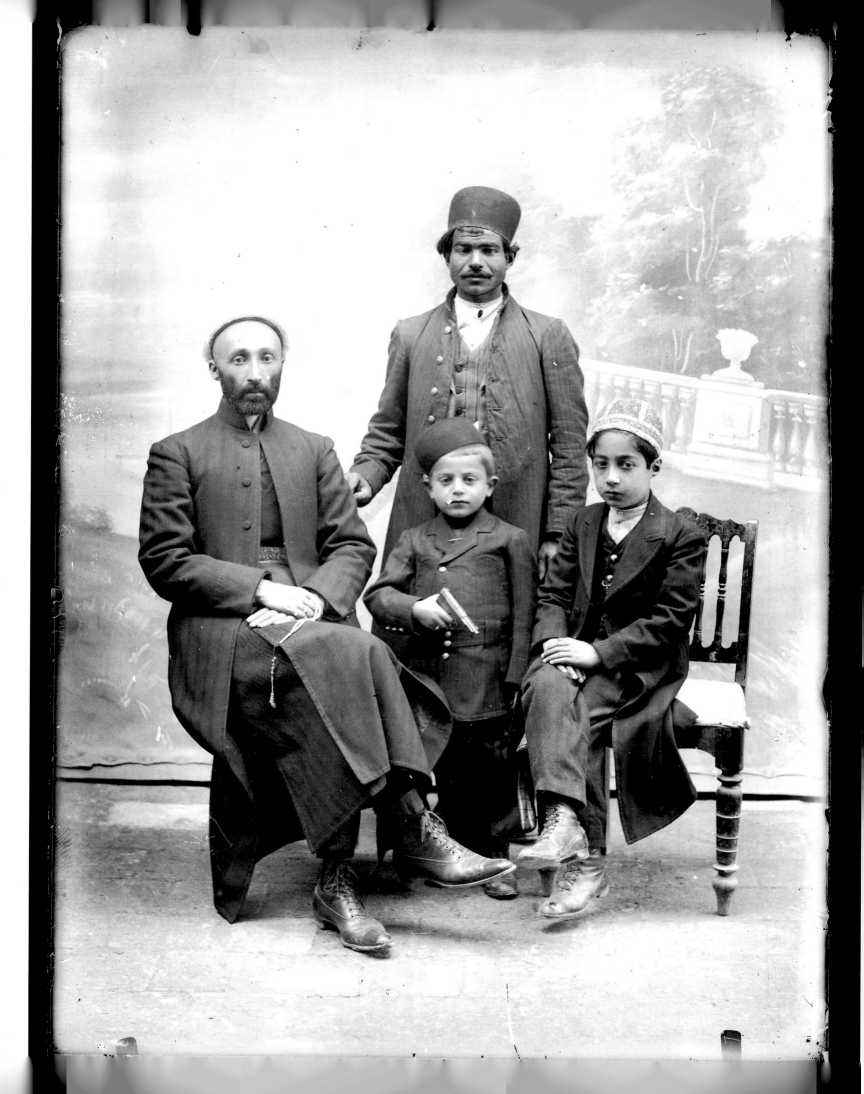

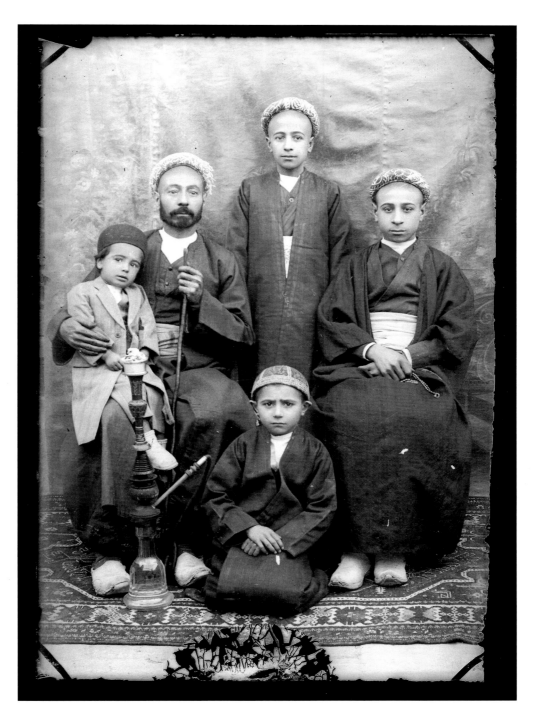

130. Untitled. Gholamhossein Derakhshan.

129. *Left: Untitled. Mirza Mehdi Khan Chehreh-Nama.*

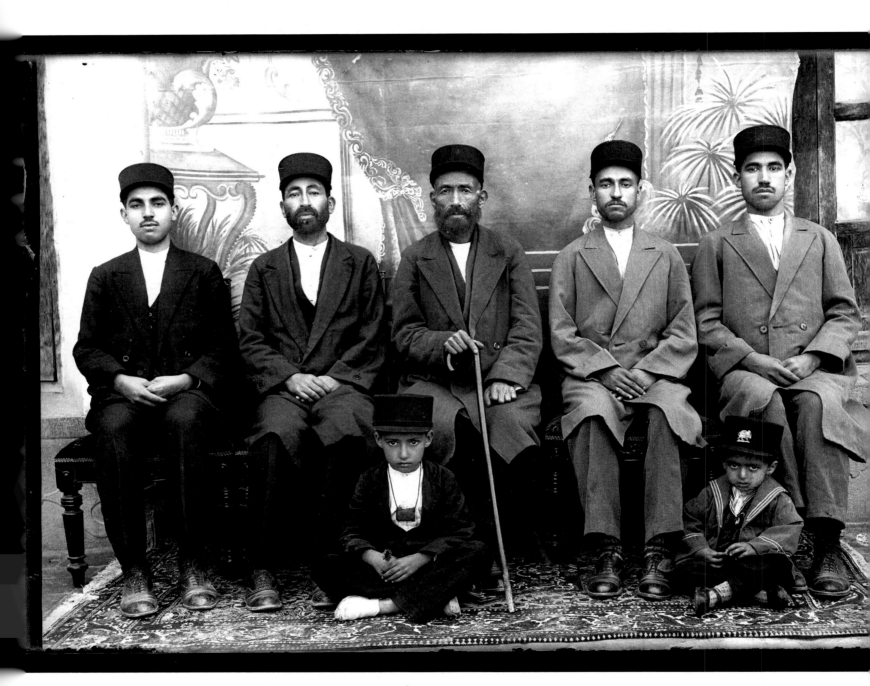

131–132. Untitled. Gholamhossein Derakhshan.

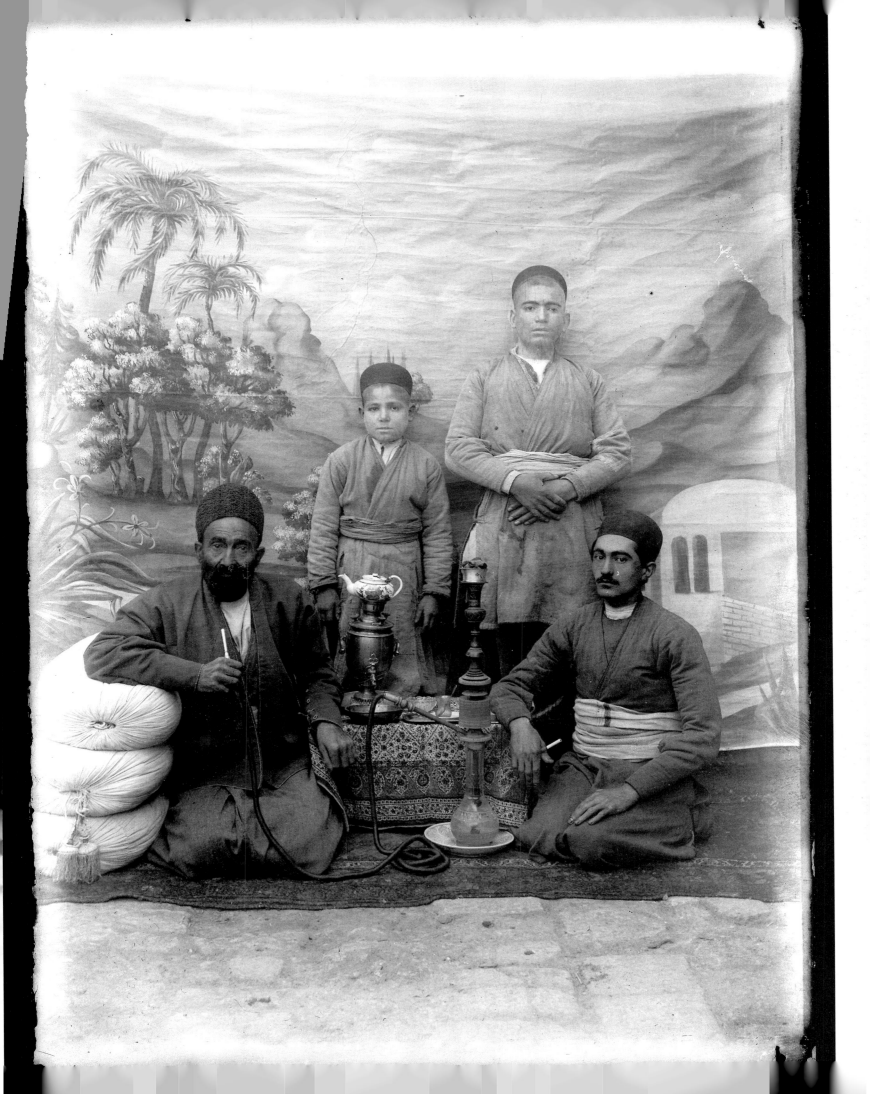

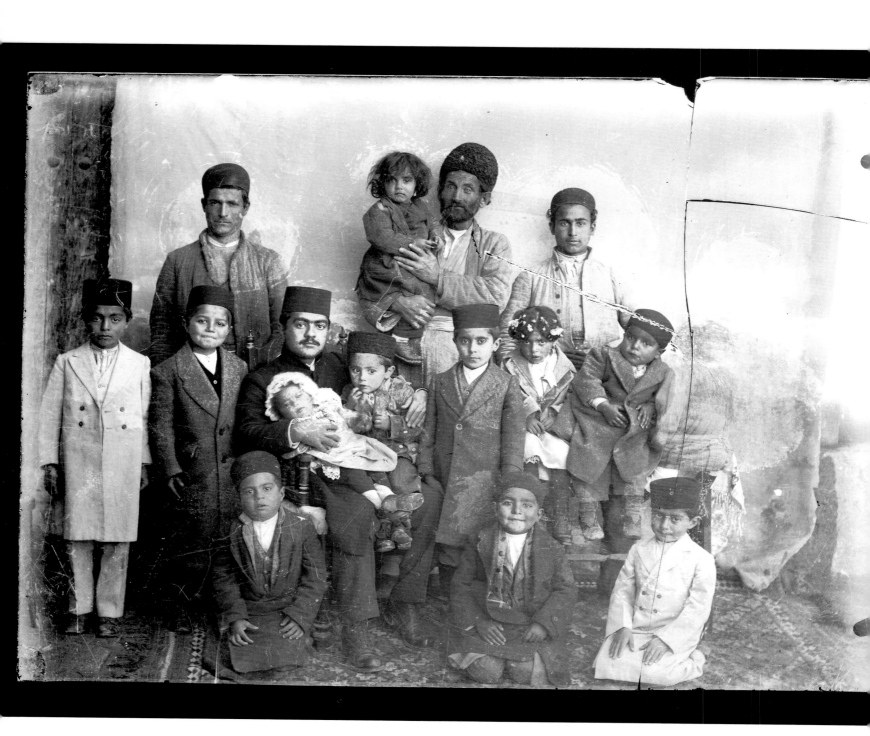

133. Untitled. Mirza Mehdi Khan Chehreh-Nama.

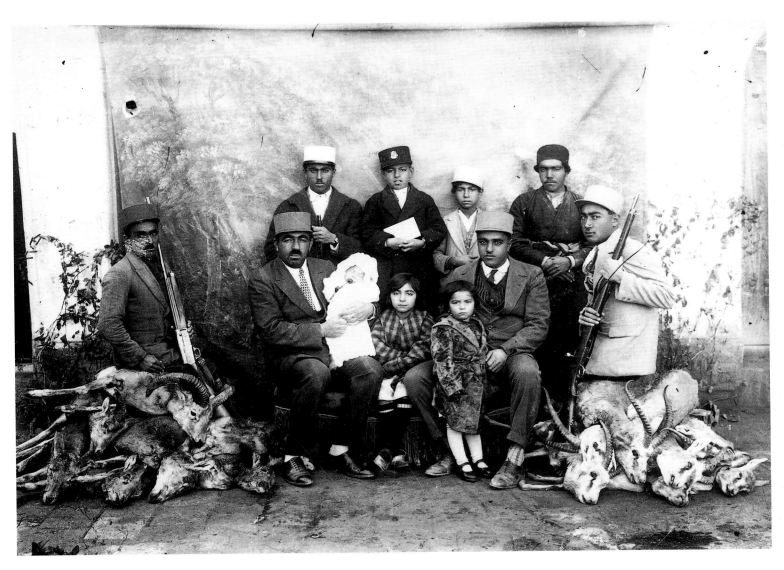

134. *Untitled. Hassan Shams.*

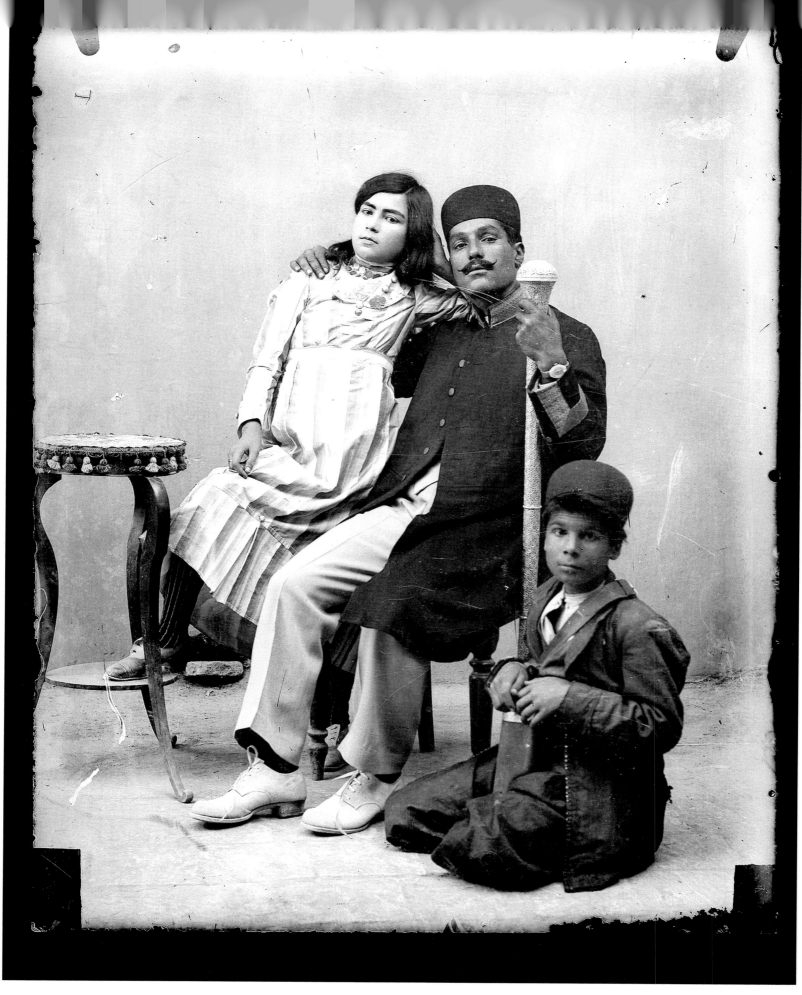

135. *Untitled. Mirza Mehdi Khan Chehreh-Nama.*

116 Portrait Photographs from Isfahan

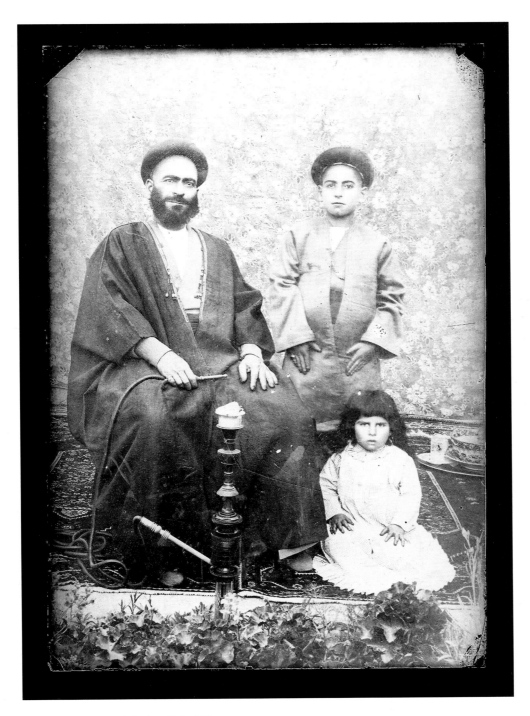

136. *Untitled. Mirza Mehdi Khan Chehreh-Nama.*

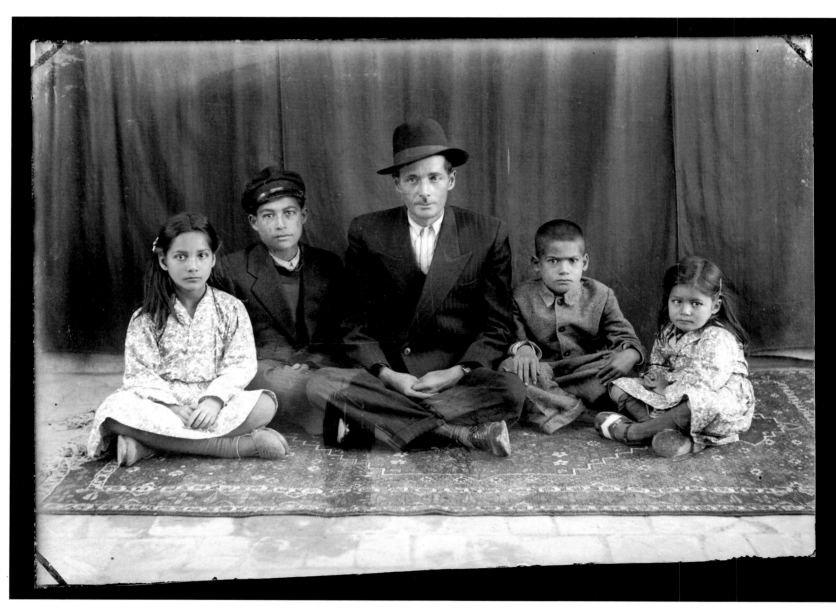

137. *Untitled. Gholamhossein Derakhshan.*

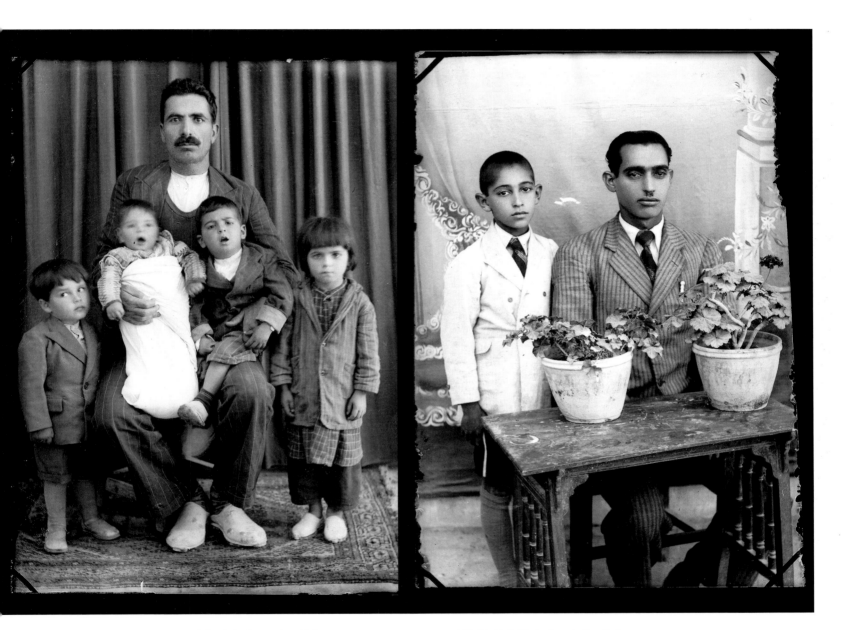

138. *Untitled. Gholamhossein Derakhshan.* 139. *Untitled. Gholamhossein Derakhshan.*

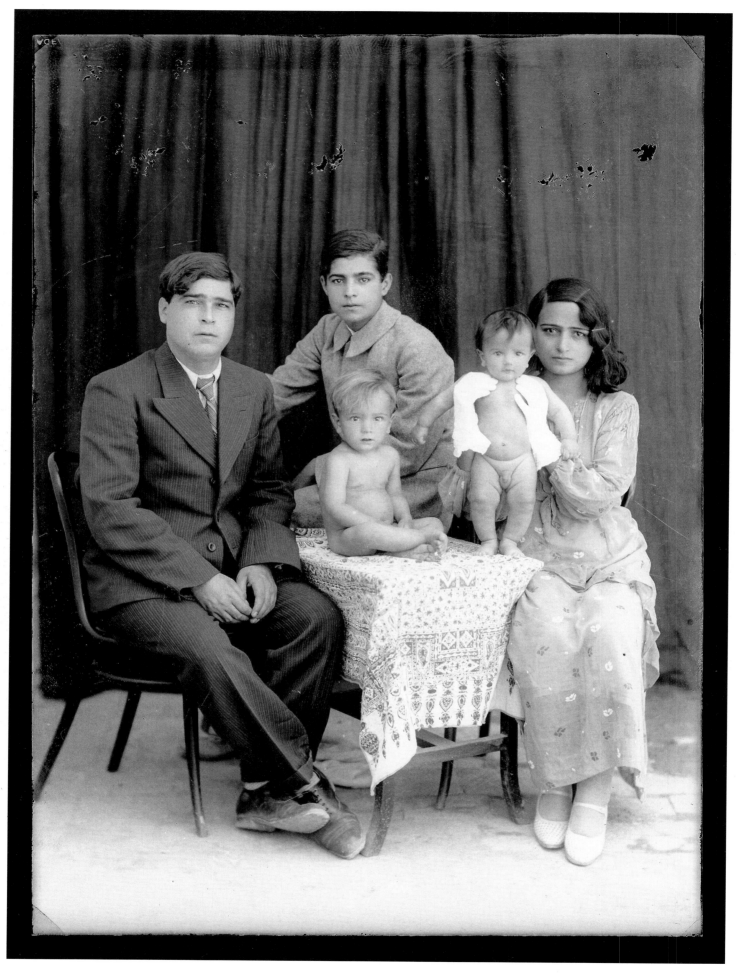

140. Untitled. Abolqasem Jala.

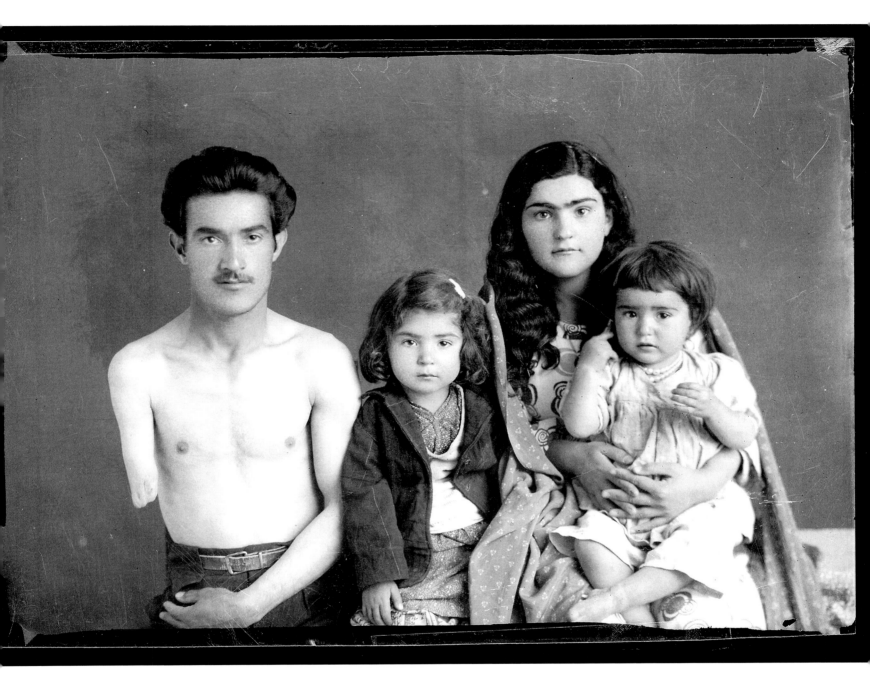

141. *Untitled. Minas Patkerhanian Mackertich.*

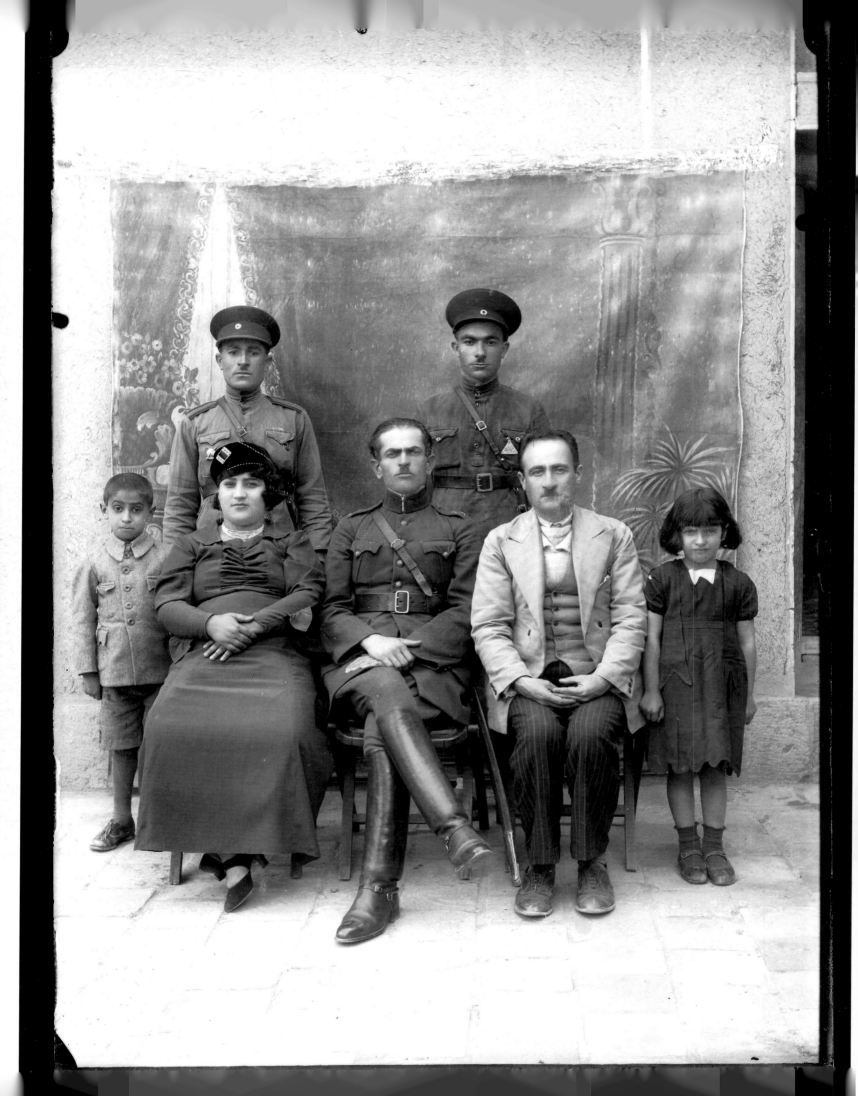

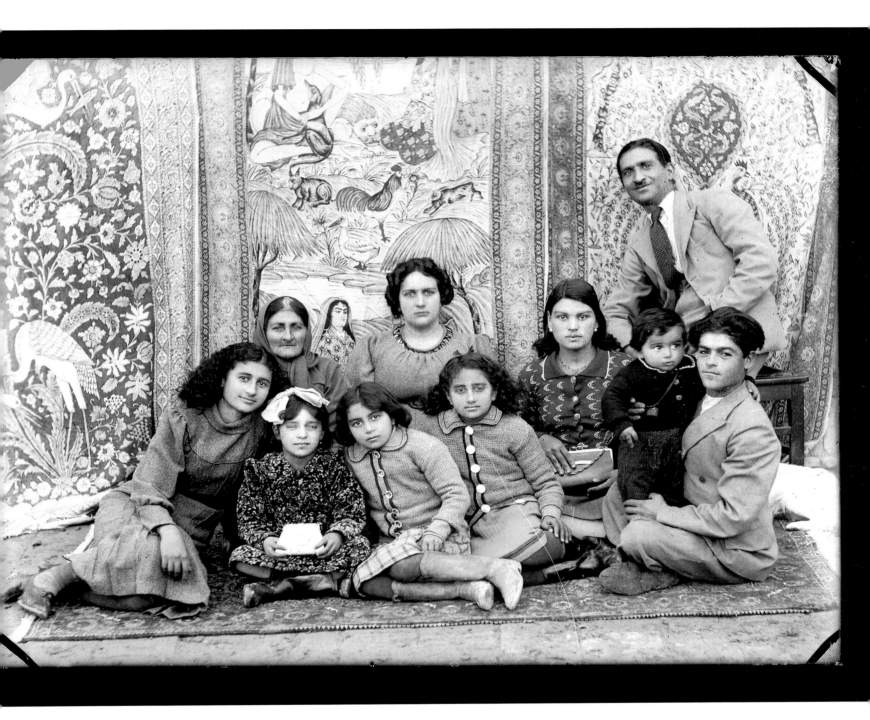

142–143. *Untitled. Gholamhossein Derakhshan.*

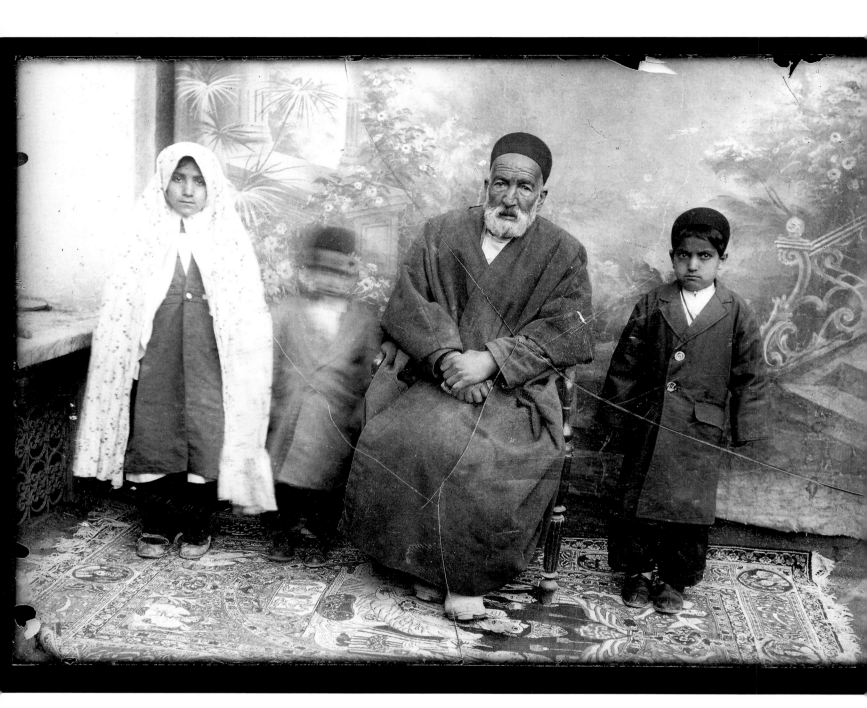

144. *Untitled. Minas Patkerhanian Mackertich.*

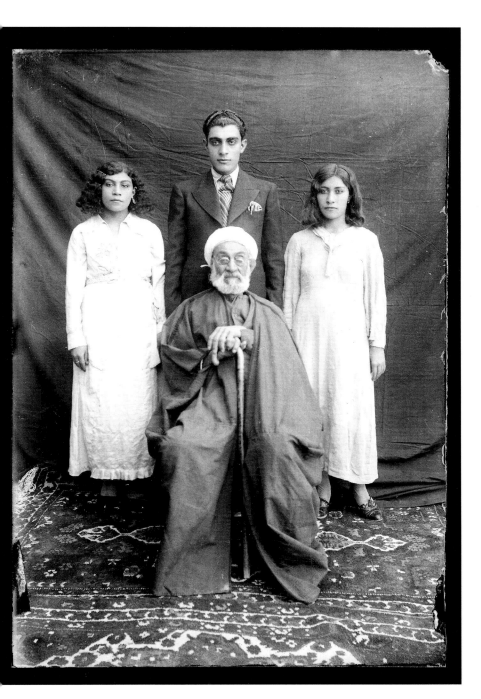

145. Untitled. Abolqasem Jala.

146. Untitled. Mirza Mehdi Khan Chehreh-Nama.

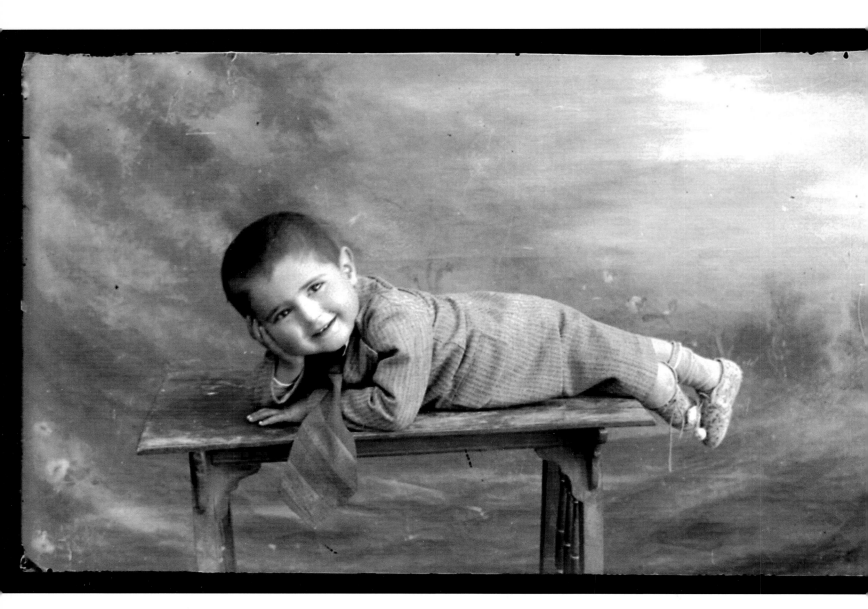

147. Untitled. Gholamhossein Derakhshan.

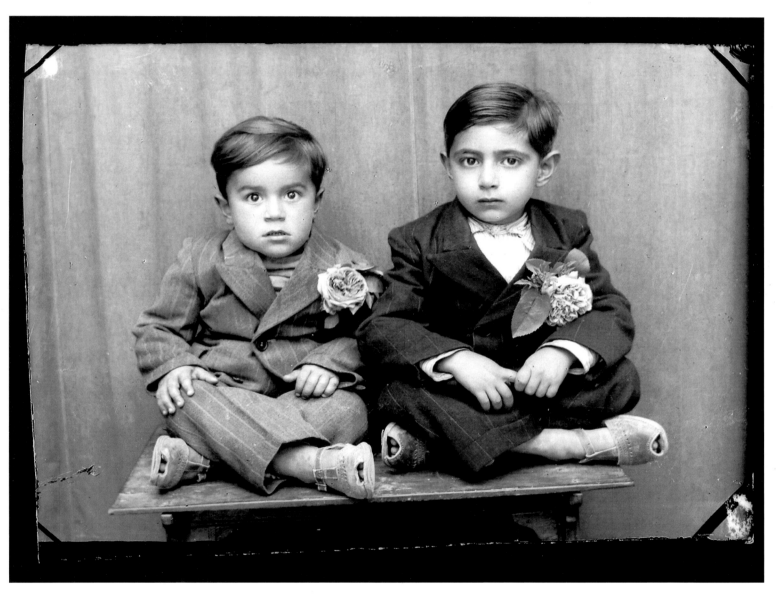

148. Untitled. Gholamhossein Derakhshan, 1952.

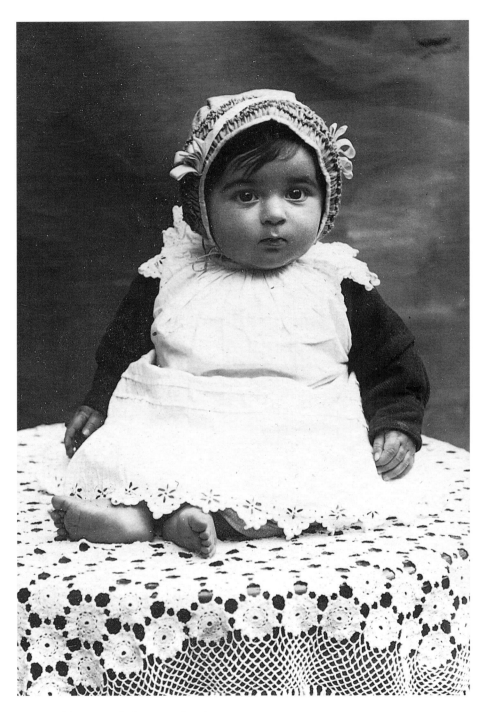

149. Untitled. Minas Patkerhanian Mackertich.

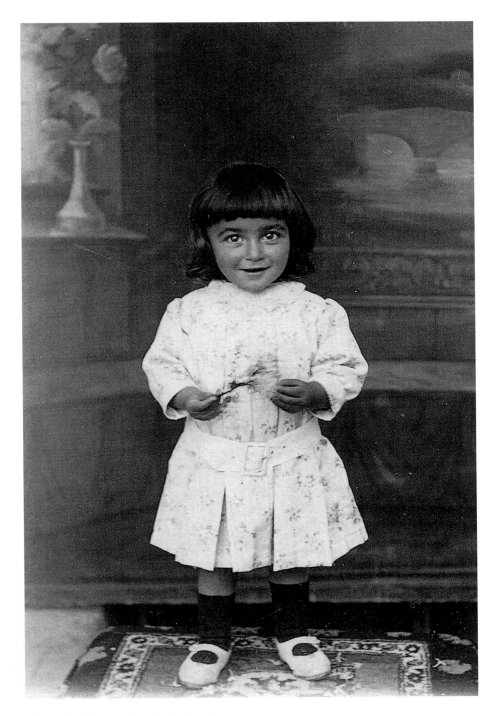

150. *Untitled. Minas Patkerhanian Mackertich.*

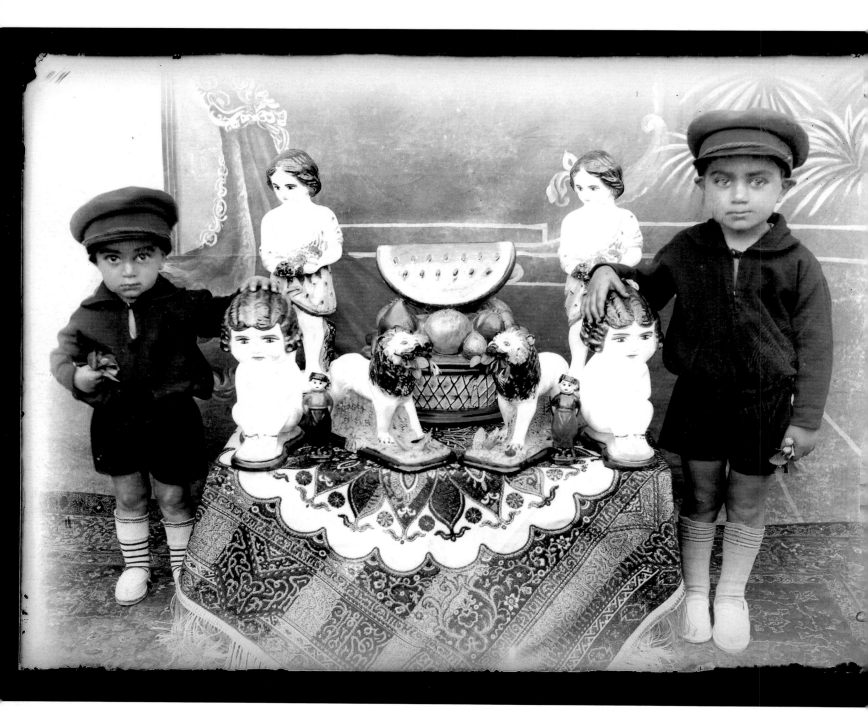

151. Untitled. Gholamhossein Derakhshan.

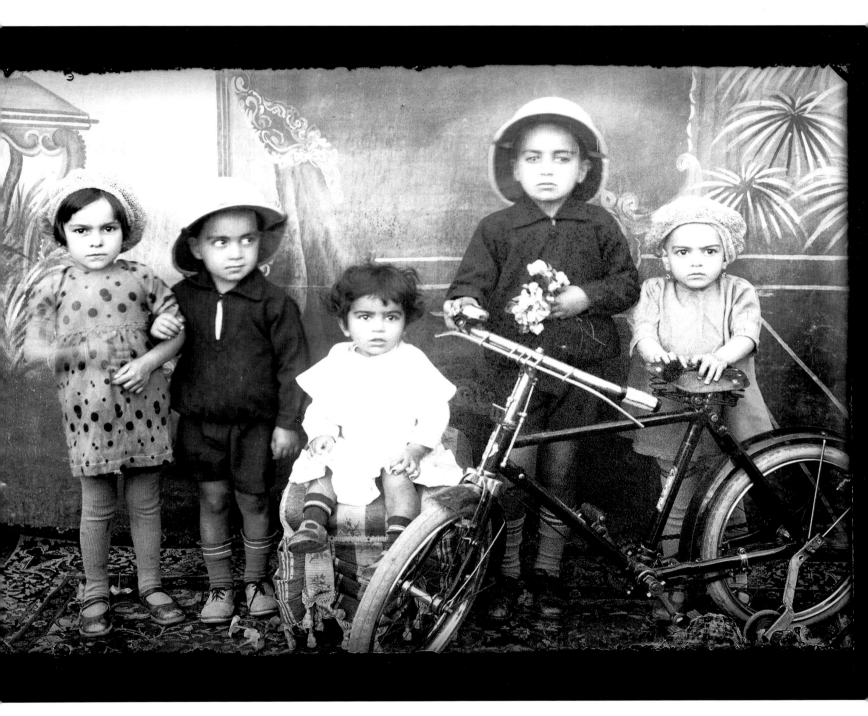

152. *Untitled. Gholamhossein Derakhshan.*

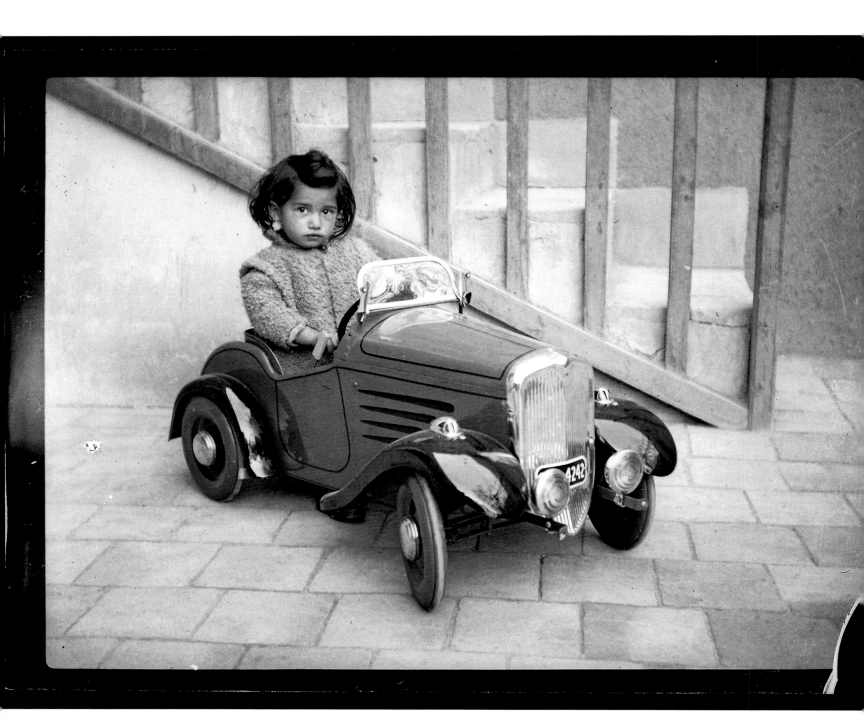

153. Untitled. Minas Patkerhanian Mackertich, 1948.

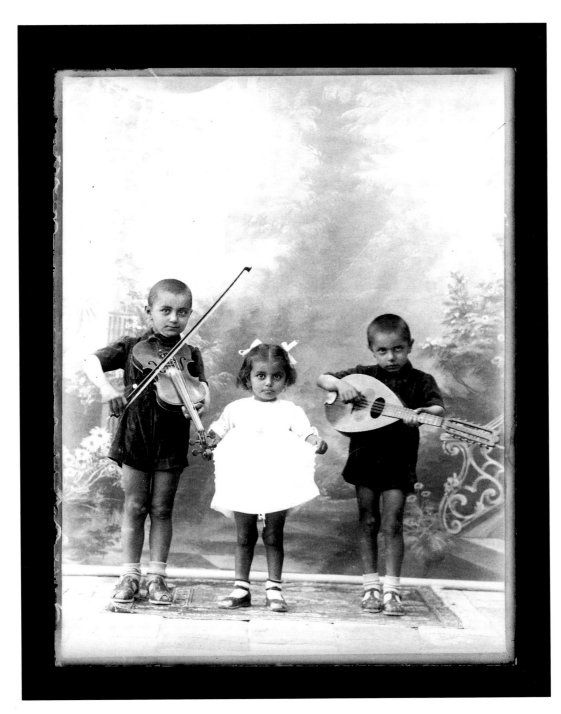

154. *Untitled. Minas Patkerhanian Mackertich.*

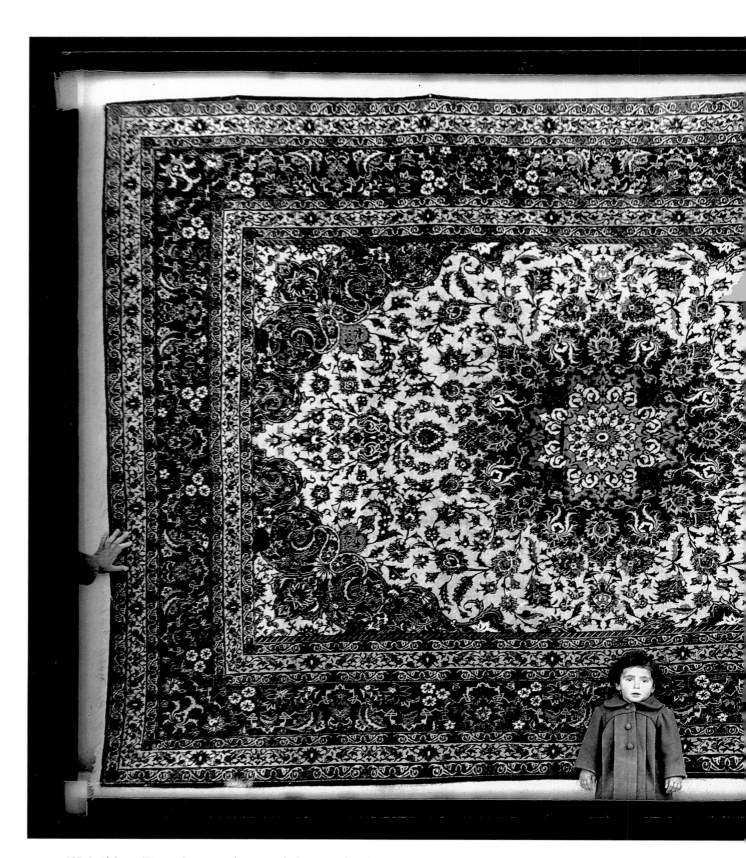

155. Javid Carpet Weaving Company Ltd. Minas Patkerhanian Mackertich.

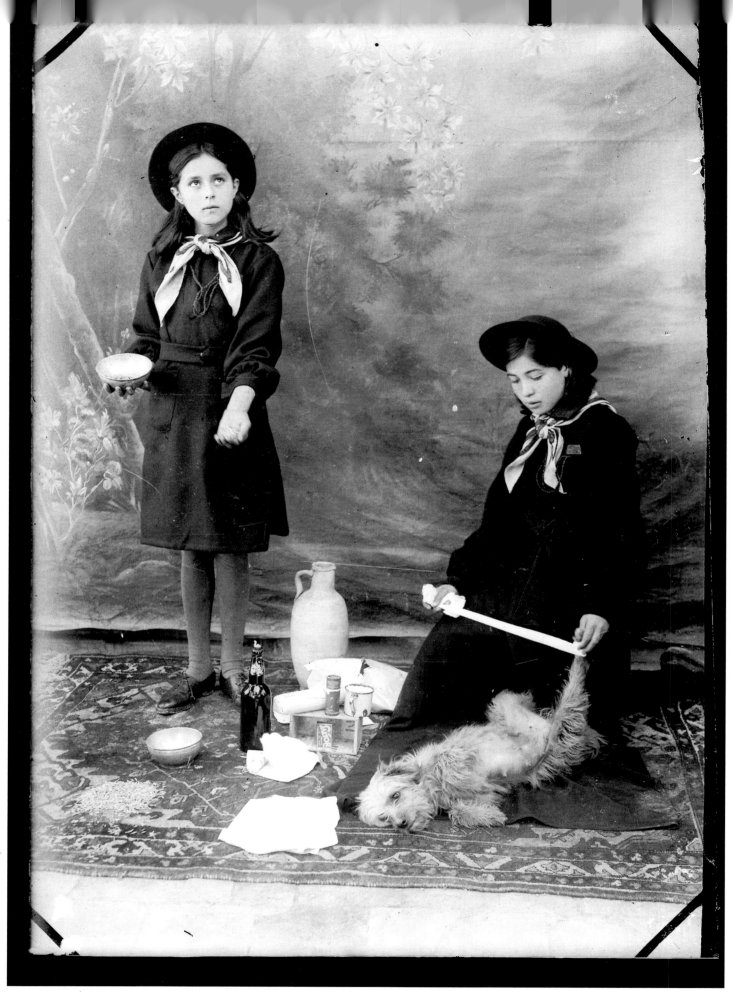

156. Untitled. Gholamhossein Derakhshan.

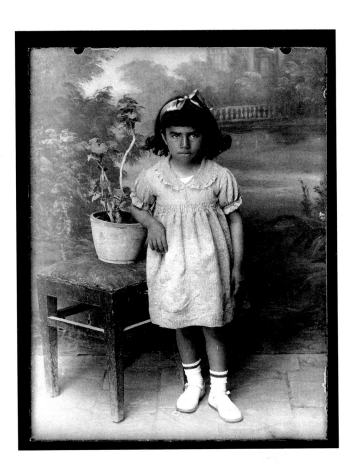

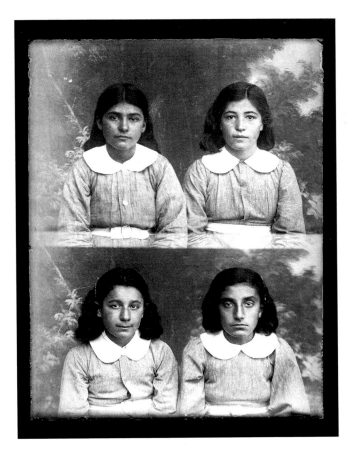

157. *Untitled. Mirza Mehdi Khan Chehreh-Nama.*

158. *Schoolgirls. Mirza Mehdi Khan Chehreh-Nama.*

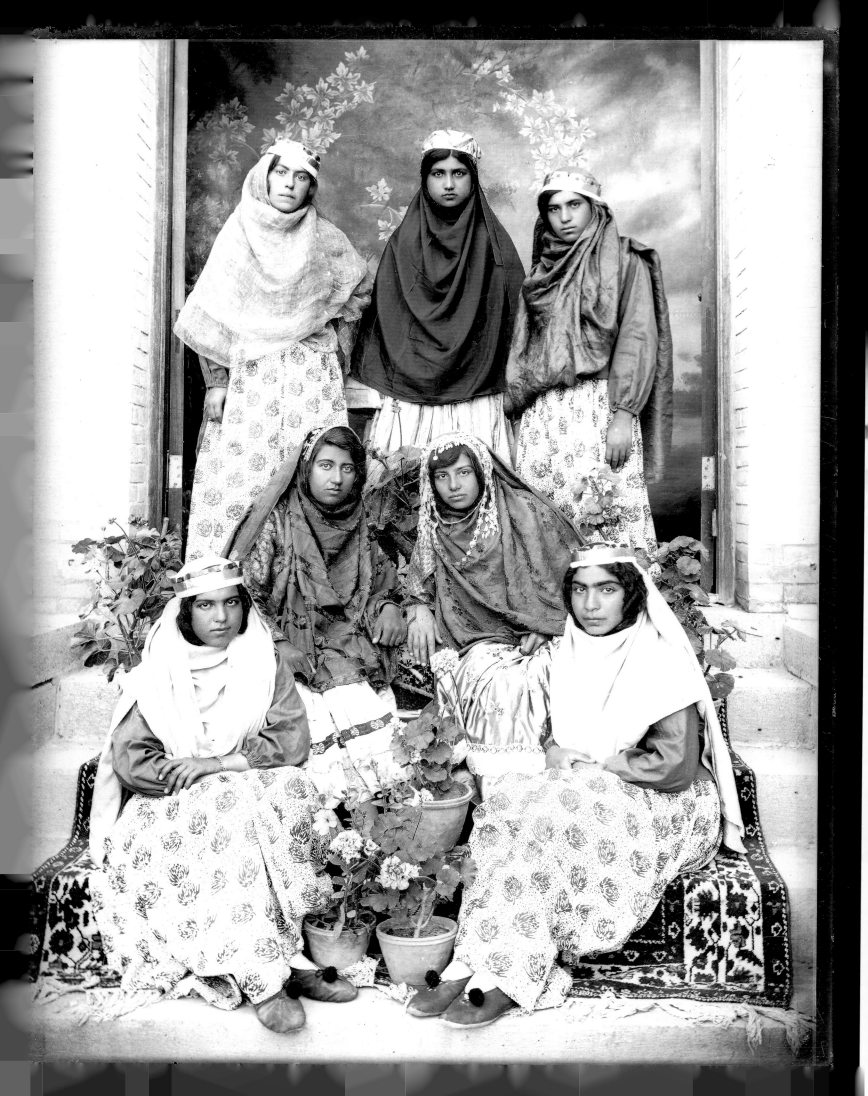

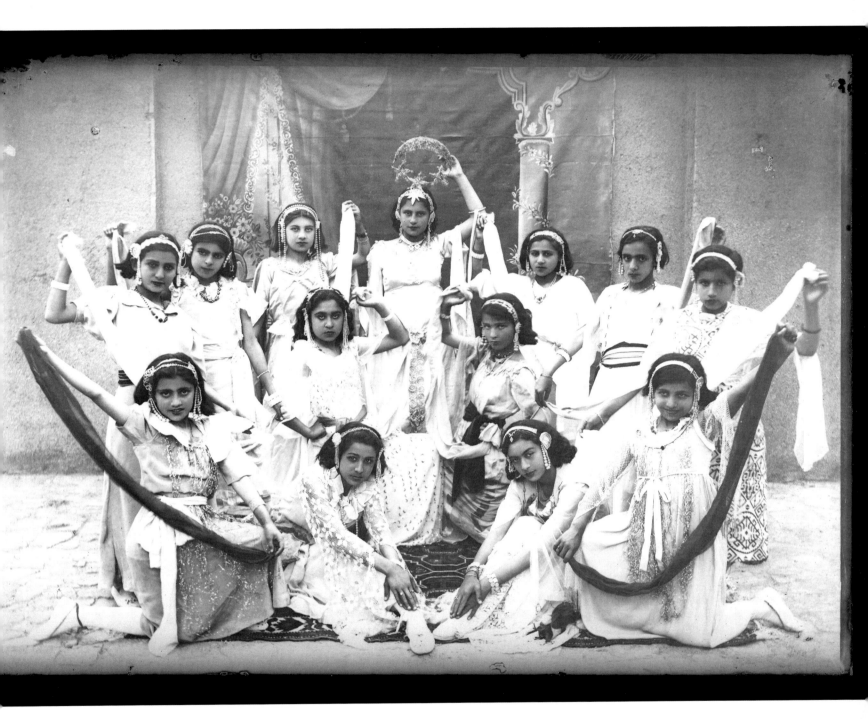

160. Untitled. Gholamhossein Derakhshan.

159. Left: Untitled. Minas Patkerhanian Mackertich.

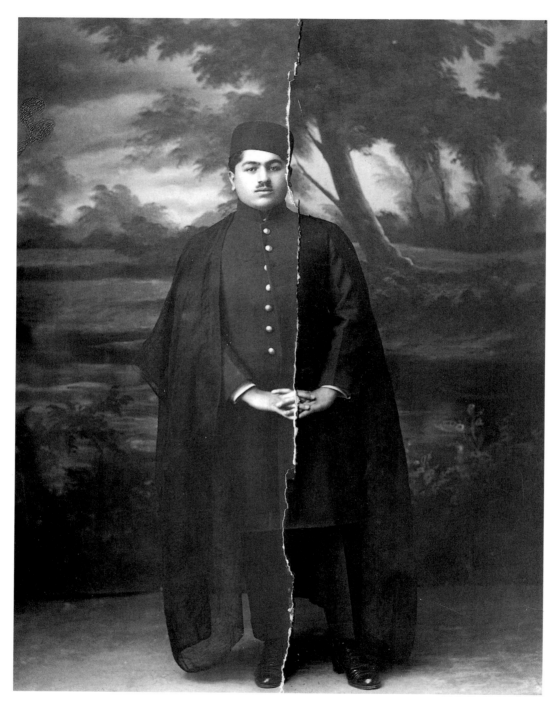

161. Untitled. Anonymous.

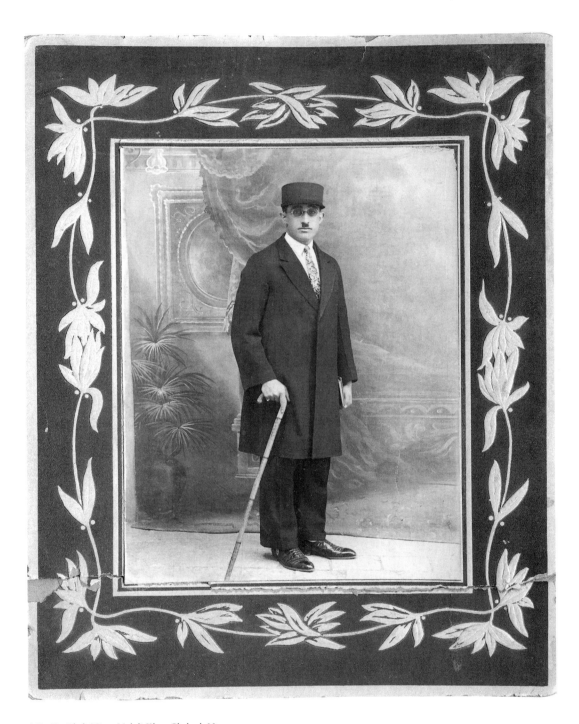

162. *Untitled. Mirza Mehdi Khan Chehreh-Nama.*

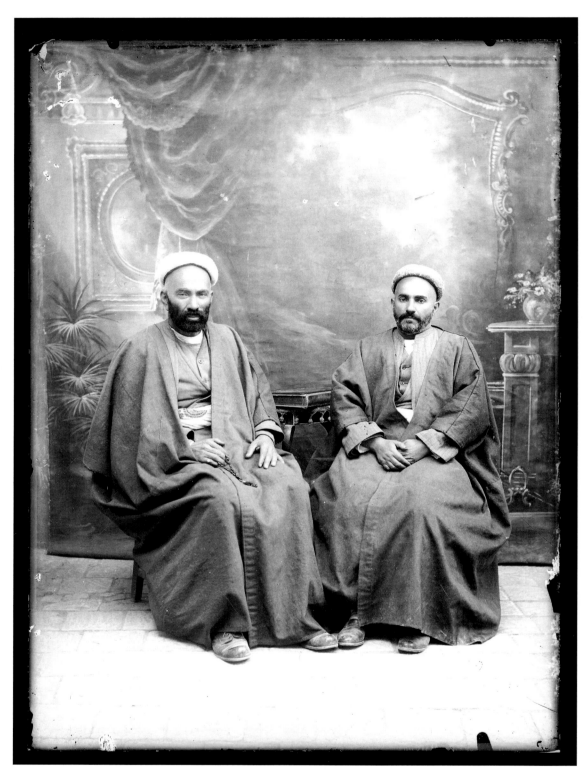

163. Untitled. Mirza Mehdi Khan Chehreh-Nama.

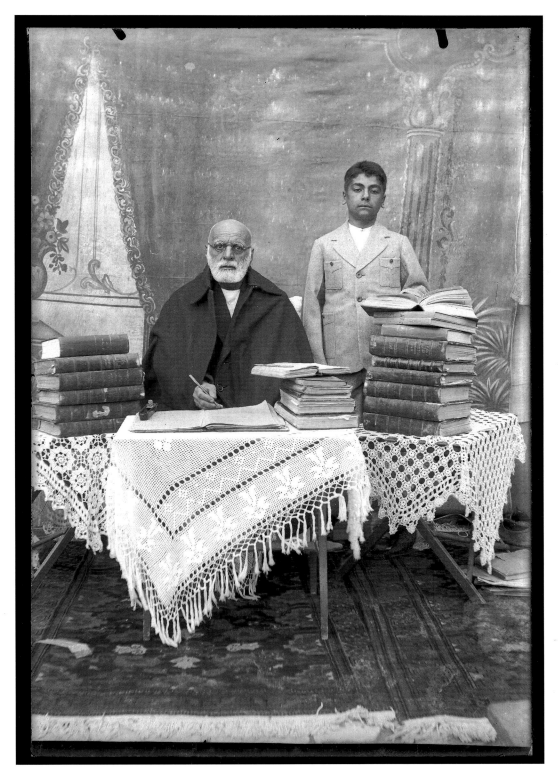

164. *Untitled. Gholamhossein Derakhshan, 1949.*

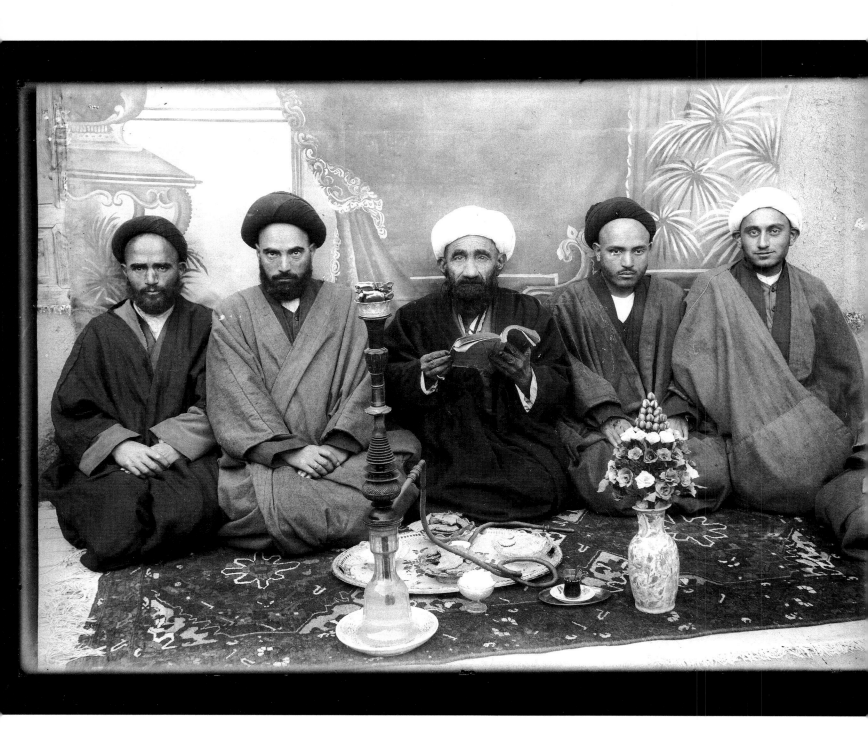

165. Untitled. Gholamhossein Derakhshan.

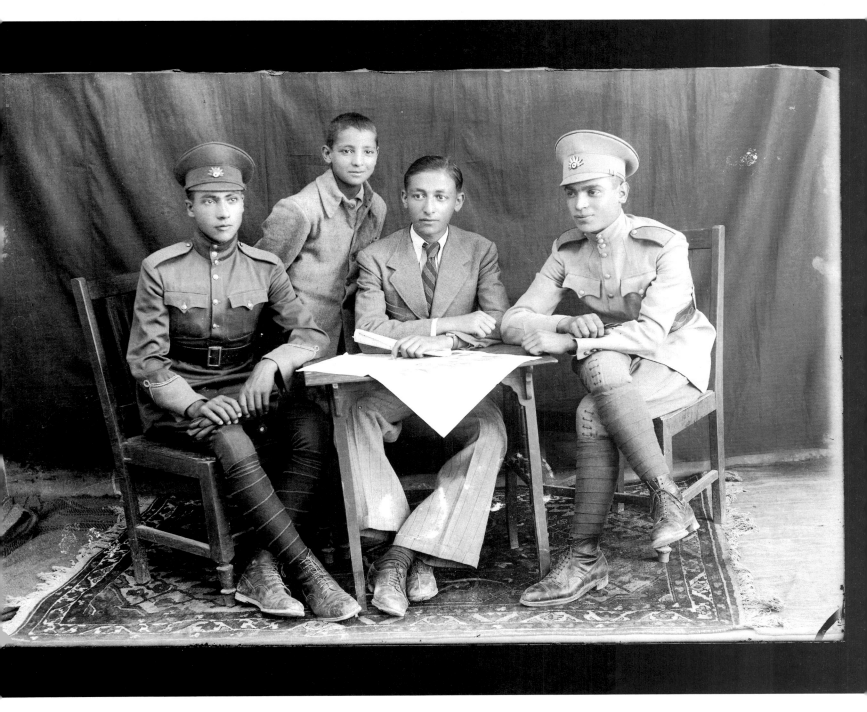

166. Untitled. Gholamhossein Derakhshan.

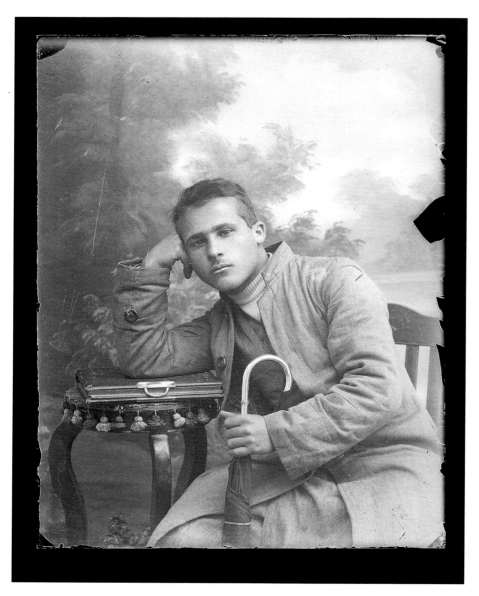

167. Untitled. Mirza Mehdi Khan Chehreh-Nama.

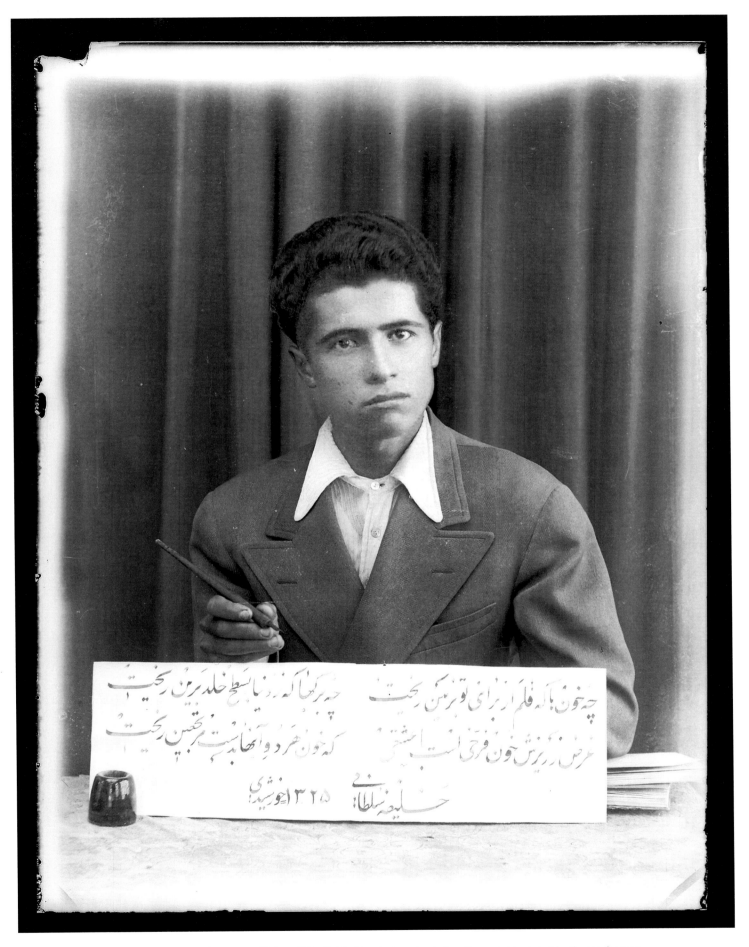

168. *Untitled. Gholamhossein Derakhshan, 1946. Original handwritten inscription: 'So much blood shed by the pen for your sake/so many leaves shed from this world onto paradise/all this because of Farrukhi and Eshghi/whose blood was shed by the reactionaries [Farrukhi and Eshghi are two twentieth-century Persian poets]. Khalifeh Soltani, 1325 Solar.'*

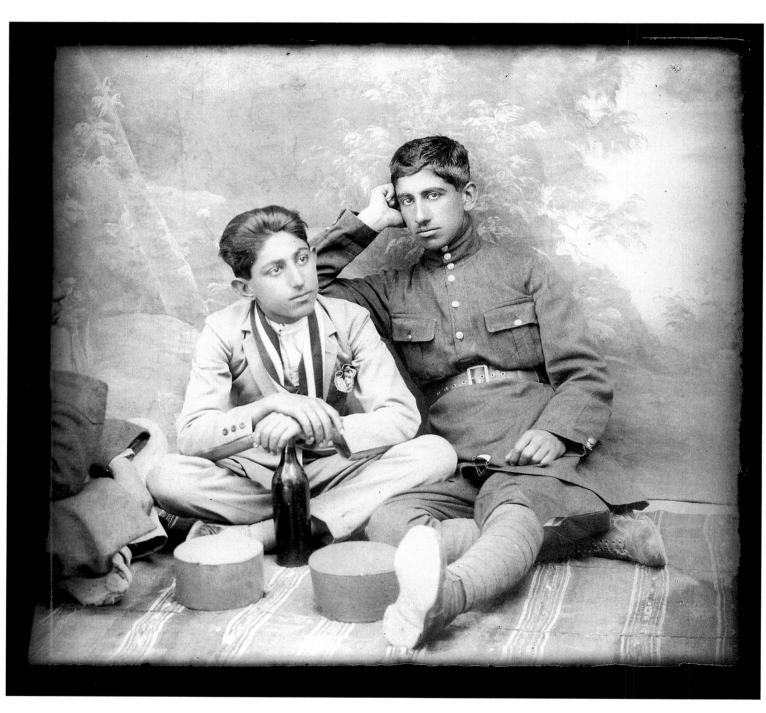

169. *Untitled. Mirza Mehdi Khan Chehreh-Nama.*

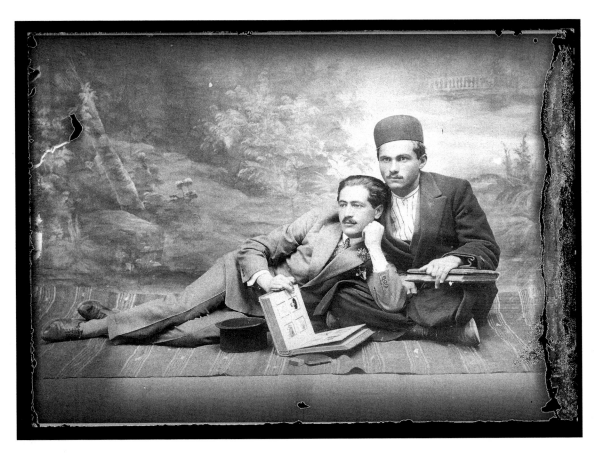

170. *Untitled. Mirza Mehdi Khan Chehreh-Nama.*

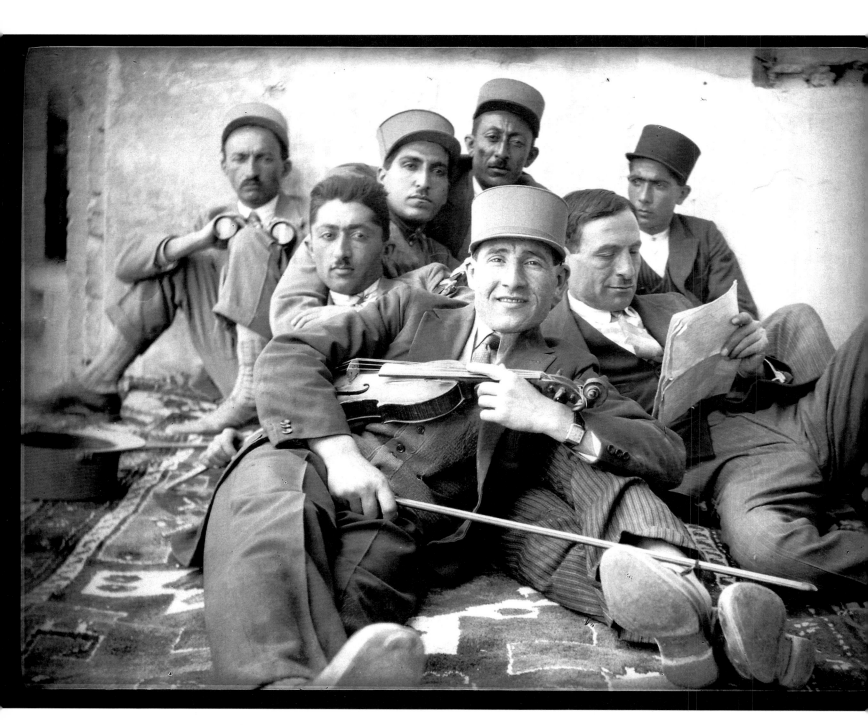

171. Untitled. Mirza Mehdi Khan Chehreh-Nama.

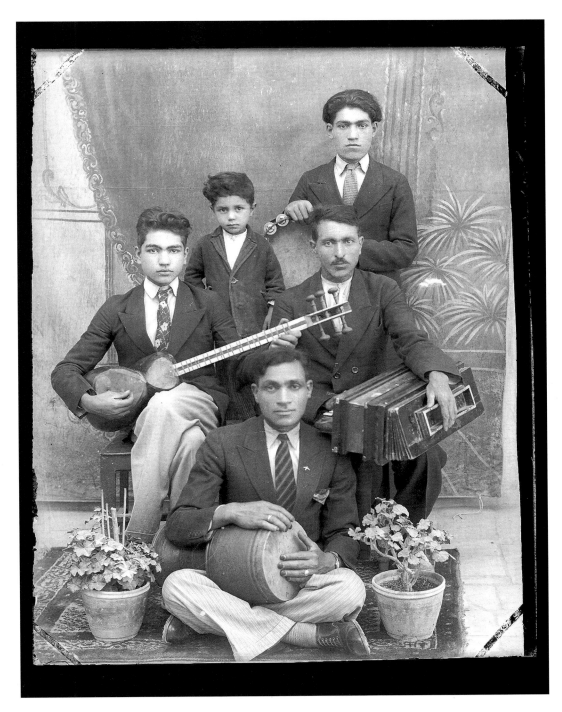

172. *Untitled. Gholamhossein Derakhshan.*

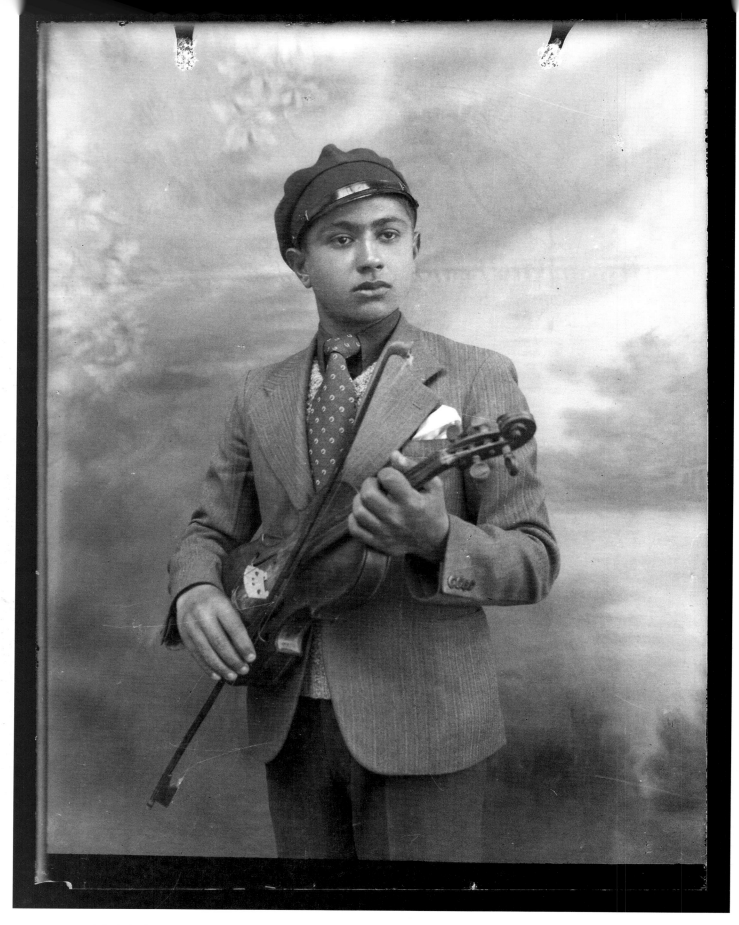

173. Untitled. Gholamhossein Derakhshan.

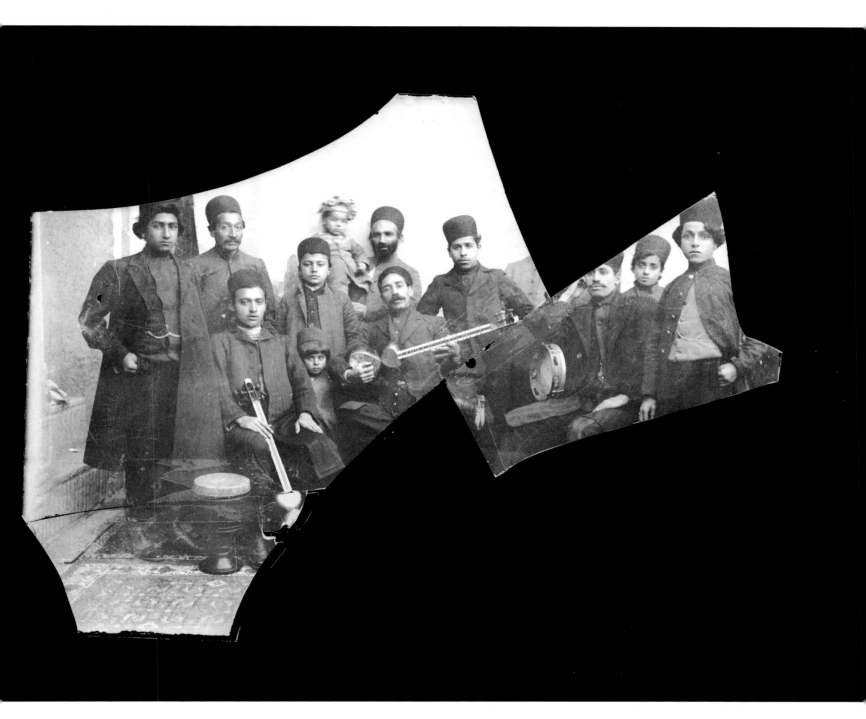

174. *Untitled. Mirza Mehdi Khan Chehreh-Nama.*

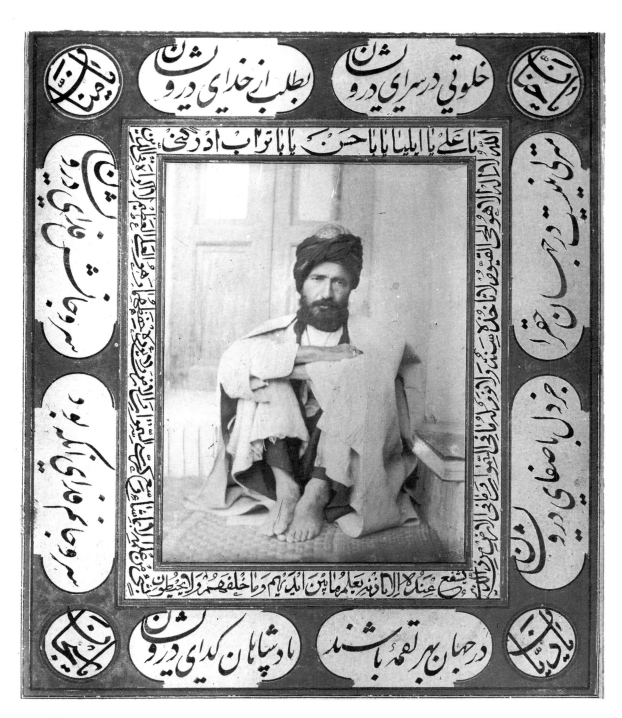

175. *Dervish. Gholamhossein Derakhshan. The continuation of the tradition of illuminating paintings with poetry, which also found its way into photo-portraiture. Original handwritten inscription: 'Pray for solace in the dervishes' abode/to the God of the dervishes/In the world has Truth no abode/other than in the pure hearts of the dervishes/For the tiniest morsels in this world/must kings beg from the dervishes/My body and soul be sacrificed/to him whose body and soul is sacrificed to the dervishes.' Four of God's names, 'the Judge', 'the Most Holy', 'the Most Compassionate' and 'the Beneficent', and several verses from the Koran, have been written around the border.*

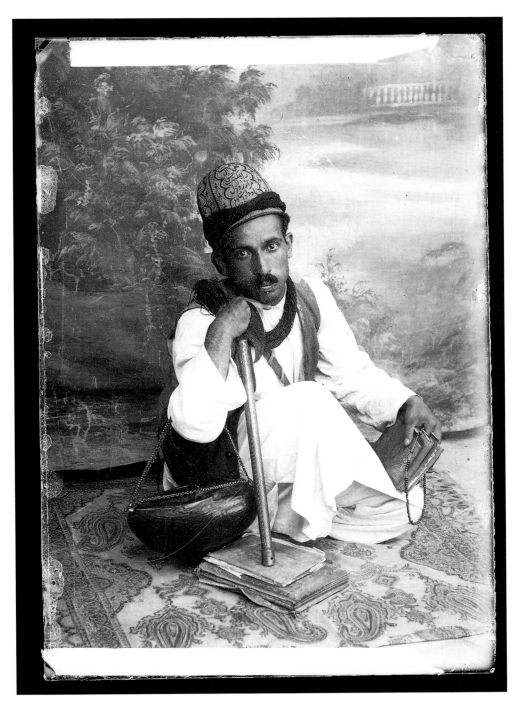

176. Dervish. Mirza Mehdi Khan Chehreh-Nama.

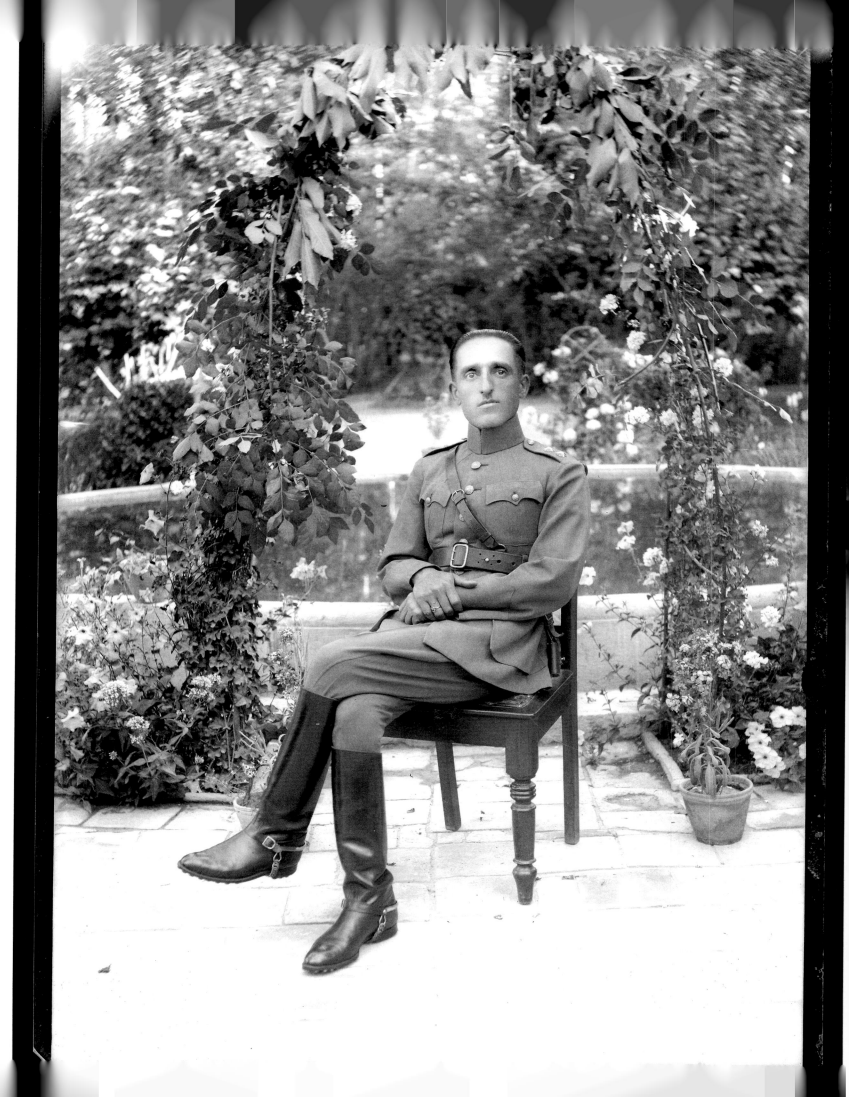

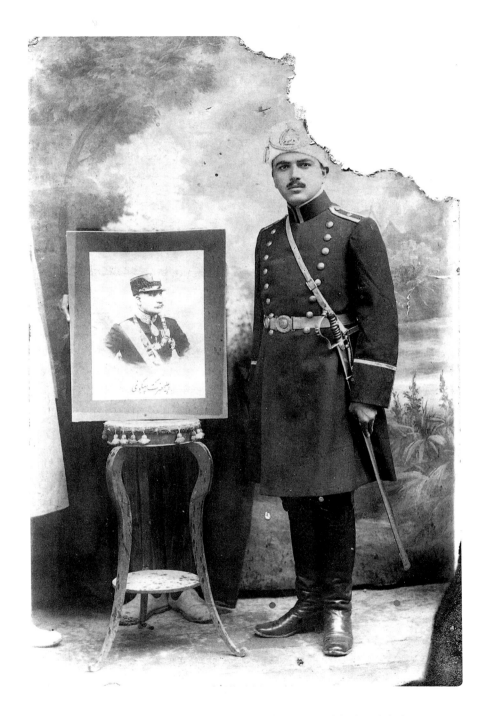

178. *Military man and the imperial figure of Reza Shah Pahlavi. Mirza Mehdi Khan Chehreh-Nama.*

177. *Left: Military man. Gholamhossein Derakhshan.*

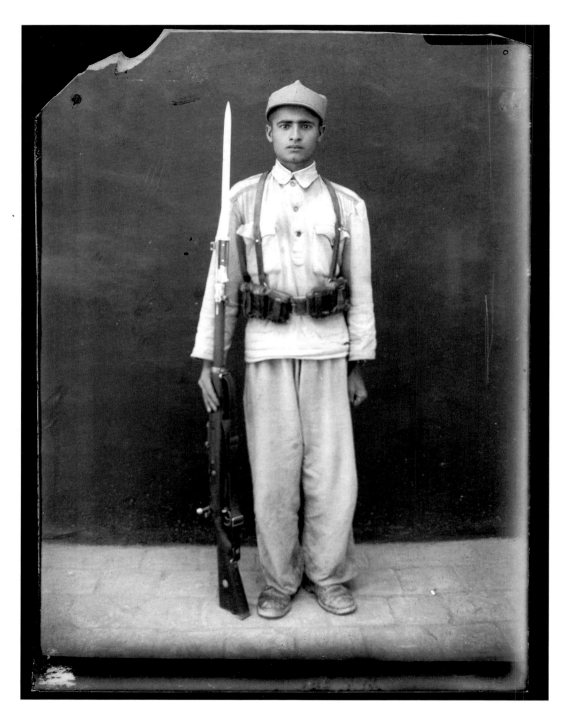

179. *Military man. Gholamhossein Derakhshan.*

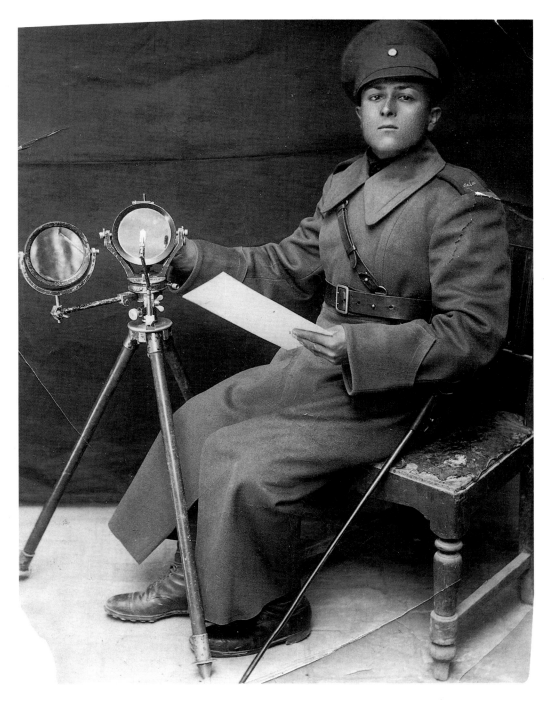

180. *Military man and surveying instrument. Mirza Mehdi Khan Chehreh-Nama.*

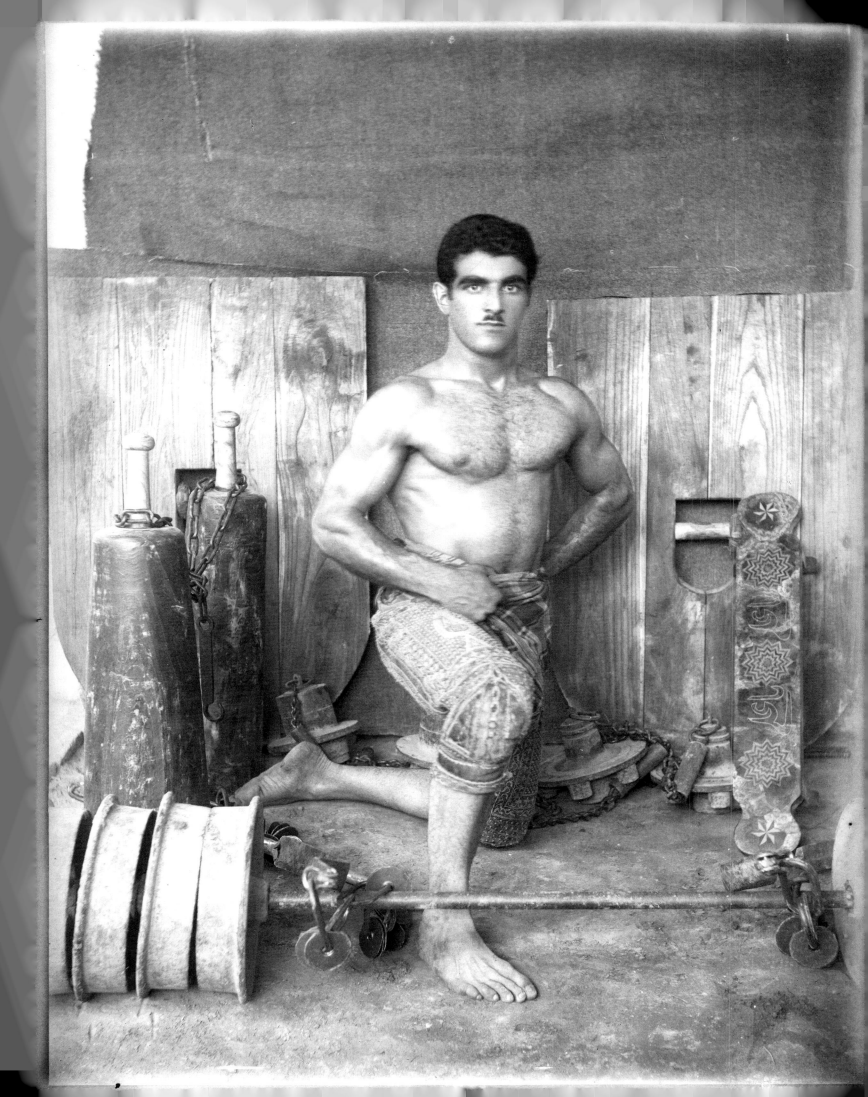

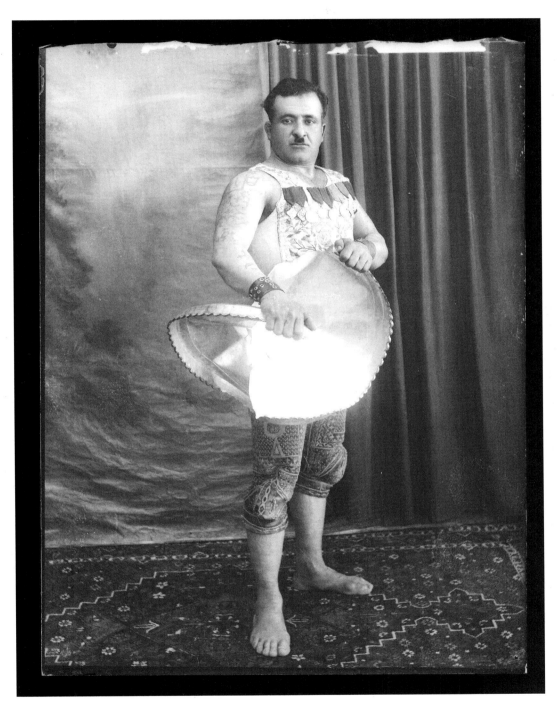

181–182. Traditional sportsman. Gholamhossein Derakhshan.

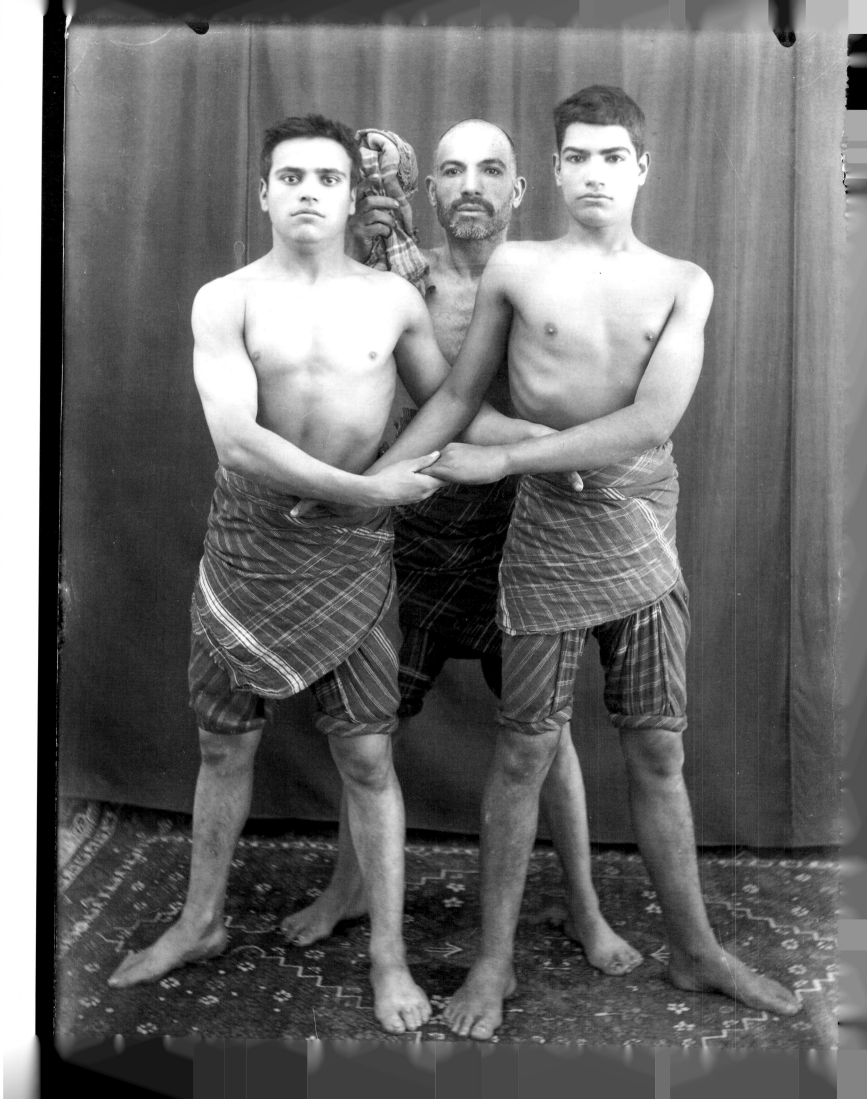

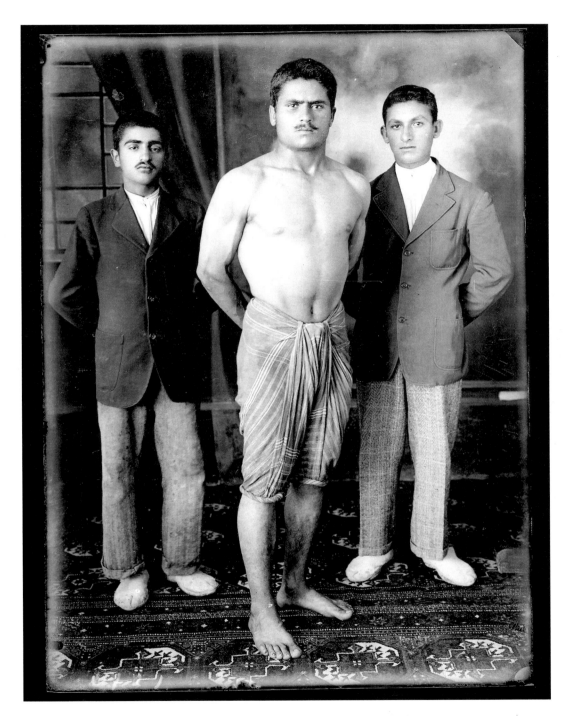

184. *Traditional sportsman with companions. Abolqasem Jala.*

183. *Left: Traditional sportsmen. Gholamhossein Derakhshan.*

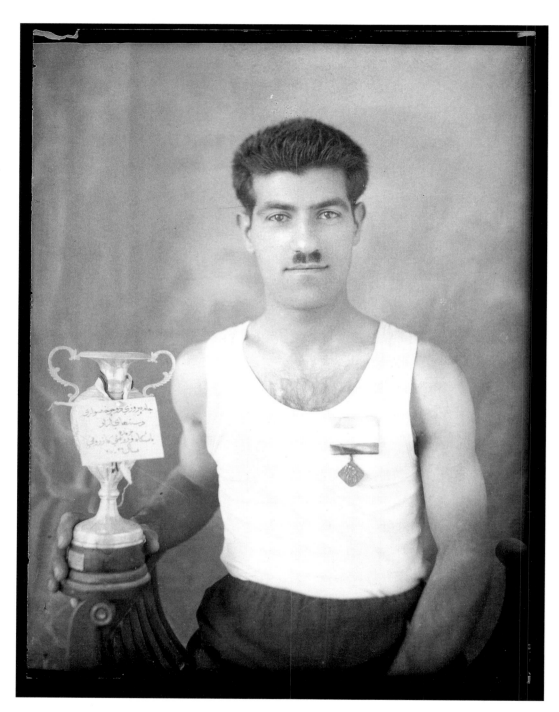

185. *Cycling champion. Minas Patkerhanian Mackertich, 1949.*

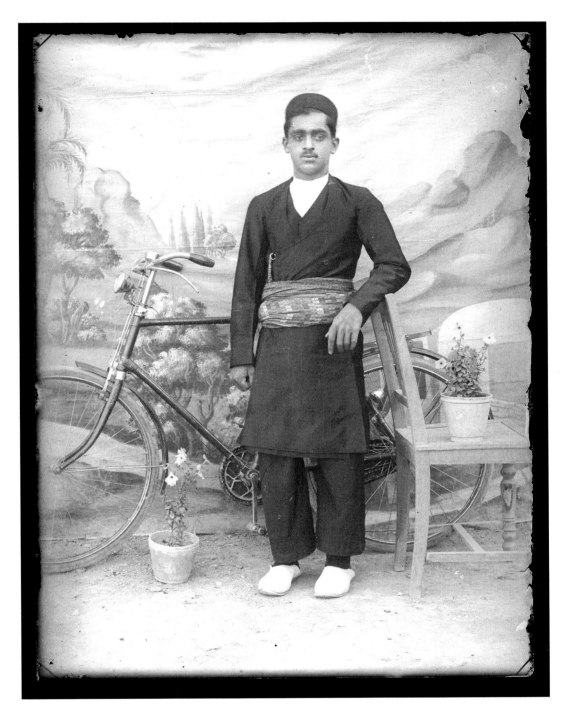

186. *Untitled. Gholamhossein Derakhshan.*

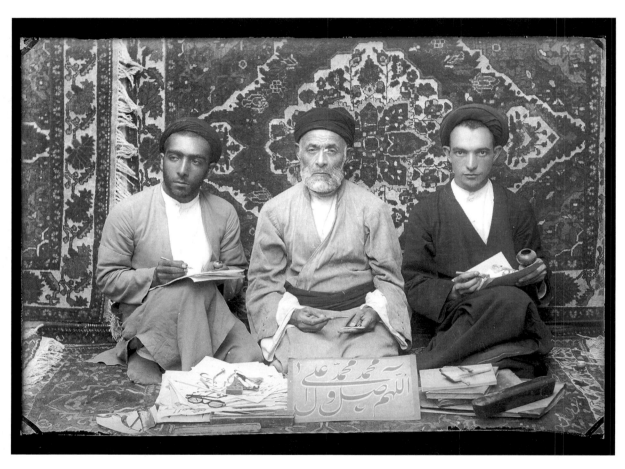

187. Calligraphers. Gholamhossein Derakhshan.

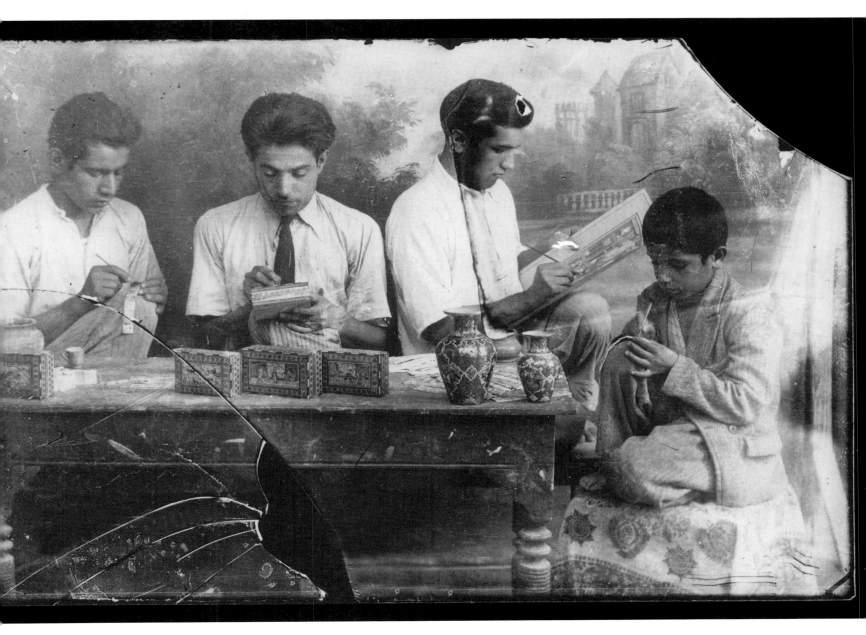

188. *Handicrafts painters. Mirza Mehdi Khan Chehreh-Nama.*

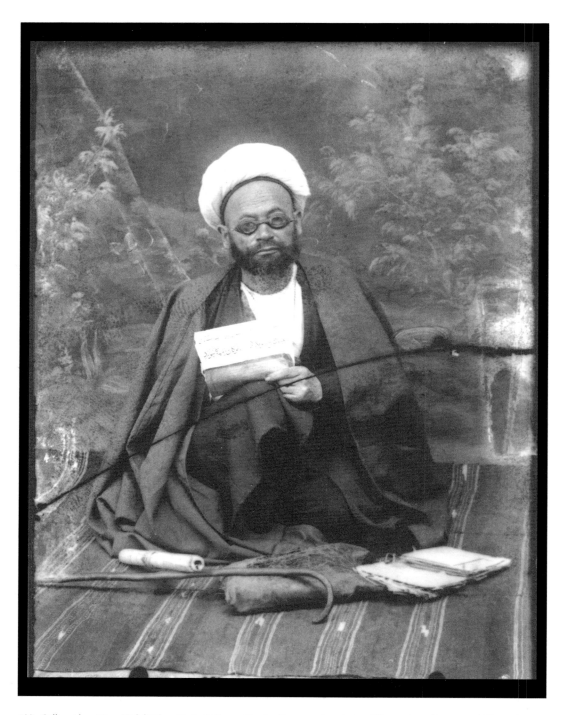

189. *Calligrapher. Mirza Mehdi Khan Chehreh-Nama. Handwritten verse inscription: 'Tis not chess, for you to deliberate/trust in God and roll the dice.'*

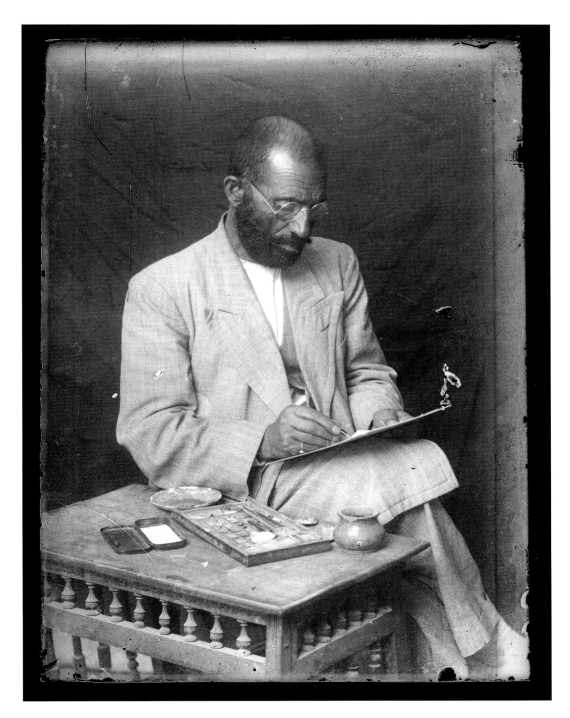

190. *Painter. Mirza Mehdi Khan Chehreh-Nama.*

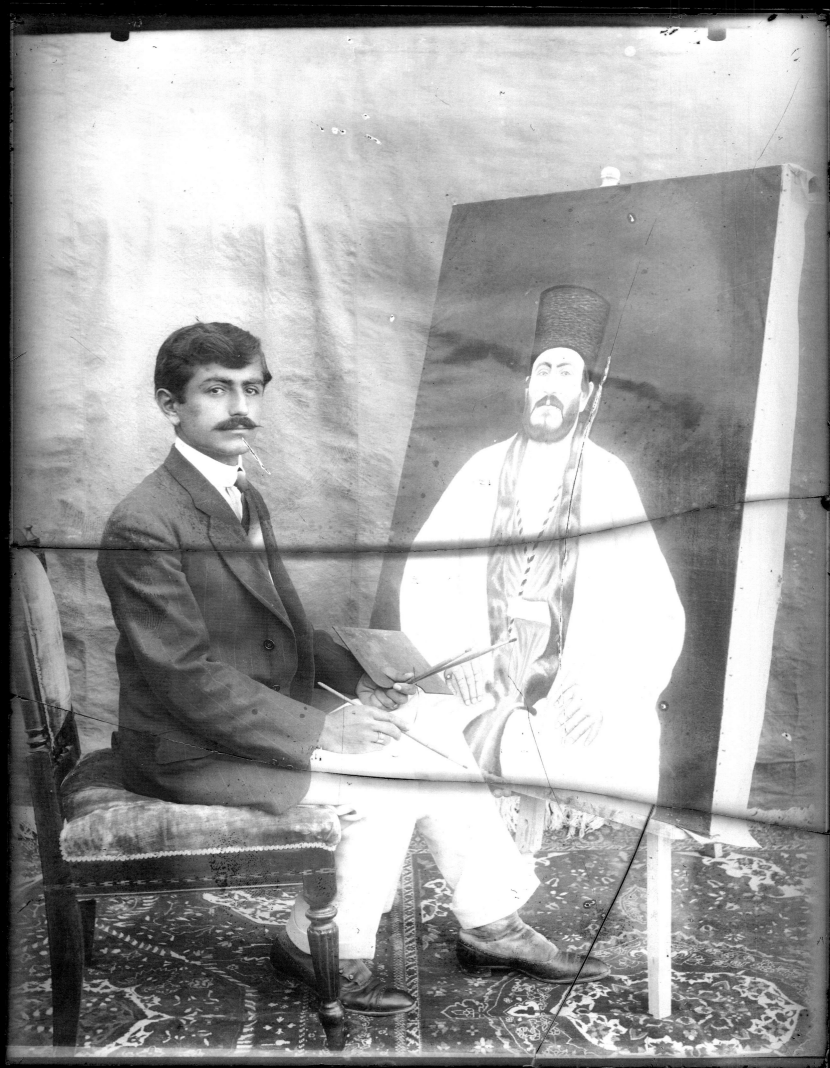

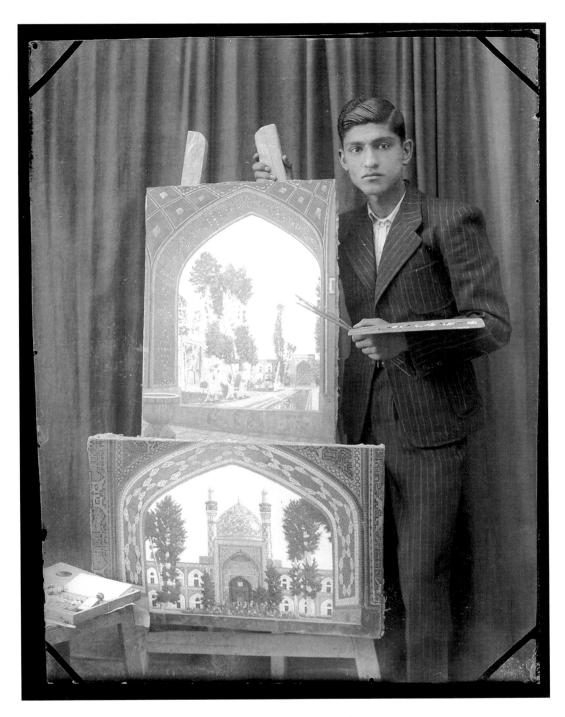

192. *The painter and photographer, Amanollah Tariqi. Gholamhossein Derakhshan.*

191. *Left: Muhammad Khan Ass'ad, Kamal al-Molk's student at the School of Fine Arts, while painting the face of Hossein Qoli Khan Ilkhani (Qashqai tribal chief). Mirza Mehdi Khan Chehreh-Nama, 1915.*

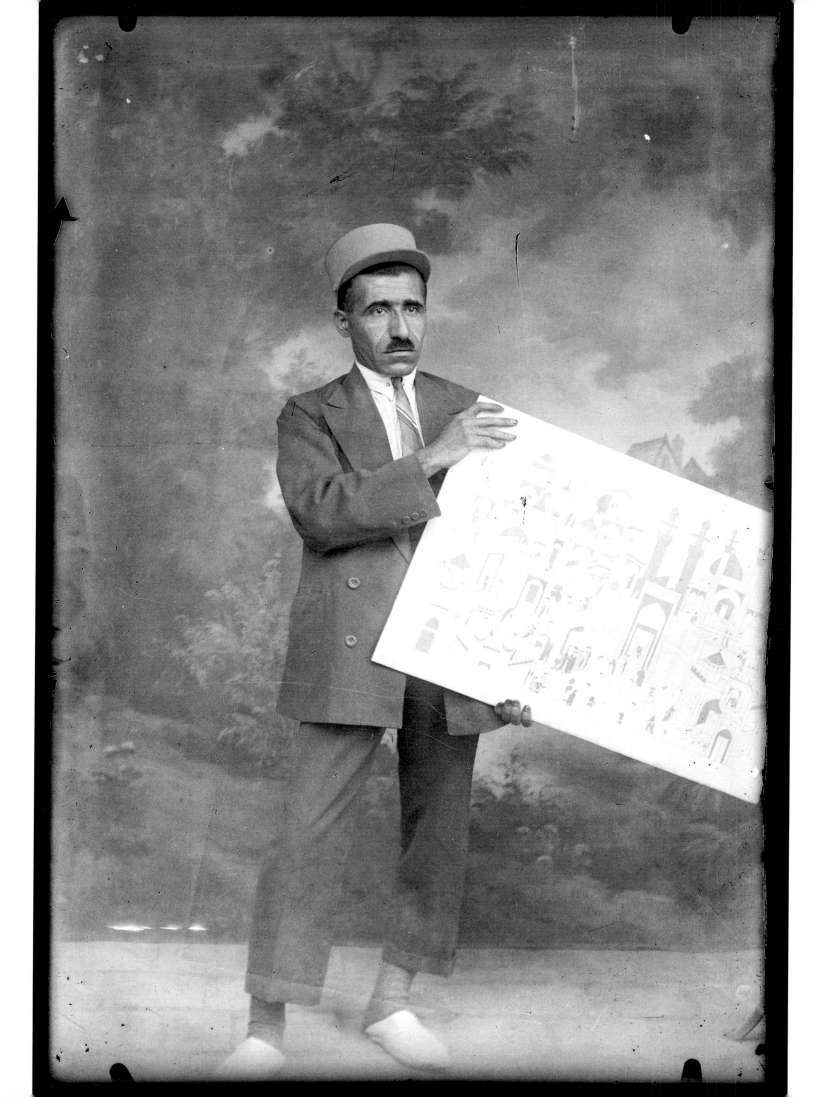

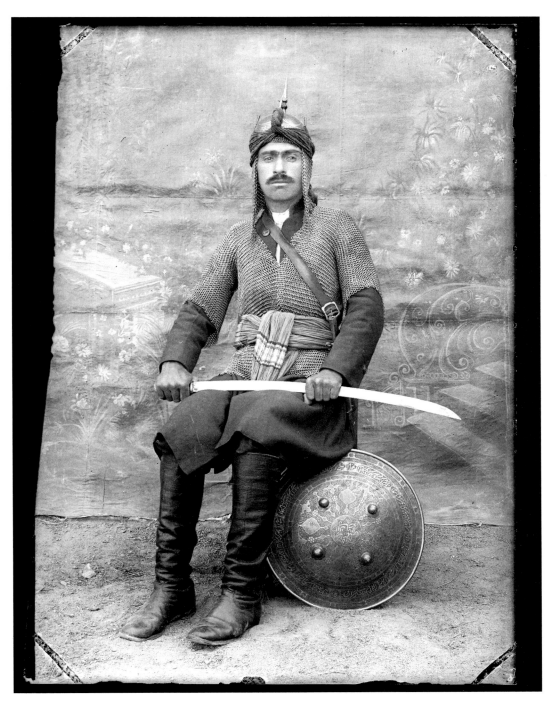

194. Taziyeh *(Passion play) actor.* Gholamhossein Derakhshan.

193. Left: Painter. Mirza Mehdi Khan Chehreh-Nama.

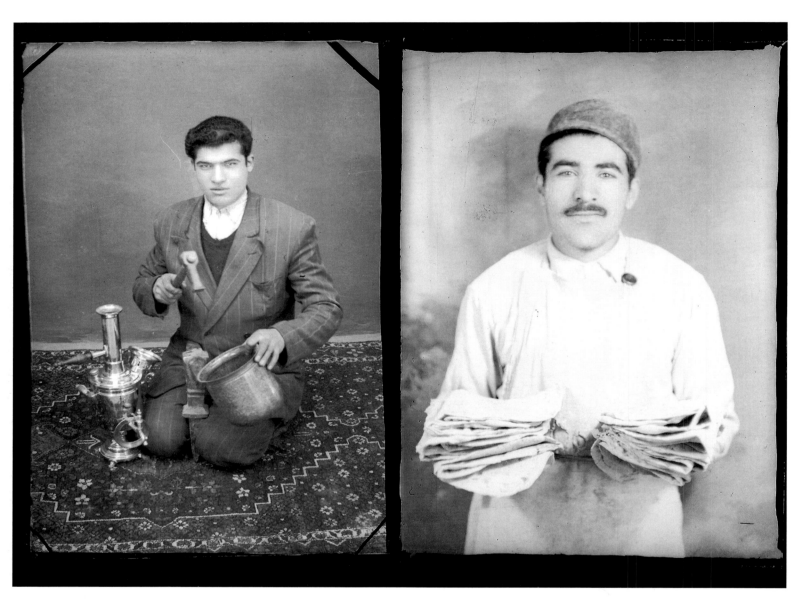

195. *Blacksmith. Gholamhossein Derakhshan.*

196. *Baker. Minas Patkerhanian Mackertich, 1952.*

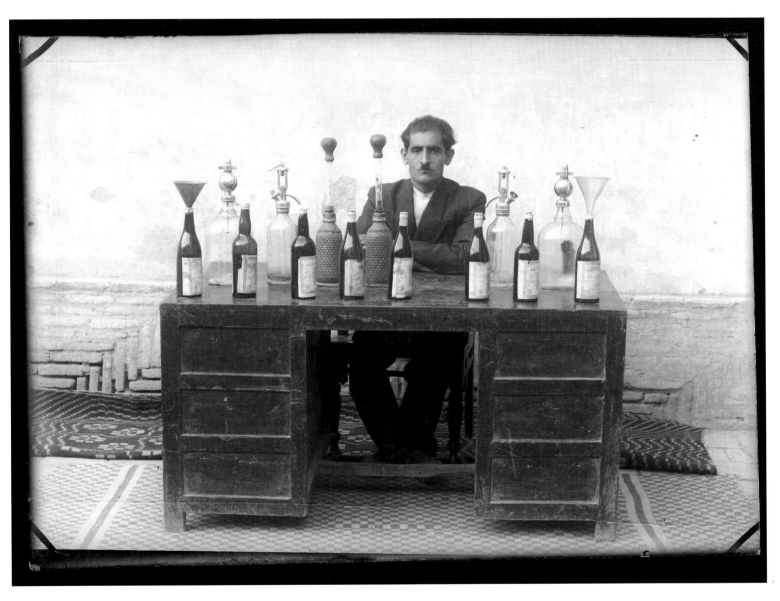

197. *Manufacturer of distilled water for batteries. Gholamhossein Derakhshan.*

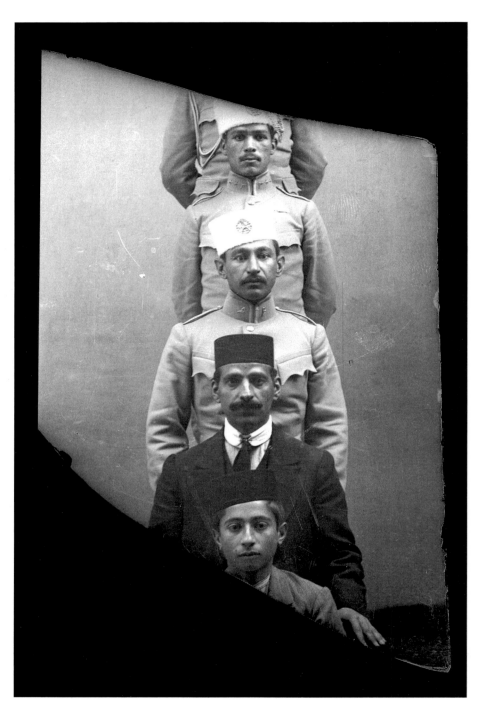

198. *Military men. Mirza Mehdi Khan Chehreh-Nama.*

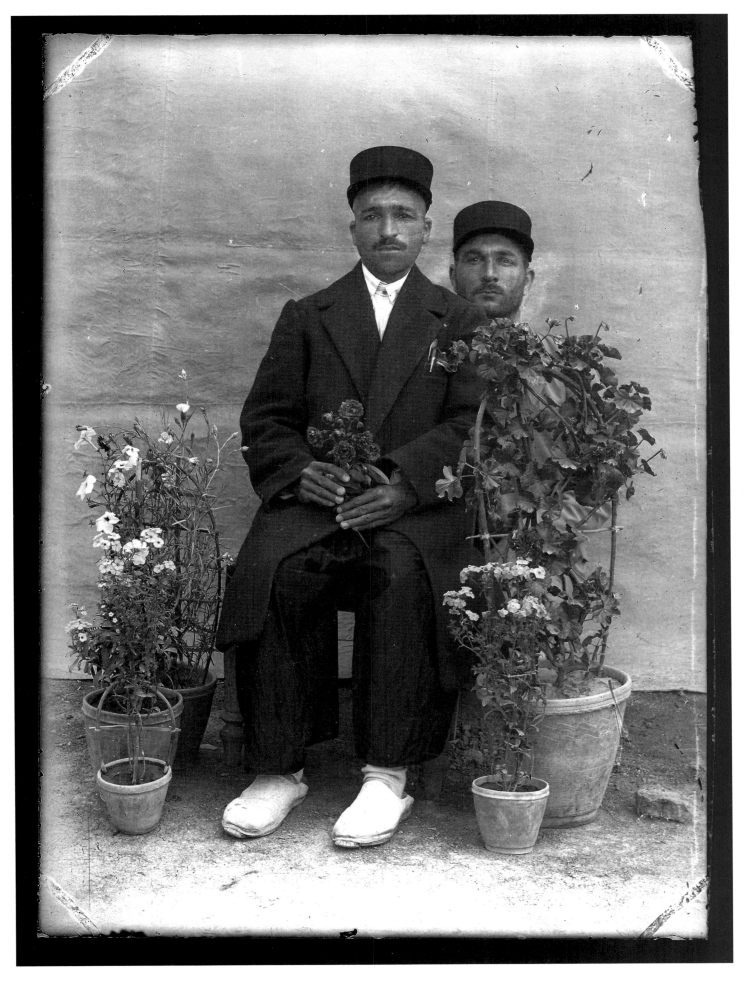

199. *Untitled. Gholamhossein Derakhshan.*

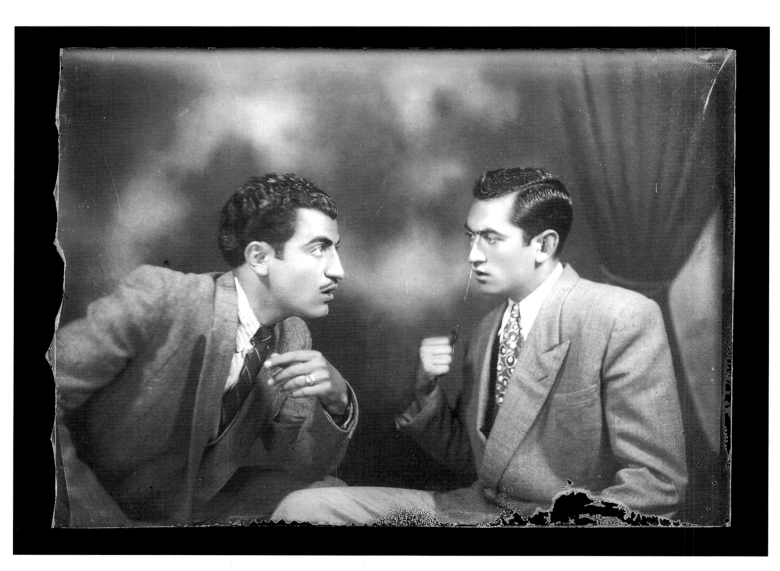

200. Untitled. Gholamhossein Derakhshan, 1950s.

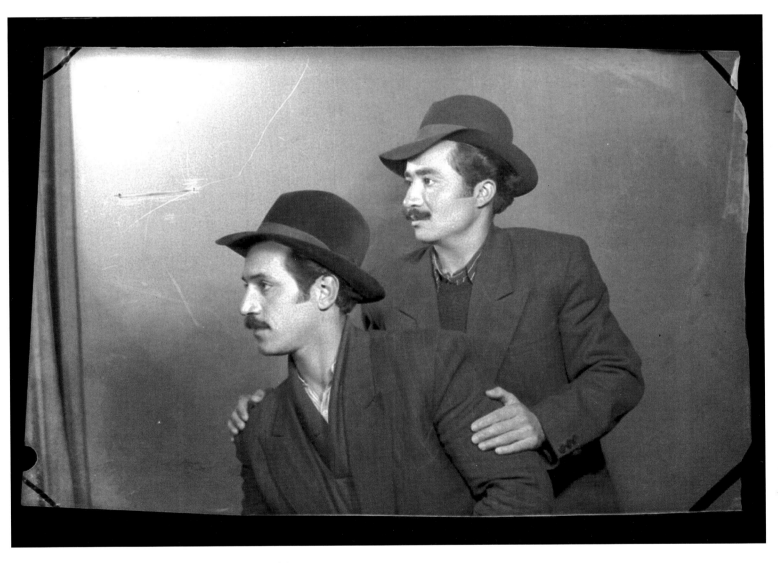

201. *Untitled. Gholamhossein Derakhshan, 1950s.*

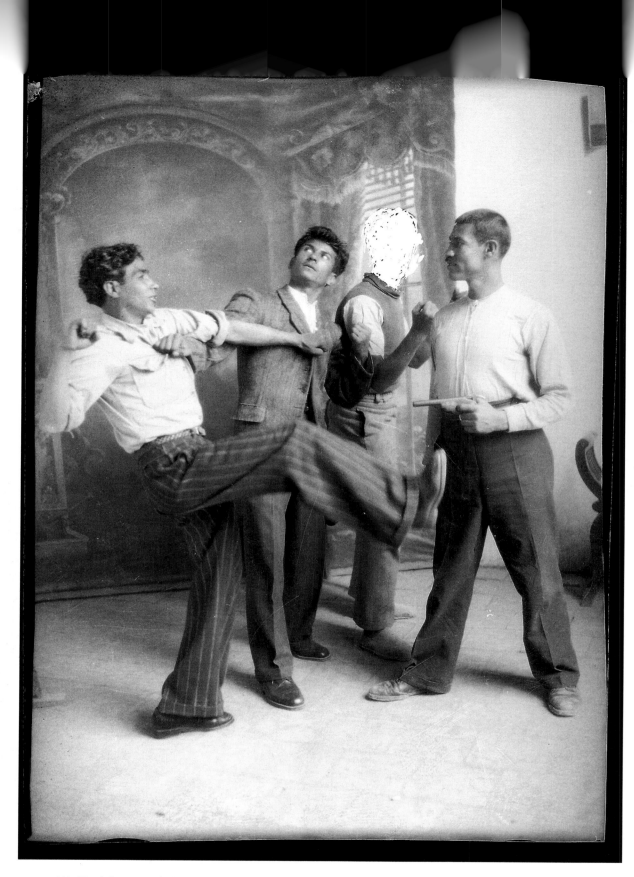

202. *Untitled. Minas Patkerhanian Mackertich.*

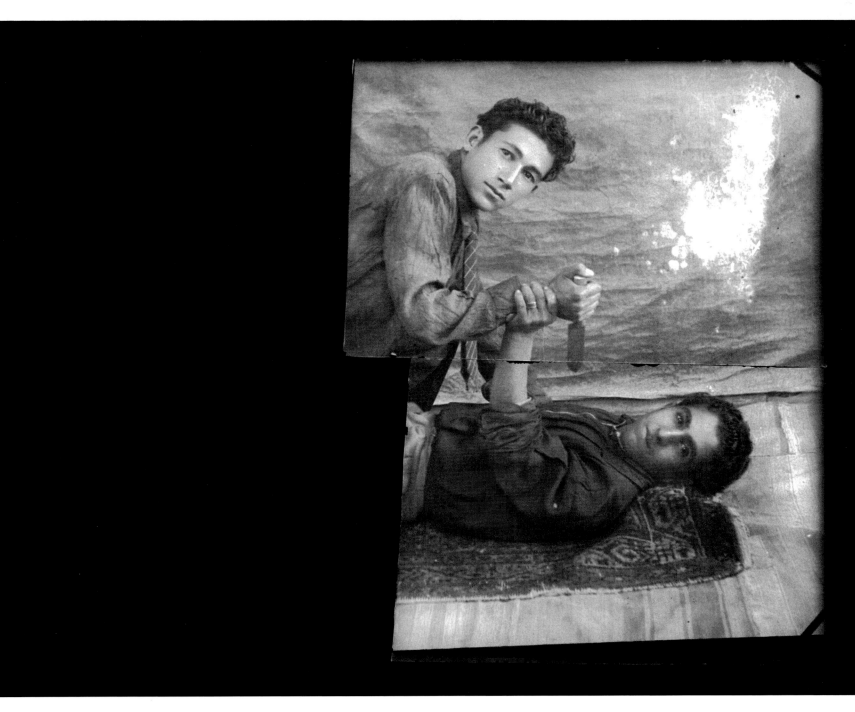

203. *Untitled. Gholamhossein Derakhshan, 1954.*

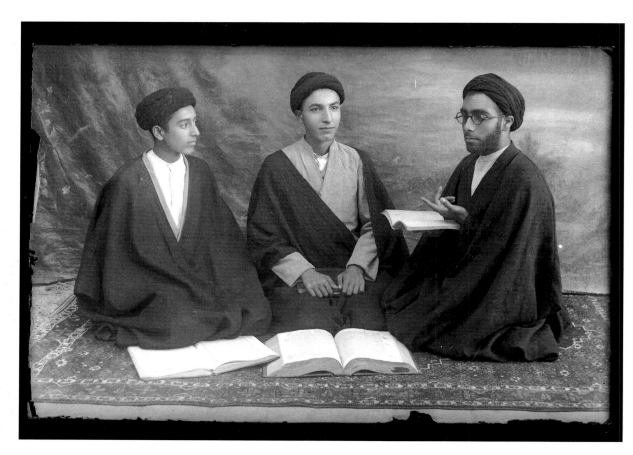

204. Clerics. Gholamhossein Derakhshan.

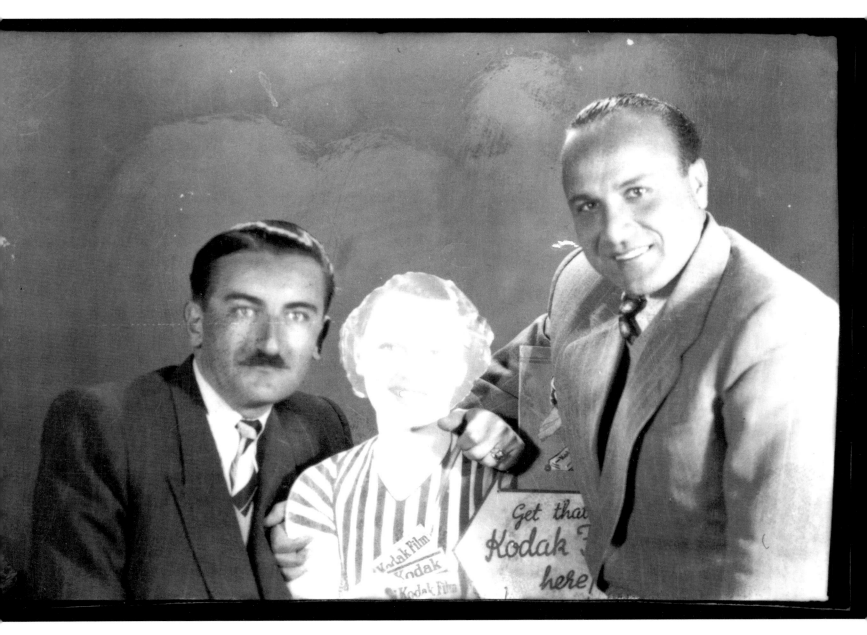

205. *Untitled. Vahan Patkerhanian Mackertich, 1950s.*

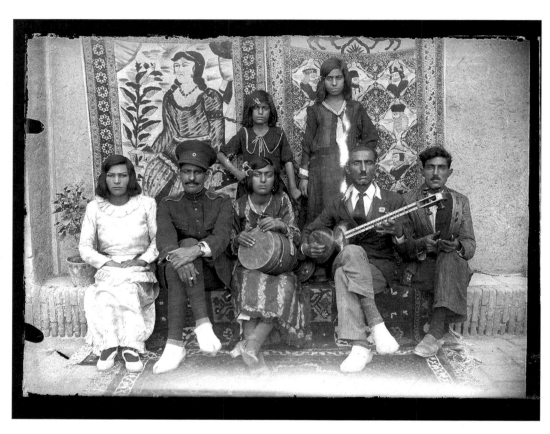

206. Untitled. Gholamhossein Derakhshan.

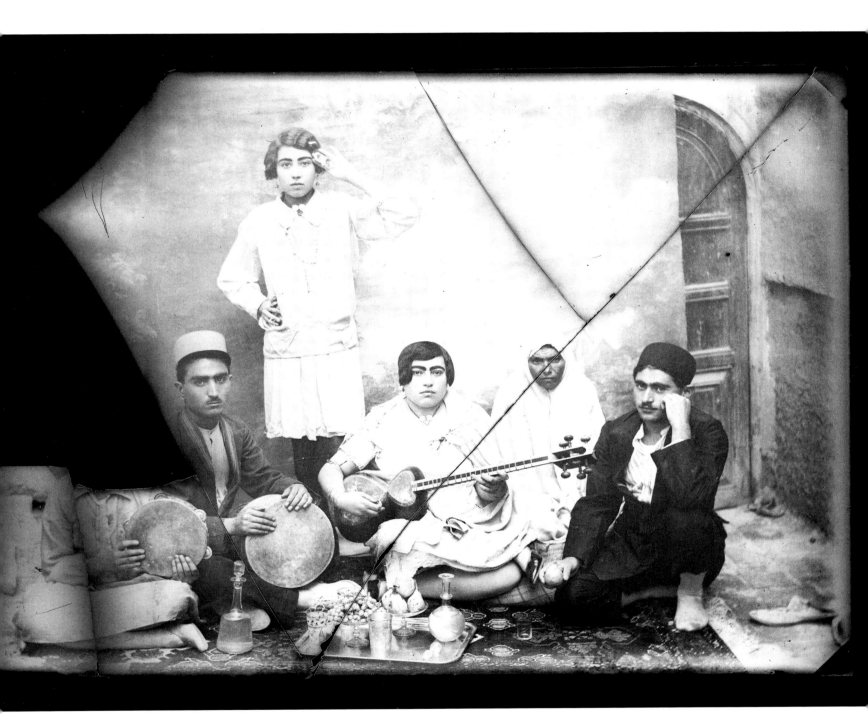

207. *Untitled. Mirza Mehdi Khan Chehreh-Nama.*

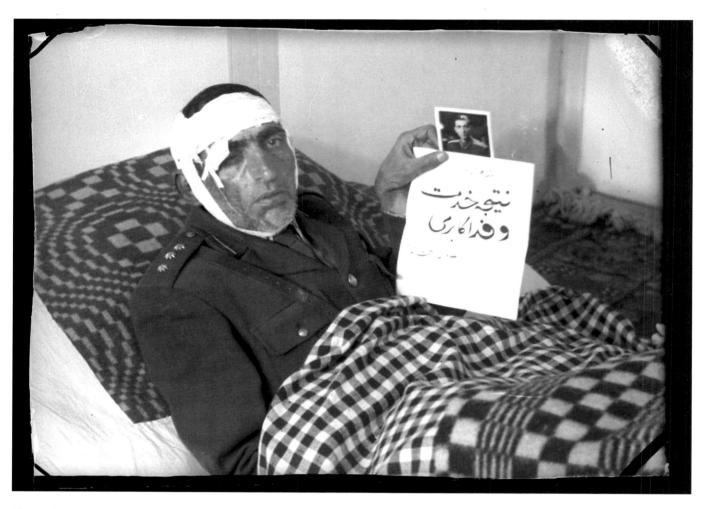

208. *Handwritten note: 'Your Imperial Highness, the result of service and selflessness (Captain Jamshidi)'. Gholamhossein Derakhshan.*

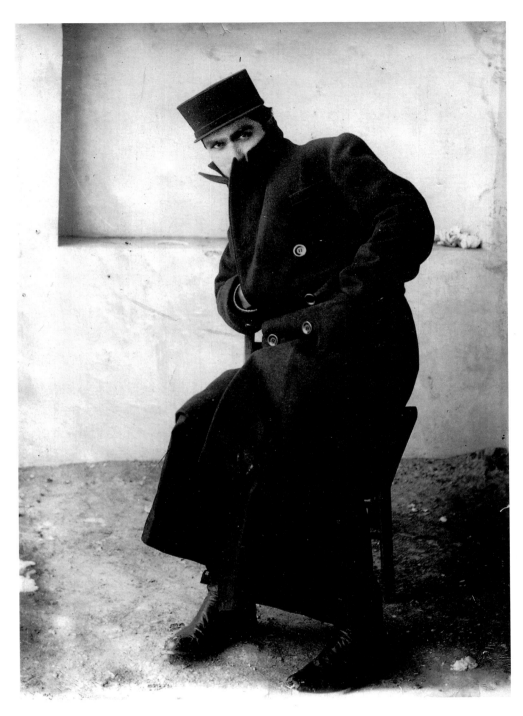

209. *Untitled. Anonymous.*

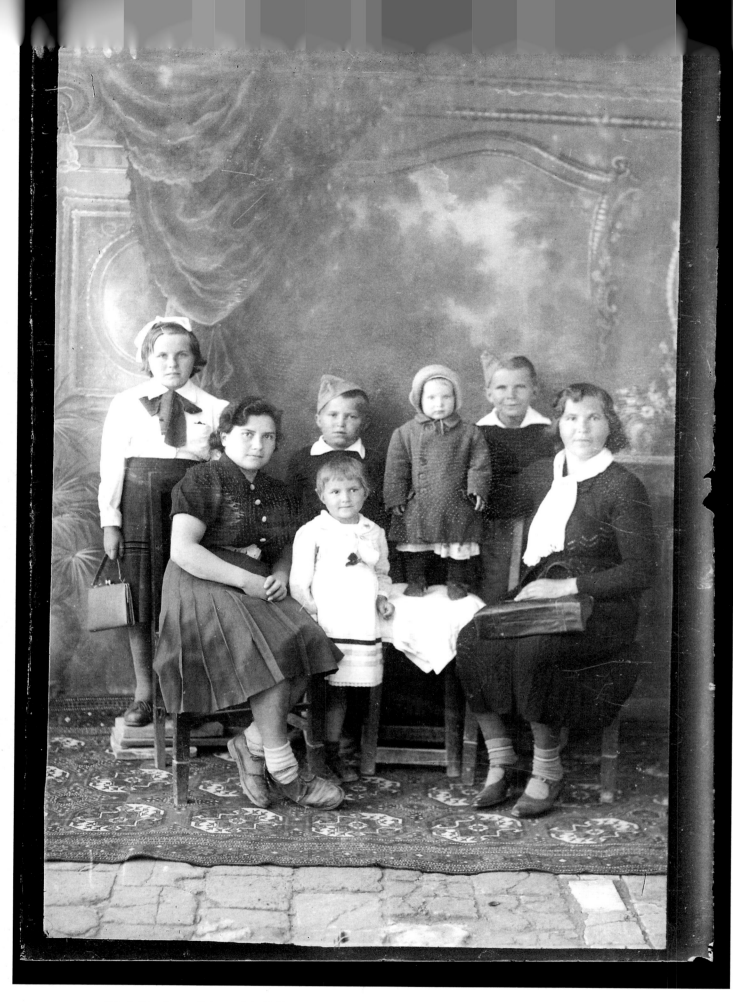

210. Polish refugees. Abolqasem Jala, 1943.

188 Portrait Photographs from Isfahan

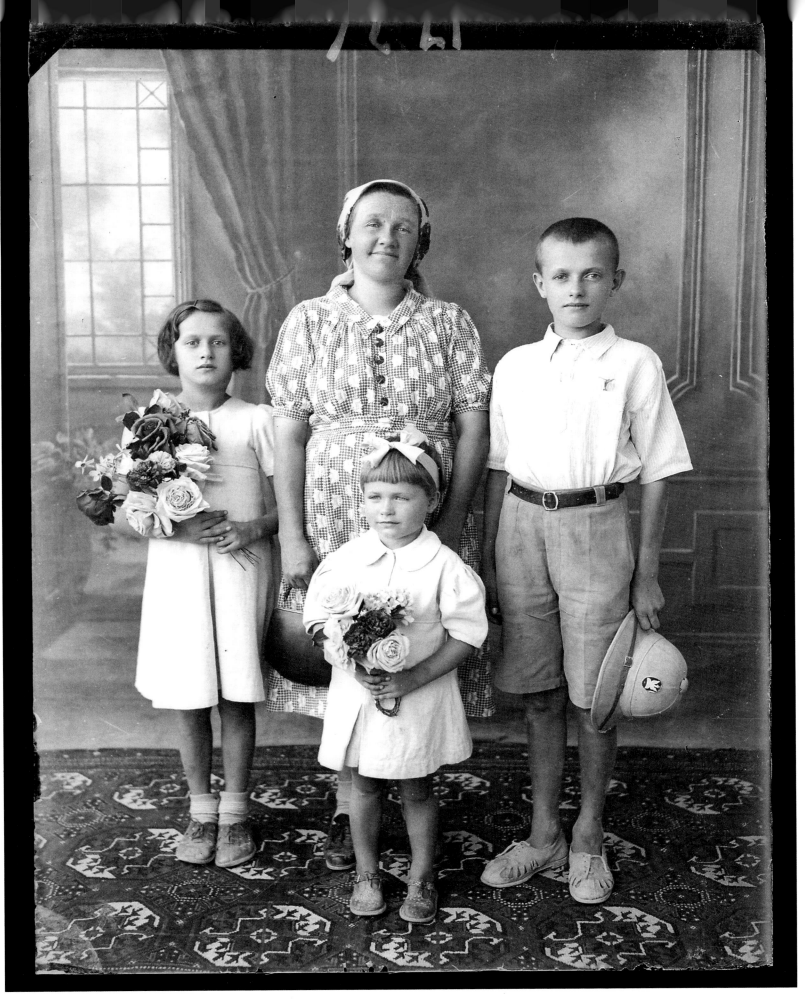

211. *Polish refugees. Abolqasem Jala, 1942.*

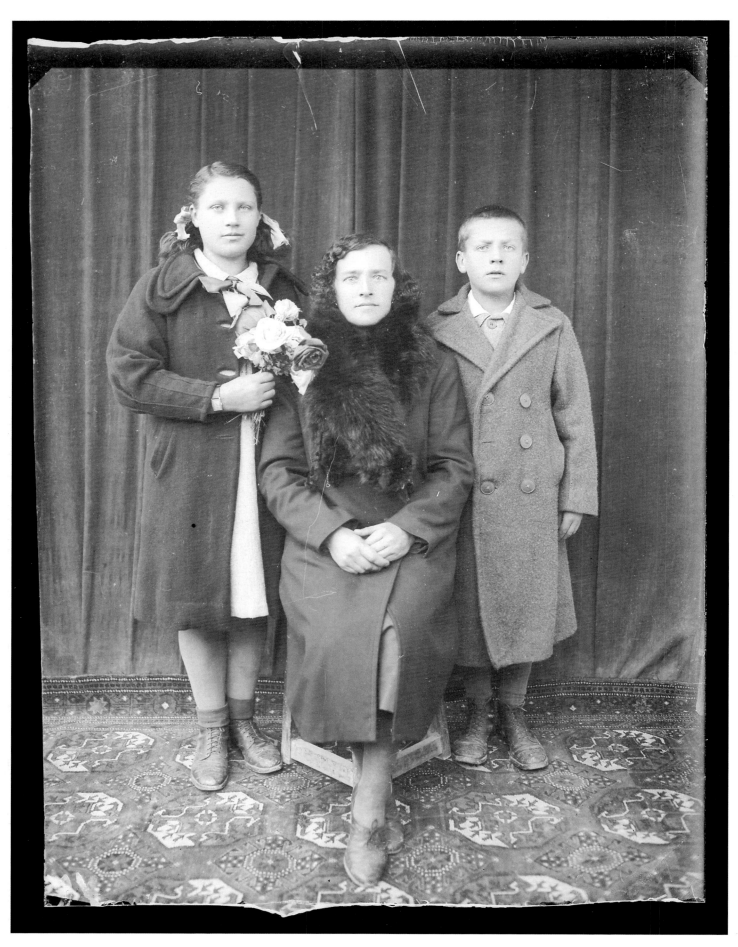

212. Polish refugees. Abolqasem Jala, 1942.

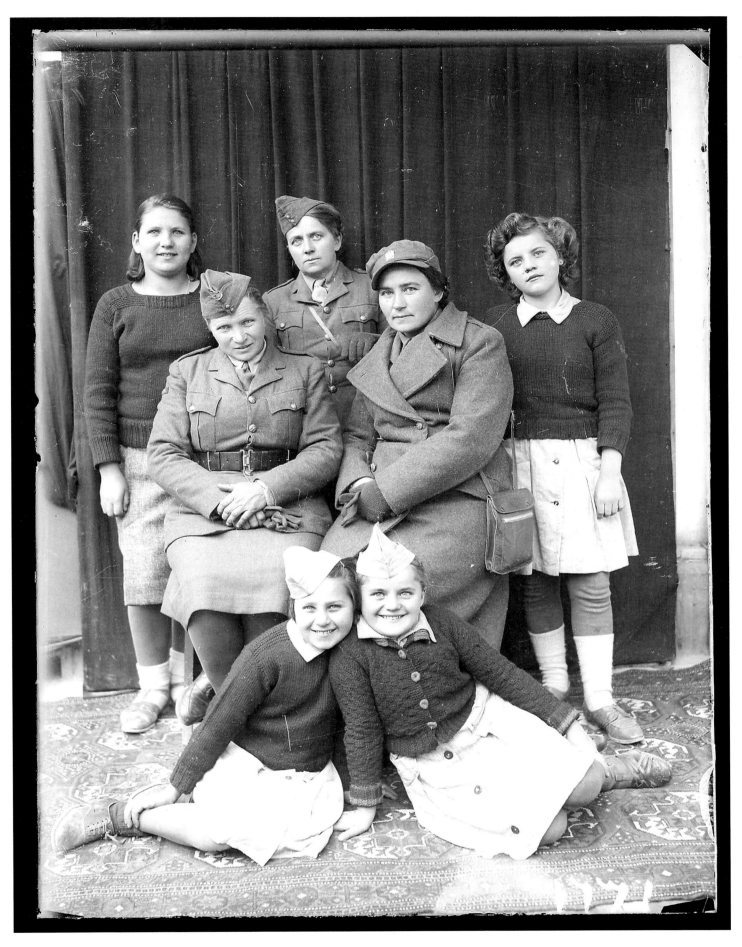

213. *Polish refugees. Abolqasem Jala, 1942.*

214. Polish refugees. Abolqasem Jala, 1942.

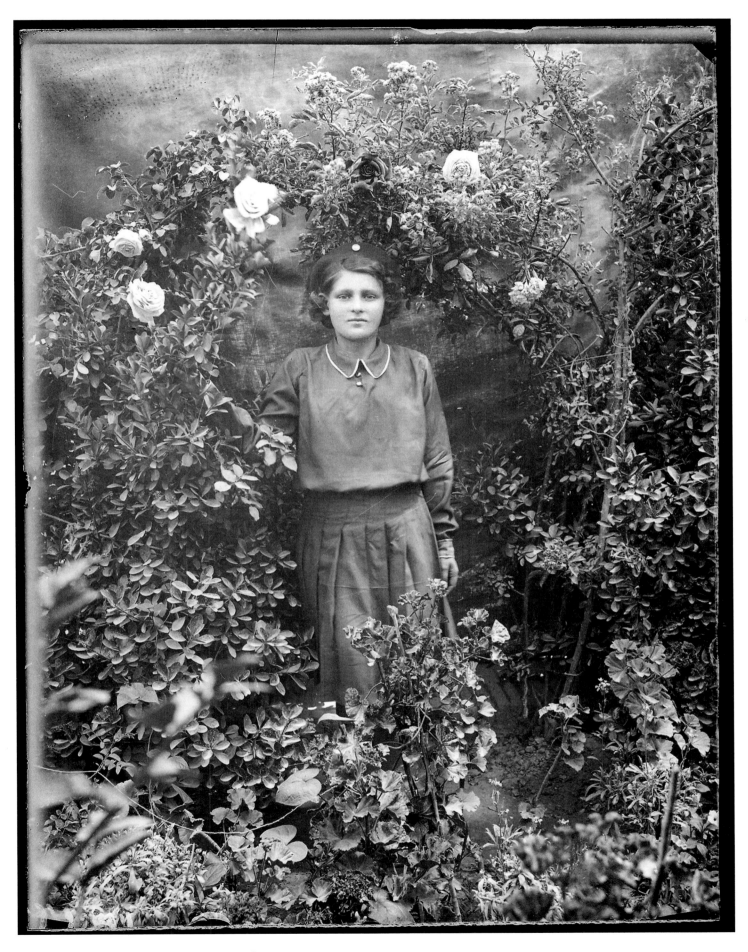

215. Polish refugee. Abolqasem Jala, 1942.

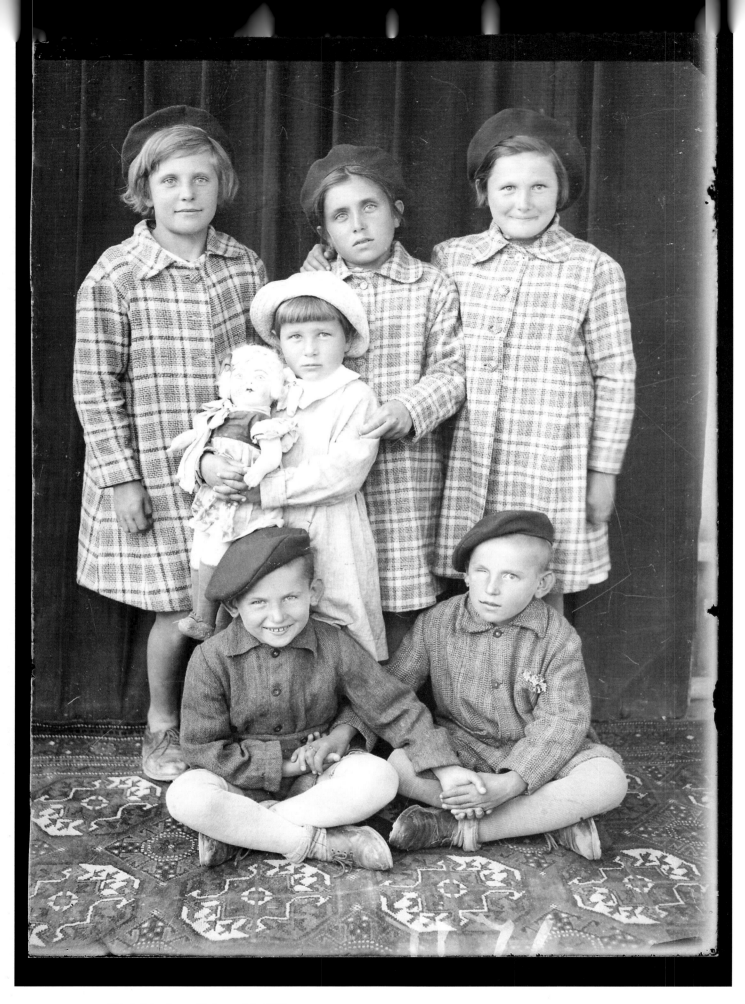

216. Polish refugees. Abolqasem Jala, 1943.

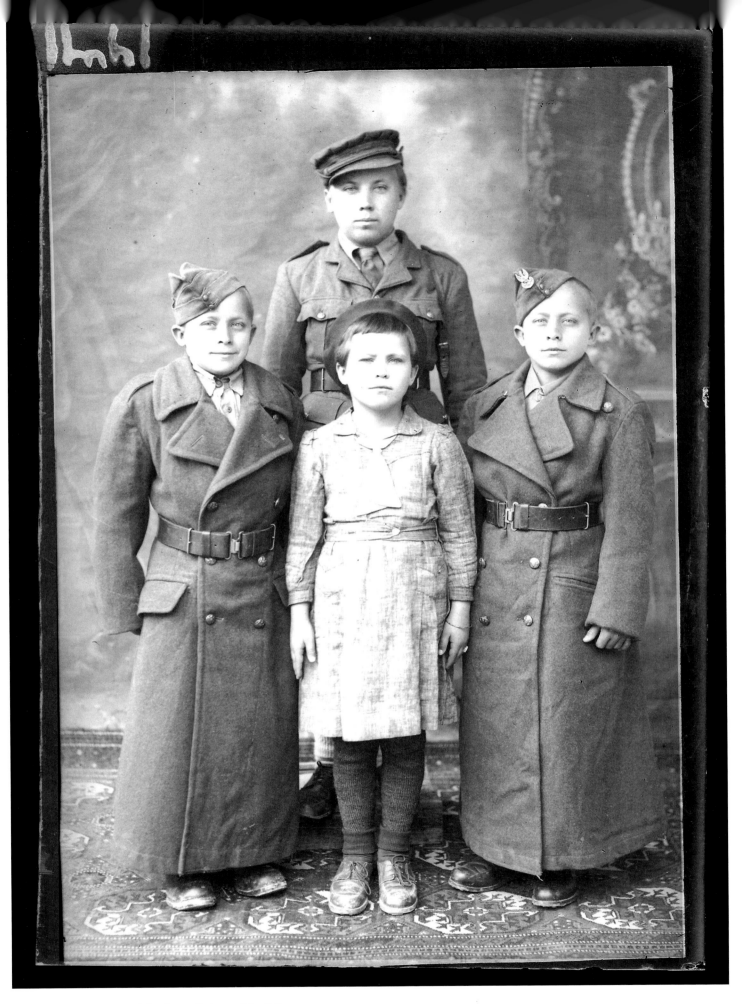

217. *Polish refugees. Abolqasem Jala, 1942.*

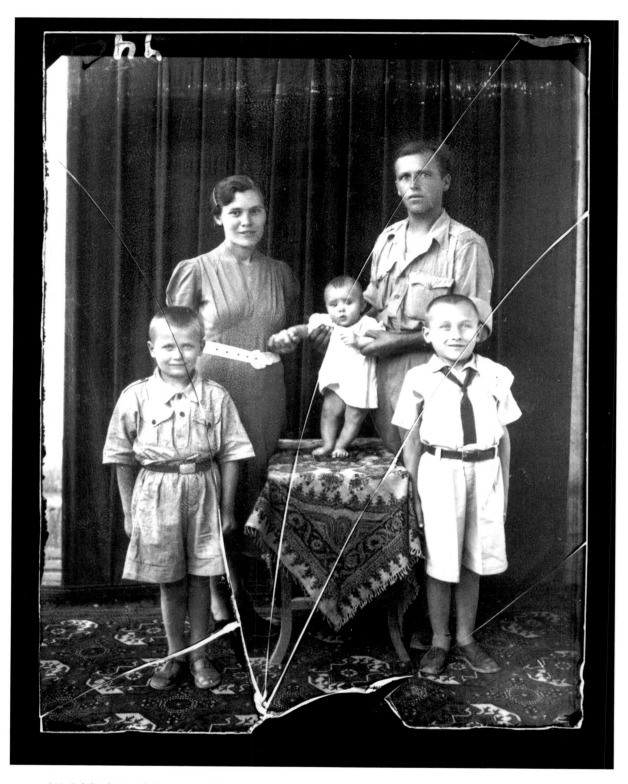

218. Polish refugees. Abolqasem Jala, 1943.

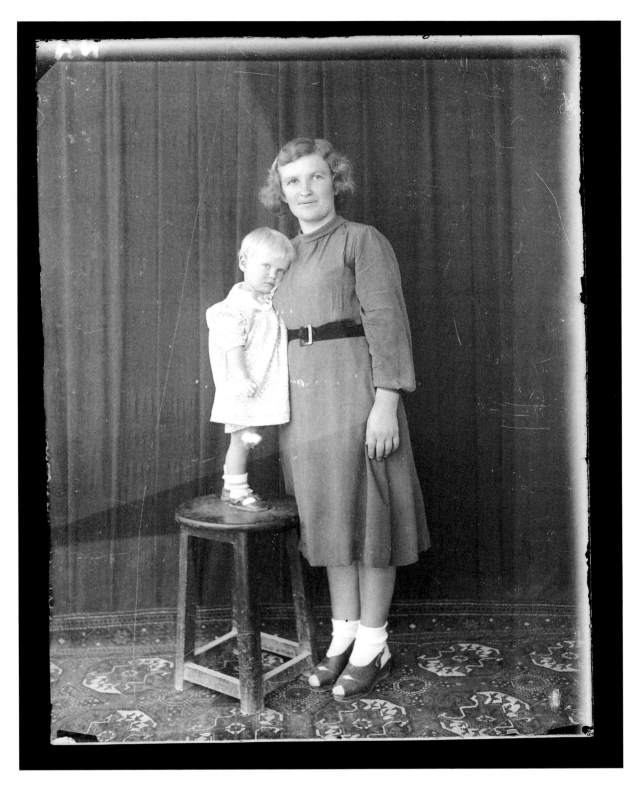

219. *Polish refugees. Abolqasem Jala, 1943.*

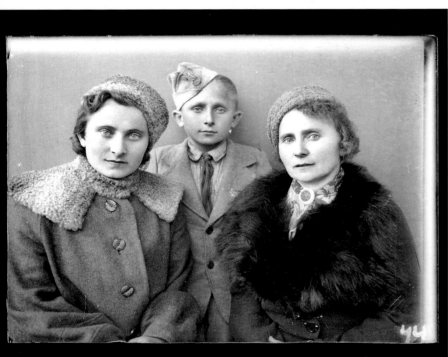

220–221. Polish refugees. Abolqasem Jala, 1943.

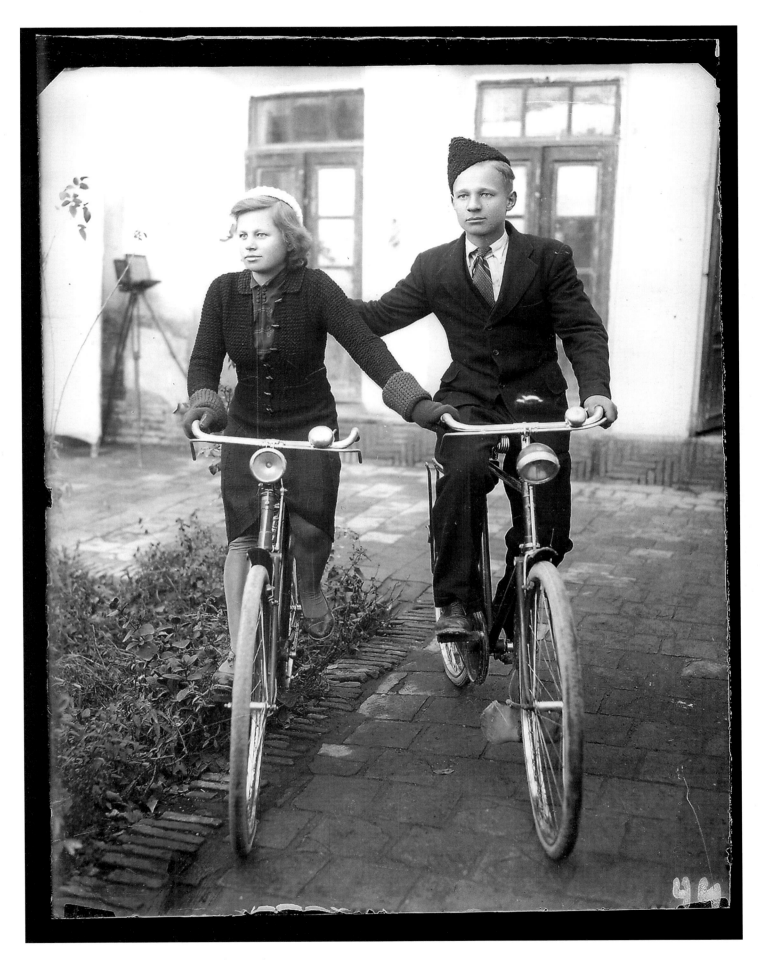

222. *Polish refugees. Abolqasem Jala, 1943.*

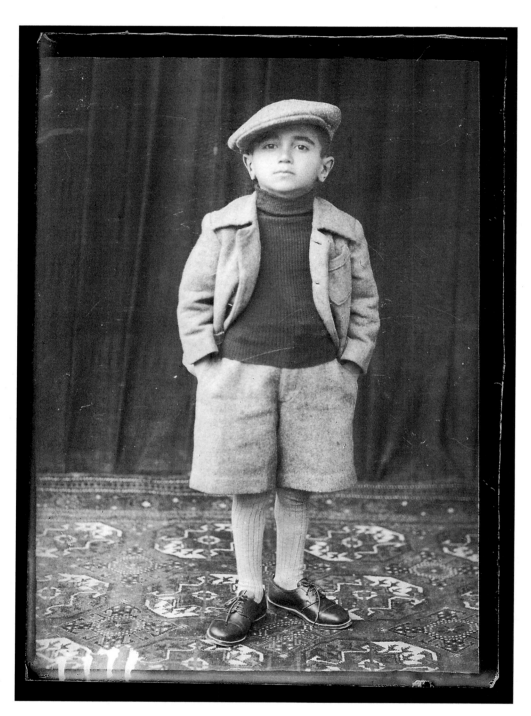

223. *Polish refugee. Abolqasem Jala, 1943.*

224. *Right: Polish refugee. Abolqasem Jala, 1942.*

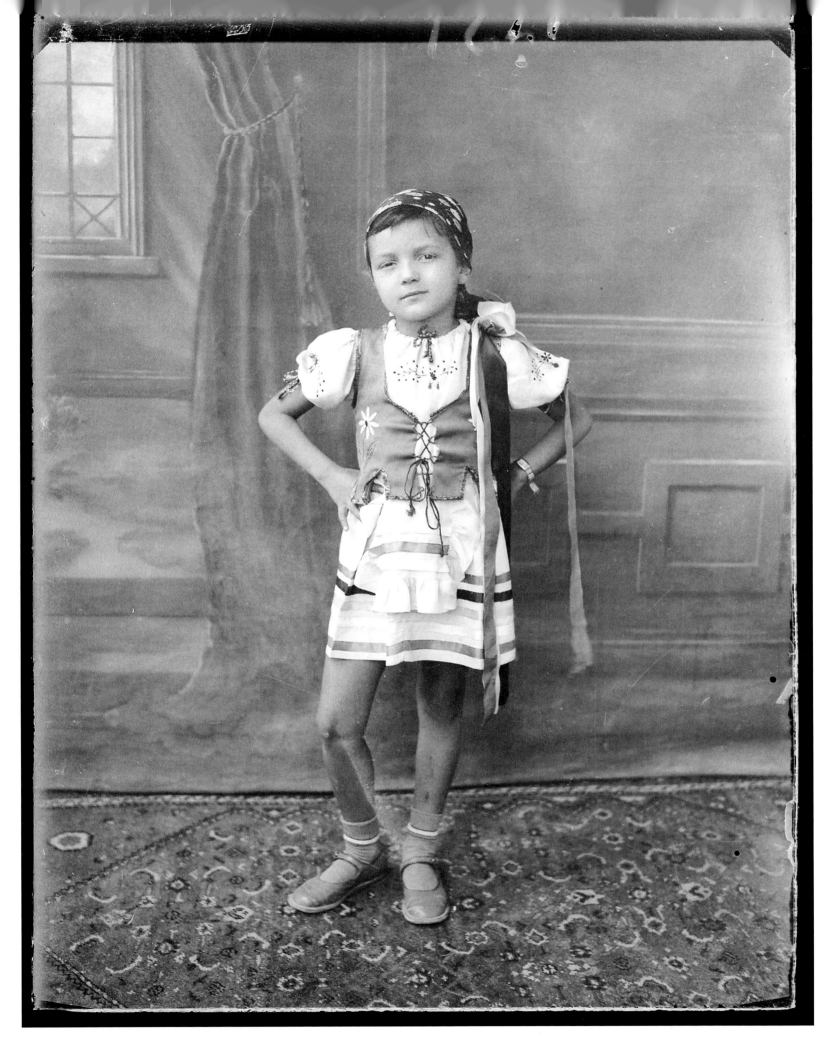

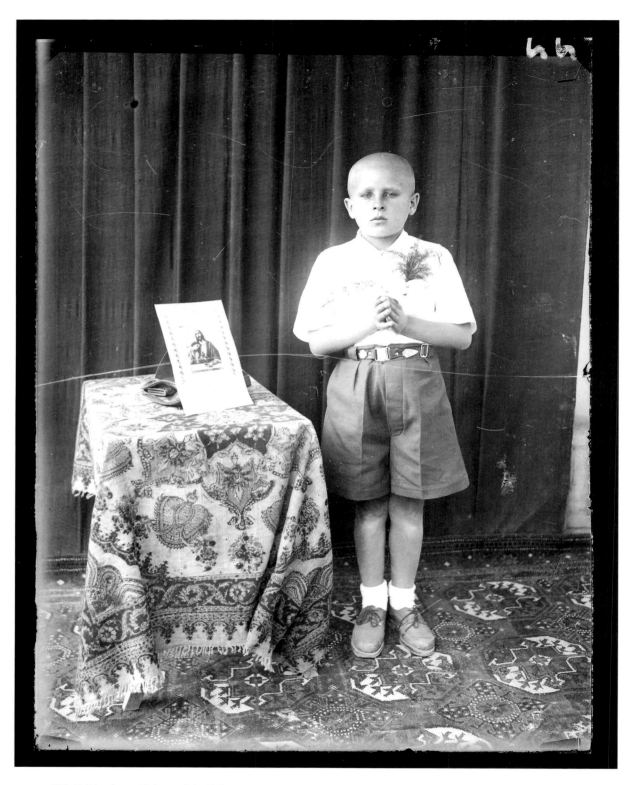

225. Polish refugee. Abolqasem Jala, 1943.

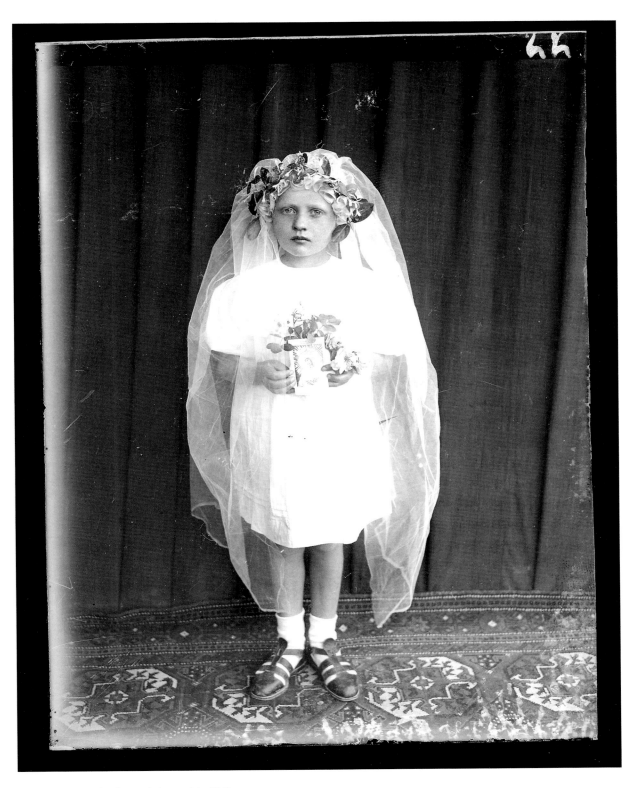

226. *Polish refugee. Abolqasem Jala, 1943.*

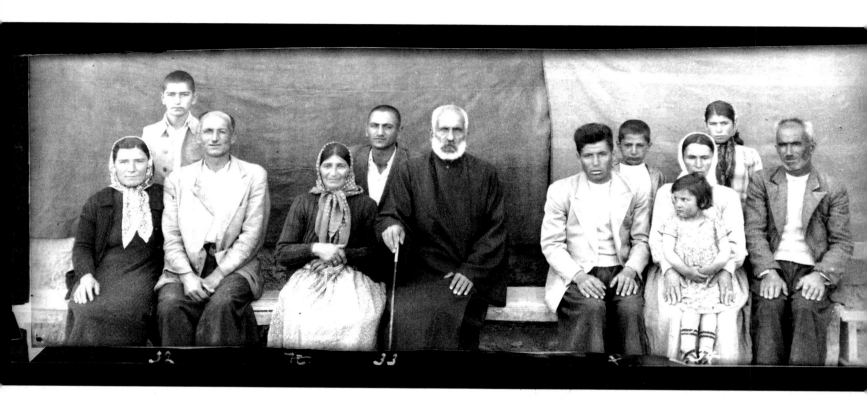

227. *Armenian migrants. Minas Patkerhanian Mackertich, 1946.*

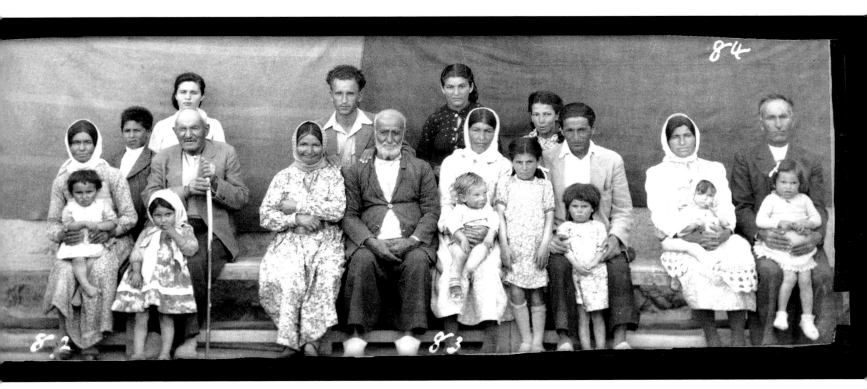

228. *Armenian migrants. Minas Patkerhanian Mackertich, 1946.*

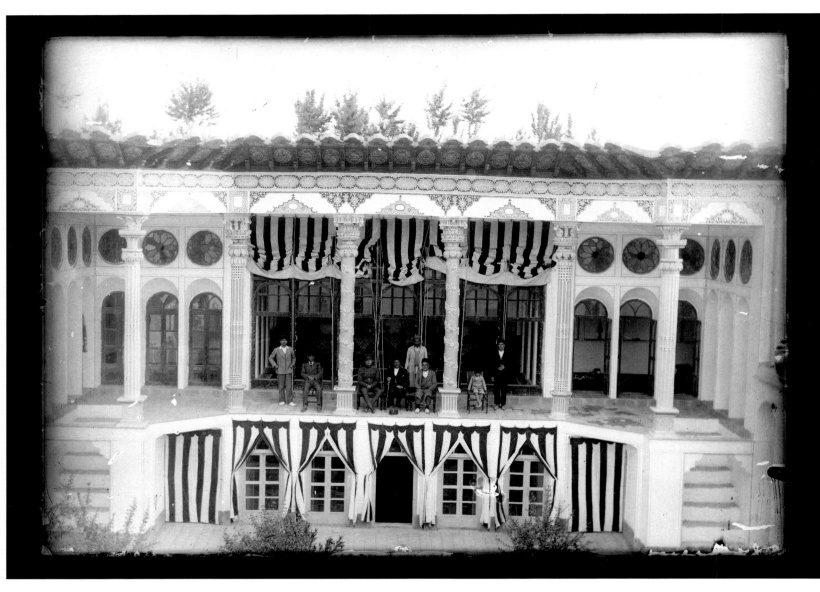

229. *Untitled. Mirza Mehdi Khan Chehreh-Nama.*

230. Untitled. Gholamhossein Derakhshan.

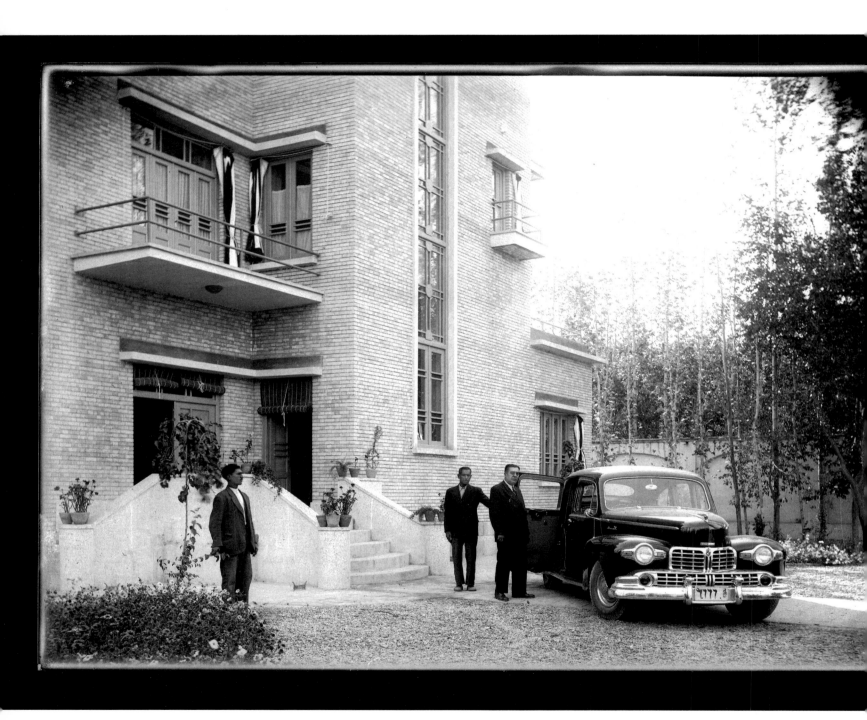

231. Untitled. Gholamhossein Derakhshan.

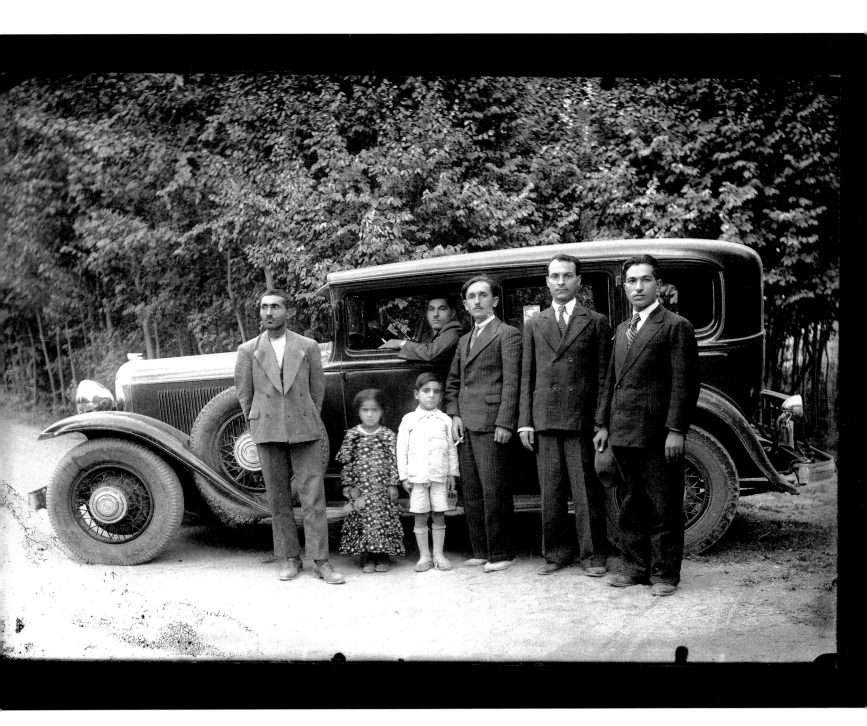

232. *Untitled. Gholamhossein Derakhshan.*

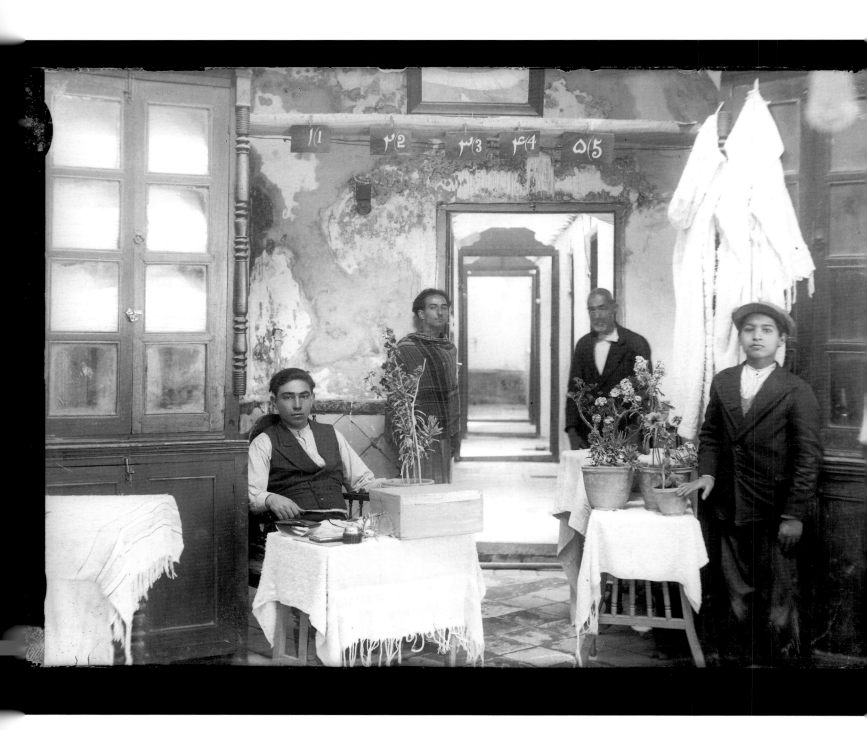

233. *Public bath owner and his workers. Abolqasem Jala.*

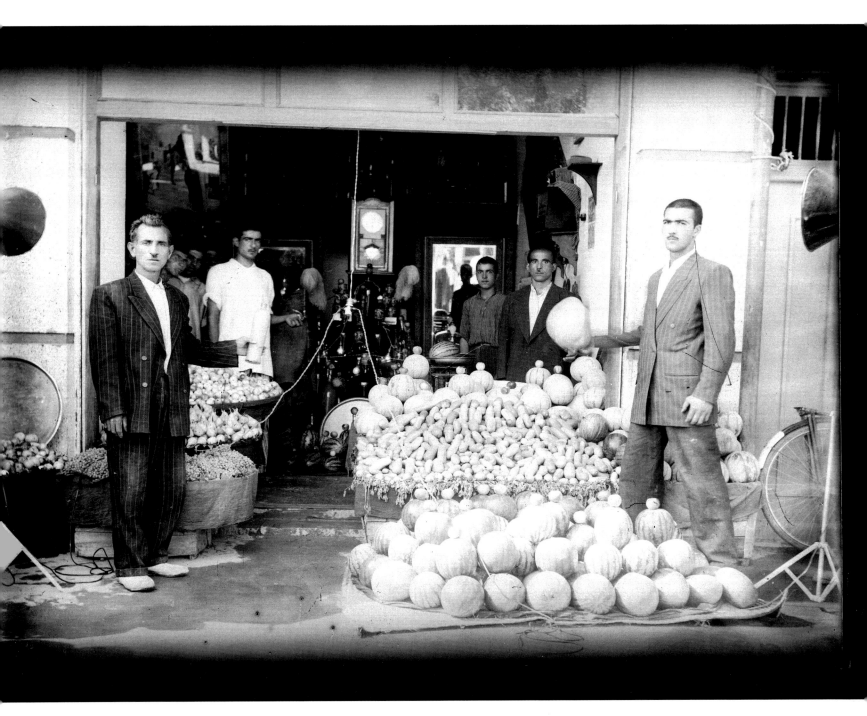

234. *Fruit sellers. Gholamhossein Derakhshan.*

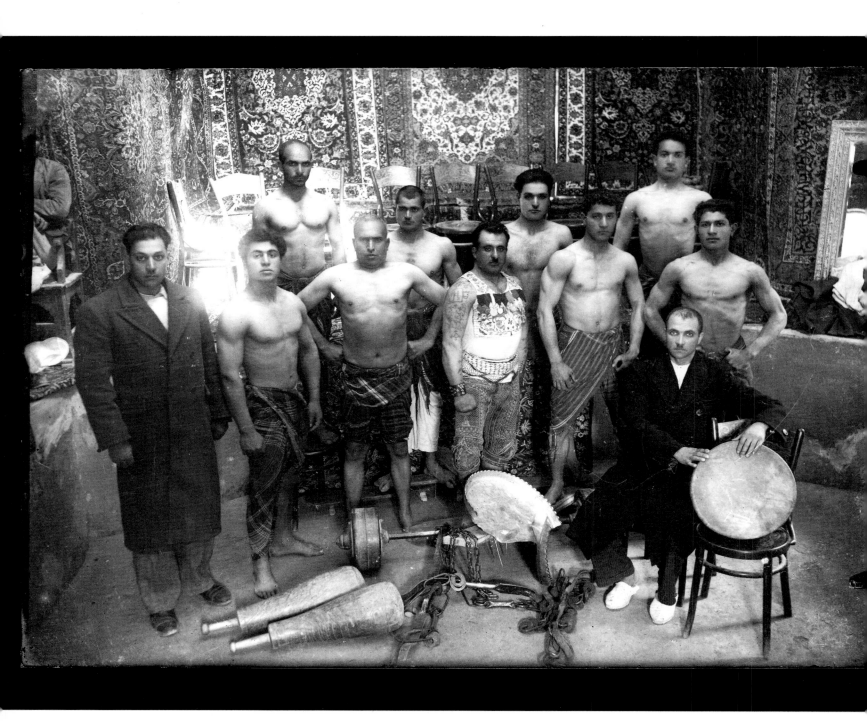

235. *Traditional sportsmen in a gymnasium. Gholamhossein Derakhshan.*

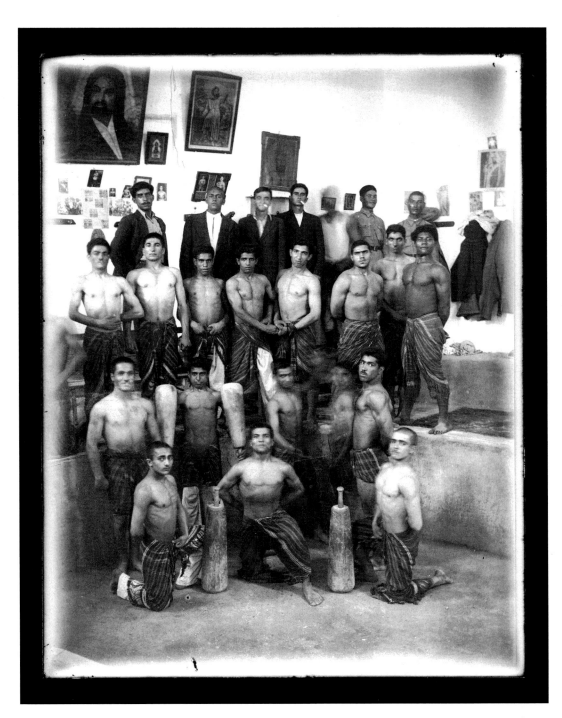

236. *Traditional sportsmen in a gymnasium. Gholamhossein Derakhshan.*

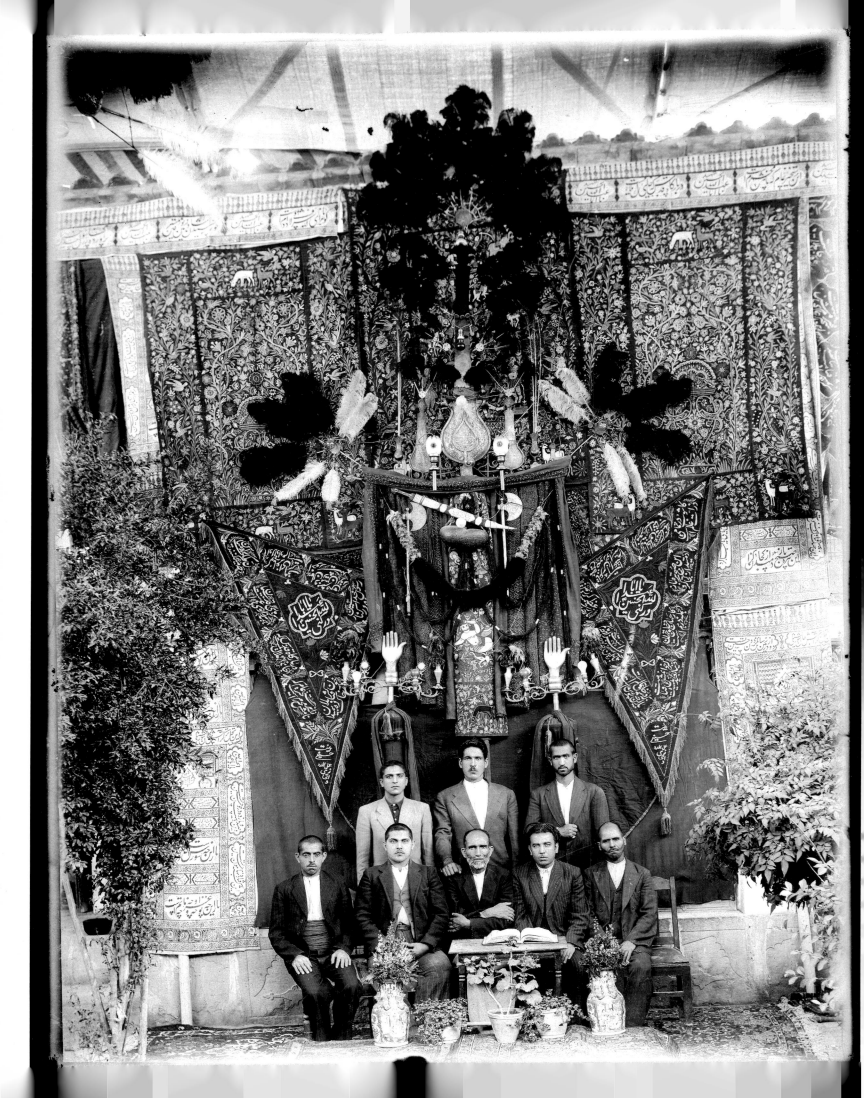

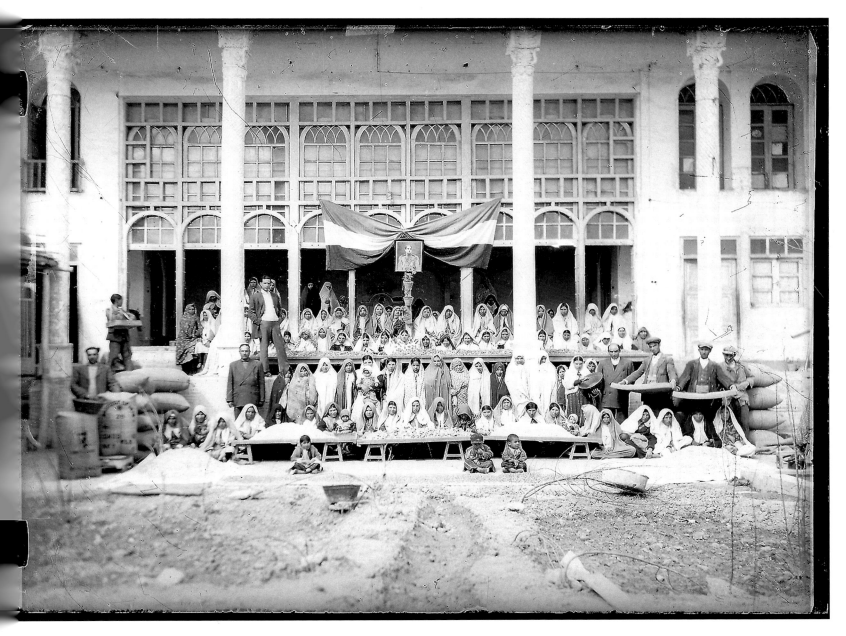

238. *Women workers. Vahan Patkerhanian Mackertich.*

237. *Left: Mourners in the month of Muharram,*
remembering the martyrdom of Imam Hussein in
Karbala. Gholamhossein Derakhshan.

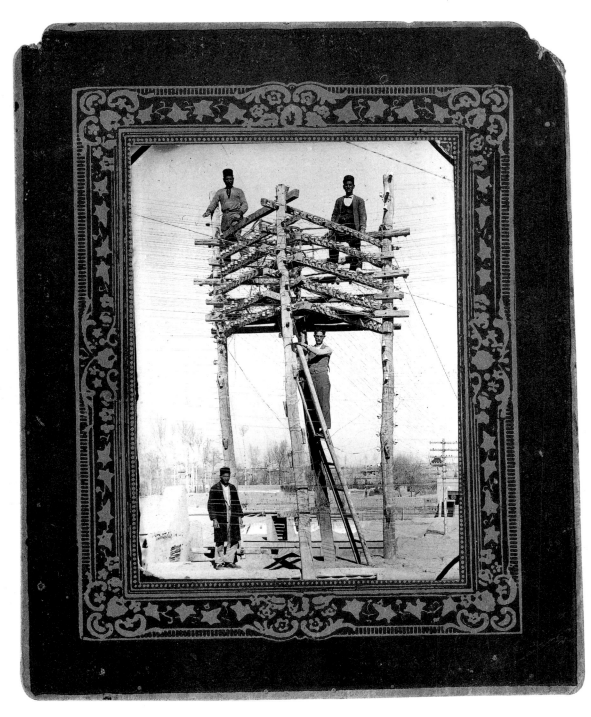

239. *Installing a winch for putting up telephone lines in Isfahan. Anonymous, 1933.*

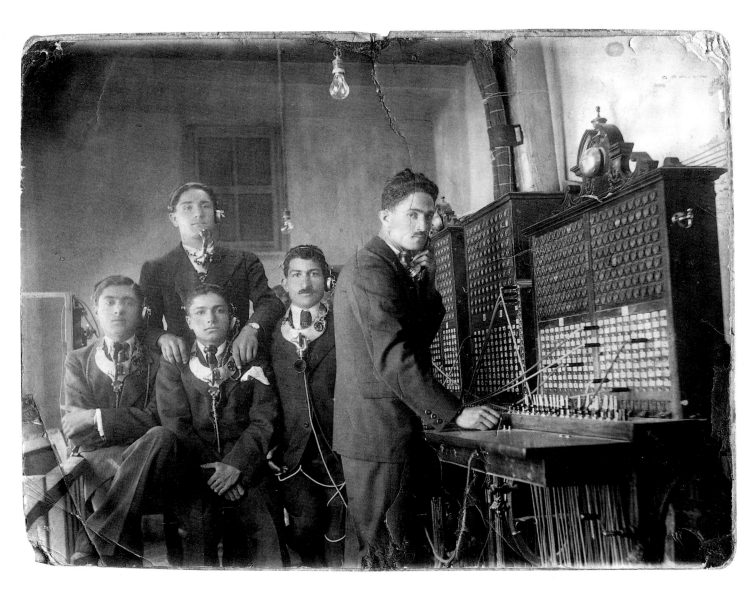

240. *Inauguration of Isfahan's telephone exchange. Anonymous.*

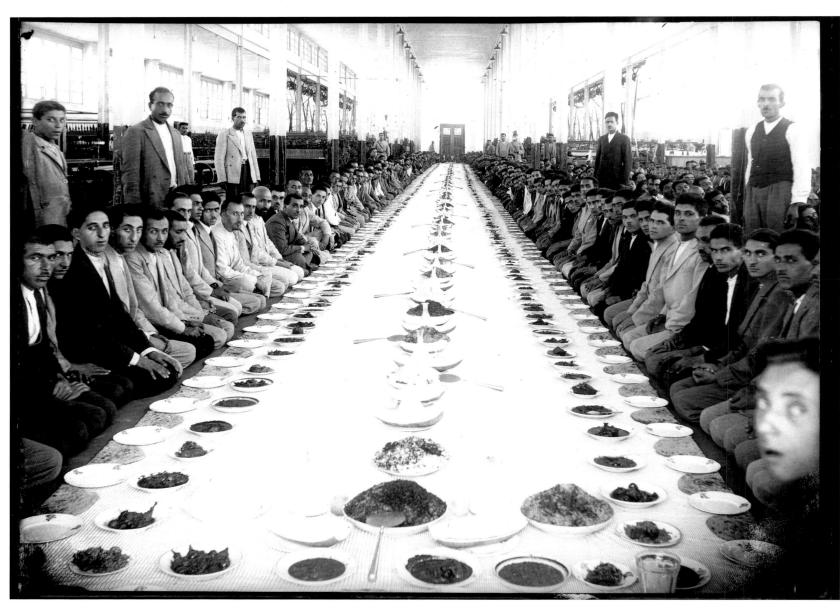

241. *Vatan Factory workers eating a meal during a celebration. Gholamhossein Derakhshan.*

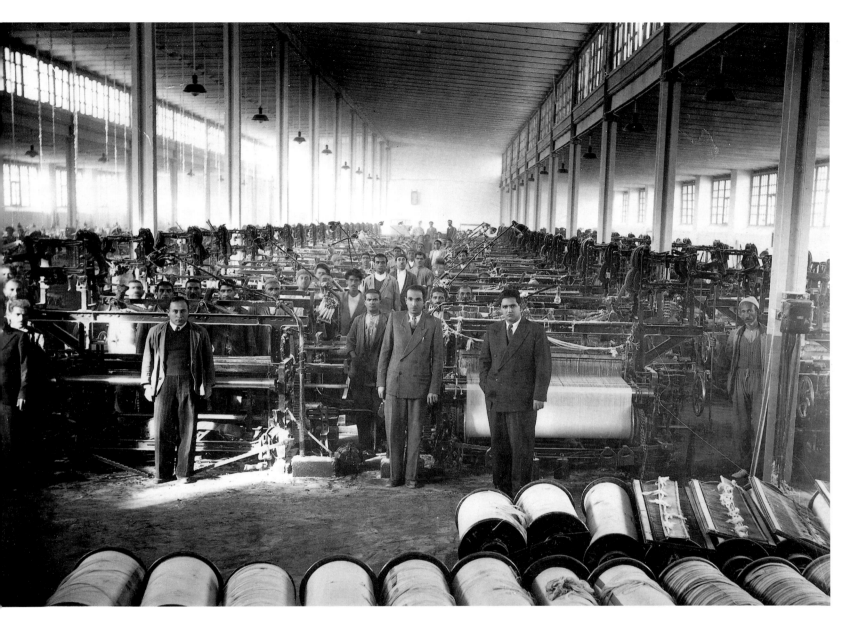

242. *Workers of Vatan ('homeland') Factory, the first textile factory in Isfahan. Gholamhossein Derakhshan, late 1920s.*

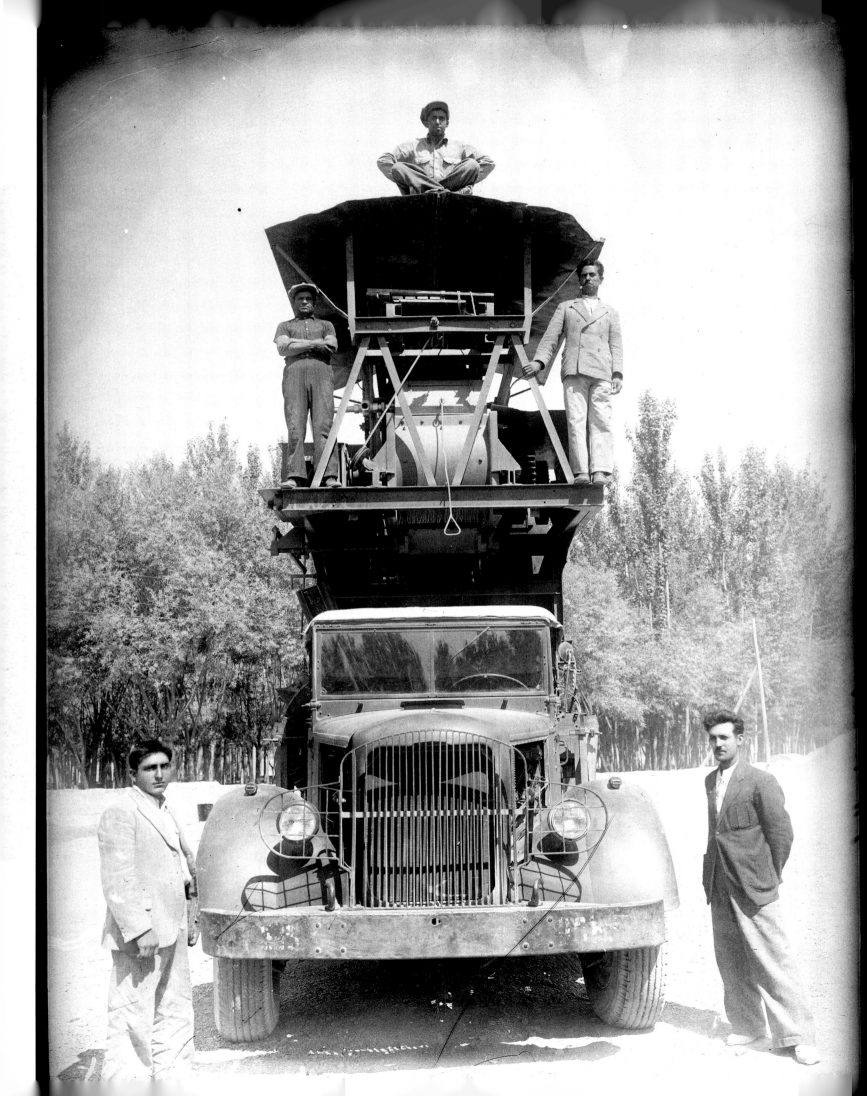

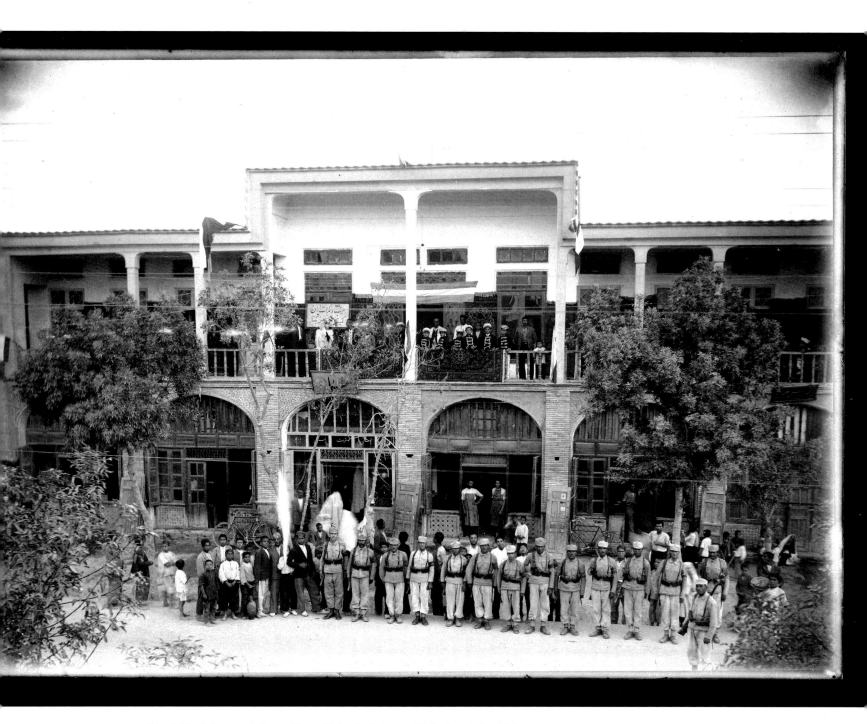

244. *Isfahan's Democratic Party office on Chahar-Bagh Avenue. Gholamhossein Derakhshan.*

243. *Left: Imported industrial machinery for textile factories.*
 Abolqasem Jala.

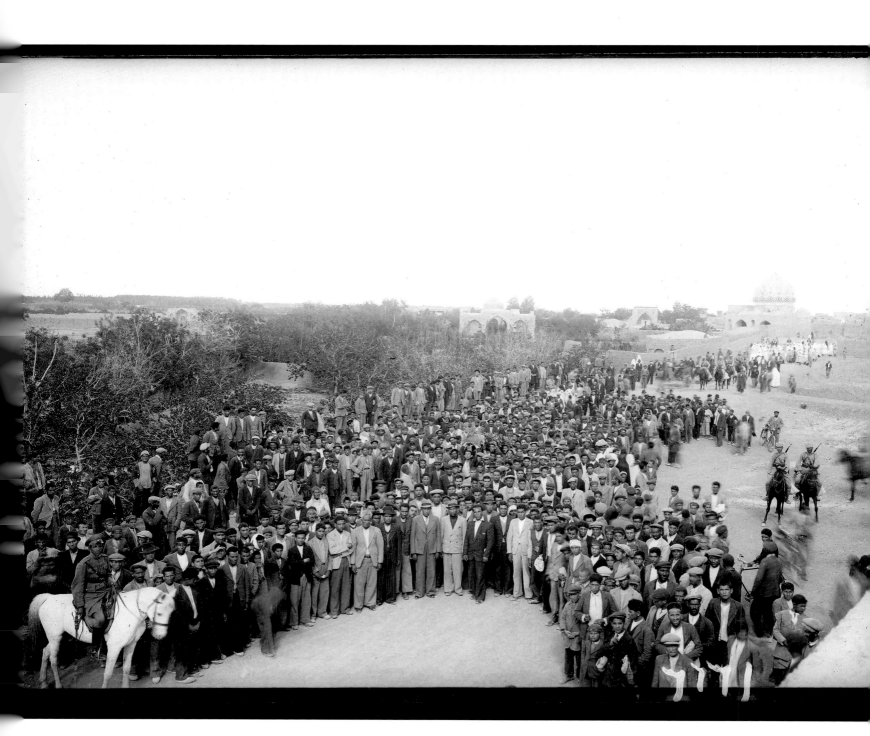

245. *Demonstration by workers. Abolqasem Jala.*

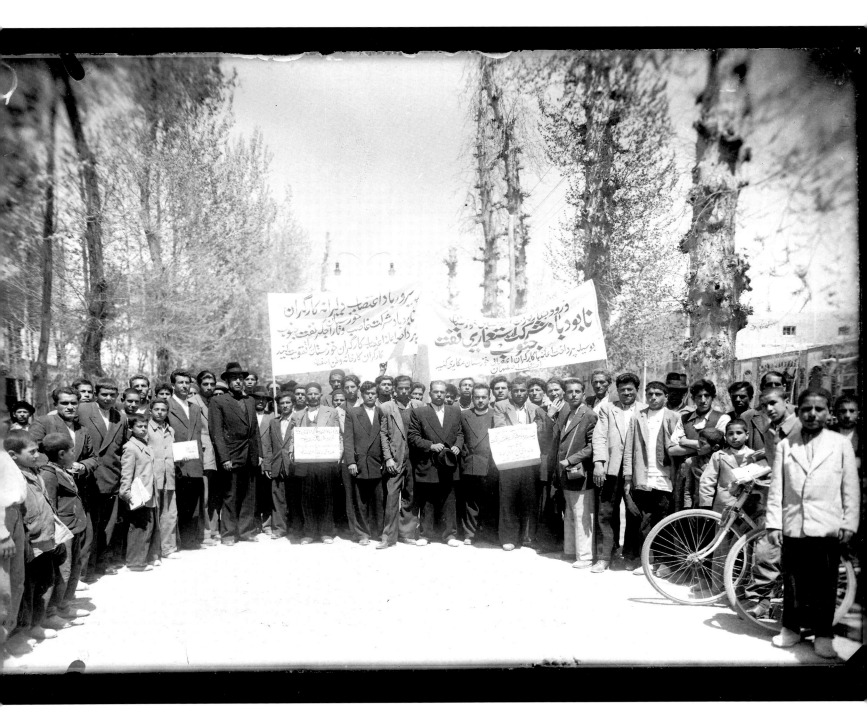

246. *Demonstration by textile factory workers in protest against the presence in Iran of the British oil company and in support of the strike by workers in Khuzestan, Iran's oil region. Abolqasem Jala, c. 1953.*

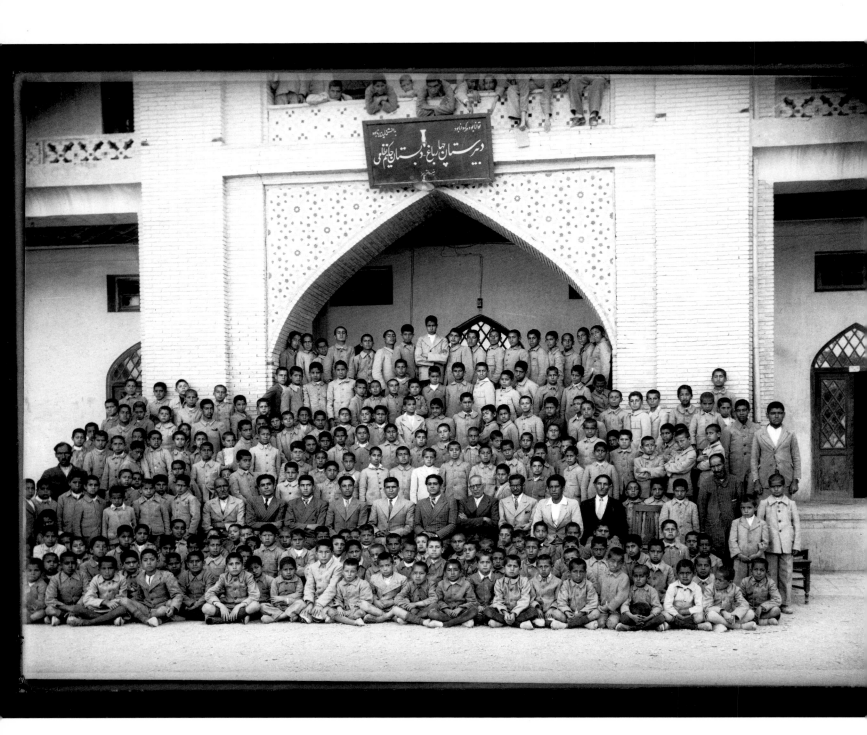

247. *Pupils of Chahar-Bagh secondary school and Hakim Nezami primary school. Gholamhossein Derakhshan.*

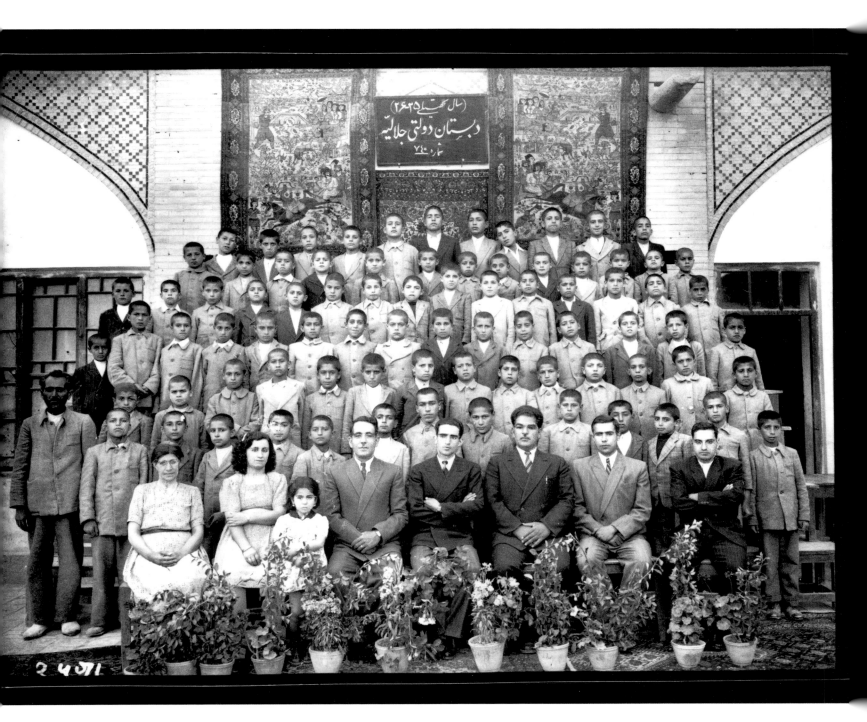

248. *Pupils of Jalalieh state primary school. Abolqasem Jala, 1947.*

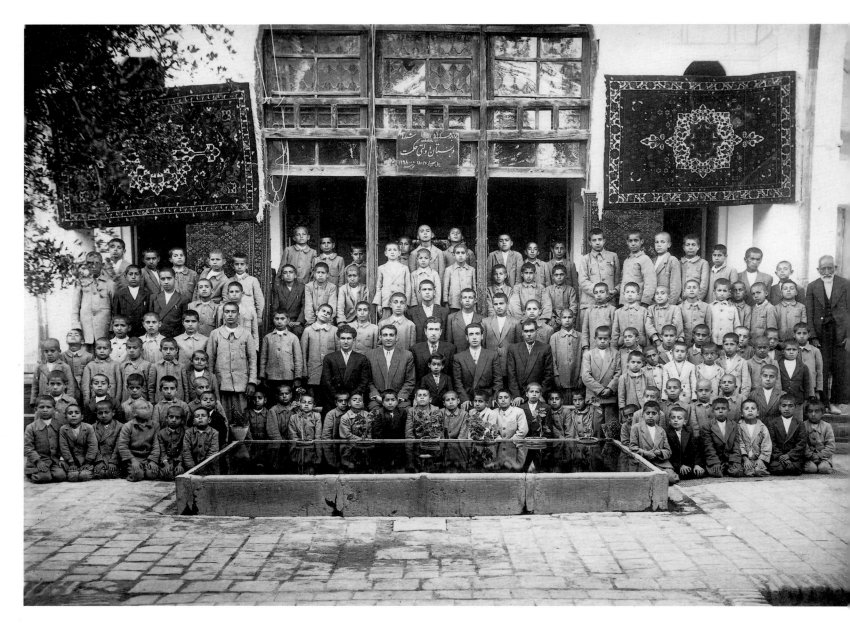

249. *Pupils of Hekmat state primary school. Gholamhossein Derakhshan, 1948.*

250. *Right: Scouts from the 15 Bahman state primary school. Gholamhossein Derakhshan.*

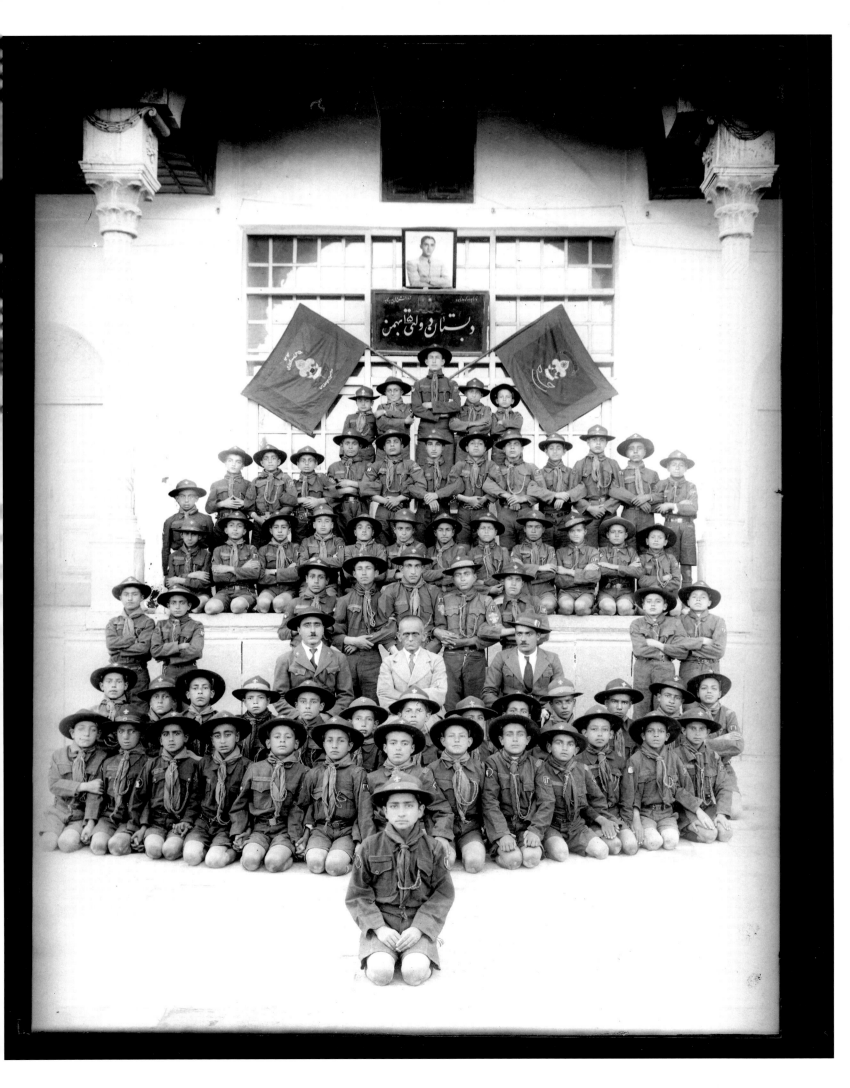

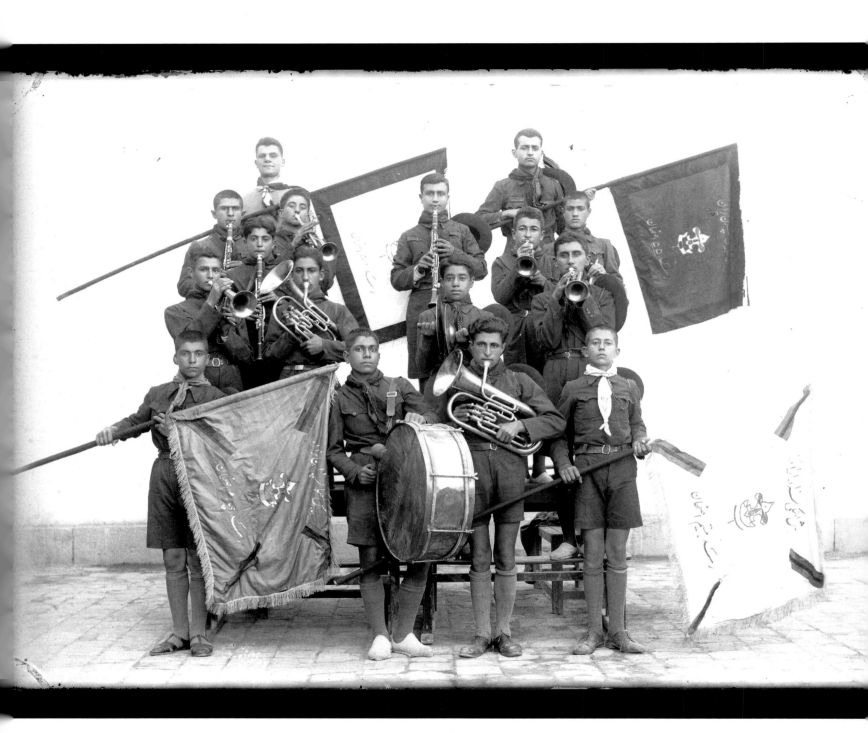

251. Scouts' musical group. Gholamhossein Derakhshan.

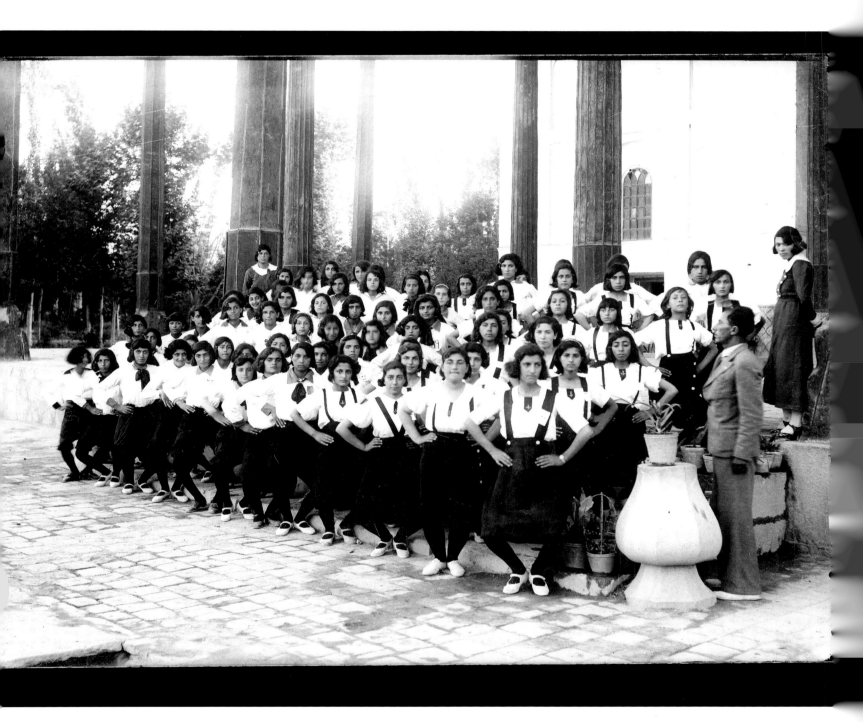

252. *Schoolgirls at Chehel-Sotun Palace. Abolqasem Jala.*

The Rise of the Kingly Citizen

Iranian Portrait Photography, 1850–1950[1]

Reza Sheikh

There is no difference between Philippe and me:
he is a citizen-king and I am a kingly citizen.[2]

A year after its invention, 160 years ago, the camera found its way into Iran as a gift for the king.[3] The following story of the first century of photography in Iran is a simple tale of king and citizen: who held the camera in his hands and who got the chance to pose for eternity in an impoverished society. A revolution, a change in dynasty and two world wars mark this century. An absolute monarchy gives way to a constitution and a bourgeoisie is born. In the midst of it all, photographic portraiture remains a dominant genre. From among the photographs scattered within family photo albums and various official archives, it is my intention to delineate a conceptual framework for viewing the body of photographs from a socio-historical standpoint and thus revealing the story of Iranian photography.

The Persia that greeted the camera in the mid-19th century was entrenched in a medieval state best symbolized by the rampart and the moat that surrounded its capital city. From behind yet another set of walls, that of the royal citadel in the heart of Tehran, the Qajar monarch reigned over a nation of six million, of whom 80 per cent were nomads and villagers residing in the countryside.[4] The country had been reduced to a state of exhausted peace after centuries of Turco-Mongol feuds on the Persian plateau. More recently, however, the country had become the stage for British and Russian long-distance sparring and another pawn in the Great Game, which would last the

whole century. The country and its meagre resources were royal property and the king viewed his citizens as *nokarha* and *ro'aya*; his officials were his 'servants' and the rest were 'plebeians'.[5]

By the middle of the 20th century, hoping to erase that medieval image of the subordinate, Persia had officially renamed itself Iran. The rampart became nothing more than a memory and the Qajar royal citadel had gone without trace. Now numbering over twelve million, Iranians had survived the unwanted intrusion of the Allied Powers during World War II. The foreign occupiers had shipped the king into exile, where he died off the coast of South Africa. Ultimately, however, as the British and Russians left through the back door, the Americans entered through the front – and stayed. While nomads continued to roam the mountains and villagers tilled the land, a confident middle class stood on the edge of political strife.[6] Young people in their mid-twenties could not believe that, at the time they were born, the country had had no paved roads, railways, schools, hospitals, running water or any of the amenities they had come to enjoy. People in their mid-forties, who had welcomed the modernizing campaign of the first Pahlavi monarch, had their hopes of political freedom crushed by his dictatorial rule. The Constitutional Revolution had taken place at the time of their birth, yet autocracy continued to loom on the horizon.

Physically and conceptually, photography in Iran took root within four walls – those of the palaces, residences of the wealthy and eventually of the studios. The photographs were idealized portraits within idealized settings. Interestingly, this made photography true to the essence of Iranian visual arts, which had always 'opted for the ideal rather than the real'.[7] For the first thirty years (1850–80) the camera remained a gadget in the service of Nasir al-Din Shah (reg. 1848–98) and his entourage, who chose to present their isolated selves in an 'ideal reality' created within the confines of palace walls or in the vast oblivion of natural settings. By the 1880s, thanks to the existence of a few public studios, photography had trickled down through the social strata in the major cities. Photographs began to circulate among the elite, a class whose faces and numbers changed with the changing times of the Iranian fin-de-siècle.[8]

The camera democratized portraiture wherever it ventured. Soliciting

the services of a portrait artist was a luxury that only the more affluent members of society could afford. Photography was a technical breakthrough that rendered portraiture amenable to the majority. In Europe and America this process was realized within a decade of the invention of the daguerreotype camera (1850s).[9] In Iran it took close to a century (late 1940s), hence the time focus of this article. The new self-awareness of the Western bourgeoisie of the 19th century, whose members were fast becoming the pillars of the social order, found in photography a means of self-expression.[10] They established the economic base that allowed portraiture to become accessible to the masses and to ensure the growth of photography as no other invention in history.[11] No well-established middle class existed in Iran until the 1930s, when the Pahlavi regime wrought deep and extensive societal changes. Until then the history of photography in Iran was subject to particular nuances, of which we find the traces in the portrait photographs of the era.[12]

The first century of photography in Iran was a tumultuous period of antagonism between its kings and citizens and eventually among its political elite. This rivalry was as much a matter of colliding spheres of interest (and brute enforcement of will and power) as it was a confrontation between their 'images' displayed within a public visual space. At the same time as the constitution curbed the absolute rule of the king, the people rose from 'plebeian' status to that of 'citizen' (ro'aya to mellat) and the government advanced from the crude rank of 'king's servants' to the more honourable position of the 'people's government' (nokarha to dowlat). A new player – an elected parliament (majlis) – entered the scene. All these protagonists solicited the services of the camera box, and their portraits became the standard-bearers of their ideal self-images and tangible records of their identity. This article also examines the concept of identity as represented by such portrait photographs.

Six kings ruled Iran during this period. Nasir al-Din Shah was the Qajar monarch who took pride in being the progenitor of photography in Iran. It was his patronage during his long reign that gave legitimacy to the new medium and paved the way for the camera to find its purpose among a people who throughout their history had been fascinated by human figurative arts.[13] Behind the palace walls, within the seclusion of court life and minimal public contact,

Nasir al-Din Shah was the centre of his universe and the sole prominent figure in his photographs, changing from an overzealous amateur in his early twenties experimenting with self-portraiture (c. 1850) to a melancholic man in his sixties invariably surrounded by servants and eunuchs. The court photographers also followed him through the course of his daily life and documented his personal world – his travels, palaces and official events – and on his orders conducted photo-expeditions around the country. Tucked away in albums and guarded in a vault, the photographic legacy of Nasir al-Din Shah remained unknown to the outside world during his lifetime and for the whole duration of the Qajar dynasty.[14] This conscious exclusion of an audience is best symbolized by a man photographing in a room covered with mirrors, as in the interior architecture of Iranian palaces. The monarch's photographs are self-reflecting and self-rebounding images (photo 251). Photography for Nasir al-Din Shah was a means to promote himself for himself and an exclusive set of individuals.

In the West, photographic illustration of printed media became possible only in the 1890s. It was not until 1903 that Muzaffar al-Din Shah ordered his court photographer to purchase a printing machine during his trip to Belgium.[15] The only means of exposing Nasir al-Din Shah's photographs to public view was thus by actual physical distribution. Only a few official portraits were sent to different corners of the country in order to promulgate the royal image. Even then, it was only government officials (*nokarha*) who were recipients of such 'favours'.[16]

Much has been said of the power of royal images in mural paintings, rock reliefs and a variety of media, which were part of a conscious propaganda campaign on behalf of the monarch through the early years of the Qajar dynasty.[17] If propaganda was the purpose, then the fact that photographs were not used is a puzzle. How many people could see the murals on palace walls, the carved images in the side of remote mountains or the photo portraits hidden in royal albums? Yet all these images were clearly excluded from the public visual space.

Unlike his grandfather, Fath 'Ali Shah, Nasir al-Din Shah was not in a financial position to commission extravagant works of art to commemorate his idealized royal self and disseminate his image. Although his face could be seen on myriad objects ranging from teapots to bills (paper money), he did not use the medium of

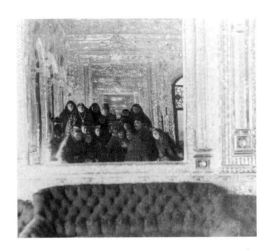

251. *Nasir al-Din Shah Qajar, self-portrait with wives, c. 1875.*

photography to its fullest potential for this purpose either. Why? Certainly it may have been technically difficult to distribute a royal portrait far and wide. I suggest a further reason, namely, that the court did not sense the need.[18] Let us not forget that Nasir al-Din Shah ruled for half a century. The infallibility of the 'royal image' had become historically ingrained in the Iranian psyche. There was no threat from the 'servants', let alone the impoverished and exhausted 'plebeians' who faced the constant threat of famine and epidemics of plague and cholera all through the 19th century.[19] The masses did not need to be constantly reminded. If they did, the brute force of autocracy wielded by the extended apparatus of governors and landed nobility would act as a reminder. The royal power base required the obedience of the 'servants' and it was they who saw the images. If the court had sensed the need, the technical infrastructure for the dissemination of the royal photographs would have been created.

Although a bullet in the chest of his father shattered the Qajar royal bliss, Muzaffar al-Din Shah (reg. 1898–1906) remained largely inattentive to affairs of state. Though his photographic legacy paralleled that of Nasir al-Din Shah and was in many ways thematically more varied, the camera remained a mere gadget that served the whim of the monarch (photo 252). While a procession respectfully carried the portrait of Muhammad 'Ali Shah (Muzaffar al-Din Shah's

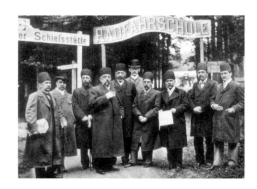

252. *Muzaffar al-Din Shah Qajar and entourage, vacationing in Europe, 1903.*

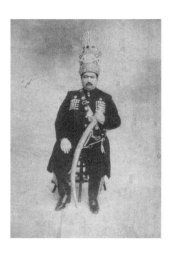

253. *Muhammad 'Ali Shah Qajar after coronation, 1906.*

son) to the *majlis* (parliament), he refused to allow any members of the newly elected body to be present at his coronation. His first official photographs were clearly taken with a view to distributing them among the public (photo 253).[20] Muhammad 'Ali Shah was keen on portraying a strong, angry and iron-willed monarch. In retrospect it is evident that he had no intention of hiding his disenchantment with the new state of affairs and the constitutional monarchy he had inherited. In fact, his portrait is confrontational and aimed at a wider audience, namely, 'his' rebellious citizens.

The tumultuous years of Muhammad 'Ali Shah's reign ended with his abdication and exile. Later the parliament placed a price on his head and published its proclamation in newspapers and pasted its posters on city walls.[21] His young son, Ahmad Shah (reg. 1909–25), succeeded him. During these last years of Qajar rule, the political elite, the young *majlis* and the *dowlat* (government) overwhelmed the public visual space with their photographs. A simple comparison with the photographs of official events taken at the time of Nasir al-Din Shah reveals a monarchy that has become more approachable. The enhanced status of the élite is apparent as they surround Ahmad Shah in group portraits (photo 254). The exigencies of the period had turned the young king into a public figure, less aloof and solitary than his great-grandfather, to whom

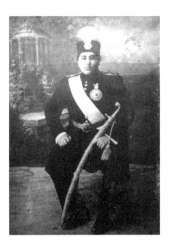

254. *Ahmad Shah Qajar, c. 1915.*

photography was a means of promoting the supreme and indivisible royal presence. Kingship was now no longer untouchable and the royal image no longer dissociated from that of the citizen.

During the first decade after the Constitutional Revolution (1906), thirty-six cabinets, six in one year, presented themselves to the *majlis* and requested its vote of confidence. At the same time, unwilling entanglement with World War I brought the country to the brink of disintegration. In the midst of the chaos 'a citizen who would be king' stepped in to save the day. He introduced himself simply as 'Reza'.[22] When in 1925 the *majlis* passed a law that required Iranians to select a family name for the first time in their history, he chose Pahlavi. In December of that year, the same *majlis* voted to abolish the Qajar dynasty and installed him as the first monarch of the Pahlavi dynasty. Photography of public events played a key role throughout this time.

Reza Khan was well aware of his identity and conscious of the image he wanted to convey as ruler. He too had his photographers. But unlike Nasir al-Din Shah and his successors, he used photography as a primary means to institutionalize his leadership and thus his kingship by injecting a medley of images into the public visual space. These photographs promoted his self-proclaimed 'real' rather than 'ideal' image – 'a nationalist and the saviour of his

country who intended to bring Iran into the modern world'.[23] He had an agenda to fulfil. There was no room for escapism. Inspecting or inaugurating and always in a military uniform, he was depicted in photographs actively tending to matters of state. Nasir al-Din Shah placed his photographs in his albums; those of Reza Shah found their way to government offices and public settings, the newspapers, official government newsletters and publications. While one promoted idealized photographic portraiture the other encouraged formal realism and inaugurated a chapter in state-sponsored Iranian photojournalism.[24]

As we examine the photographs of the first Pahlavi monarch from his sudden appearance on the public scene to his unanticipated departure from the country (1921–41), it is evident that he found it necessary to promote his kingship through a massive public campaign. Iran had manifestly undergone enormous changes and the institution of the monarchy could no longer afford to remain oblivious to a newly awakened citizenry.

Iran-e Bastan ('Ancient Iran') may be considered the first photographically illustrated newspaper in Iran.[25] The first page of the first issue (21 January 1933) was a full-page photograph of Reza Shah (photo 255). The second issue carried that of the crown prince. In the absence of television, it was the print media that kept father and son in the public eye. Always a step behind and under the shadow of his father in life and in their photographs, Muhammad Reza Shah (reg. 1941–78) battled this subordinate image through the first decade of his reign. After two years of occupation of Iran by the Allied Powers, his continued bewilderment is unmistakably apparent in his souvenir photographs with the giant figures of Stalin, Churchill and Roosevelt, as he was shuffled in between sittings of the Tehran Conference (end of 1943). Before the war, his marriage in 1938 to a beautiful Egyptian princess had taken centre stage for a while and their photographs had flooded the public scene. As the memory of the monumental effigies depicting Ramses and Darius lost lustre, the image of the fantasy couple remained youthful and innocent. In the chaos that trailed the departing Allies, it was 'unreal'. Reality was a failed attempted regicide (1949) and photographs were published of the wounded monarch who barely escaped bullets at point-blank range.

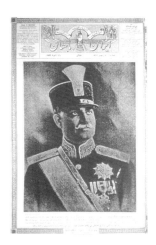

255. *Reza Shah Pahlavi, front page of Iran-e Bastan journal, 1933.*

256. *Bullet-punctured suit of Muhammad Reza Pahlavi after an unsuccessful assassination attempt, 1949.*

We began our discussion of a century of kings with Nasir al-Din Shah posing with his wives in front of a mirror. We end with the 'image of a wounded king' as portrayed by the bullet-holed military uniform of Muhammad Reza Shah (photo 256). We enter a new era symbolized by the man in the background and the finger pointing at the bullet hole, the intrusion of 'citizens' into a photograph pertaining to the king.

It all began with a royal decree.[26] Among the assignments of the first court photographers was photographing the royal entourage within the private world of the palace (*'amale-yi khalvat*). The photographs were placed in albums and presented to Nasir al-Din Shah who, in turn, in his own handwriting, identified the men and proceeded to accumulate a priceless visual catalogue for posterity of all his 'servants'.[27] Staring into the camera, these men were keenly aware of the eventual royal inspection. Their self-image was overshadowed and their individuality was dwarfed by the virtual presence of the monarch. The contrived and abject stance of the man in photo 257 clearly demonstrates a conscious self-debasing, even self-effacing posture. Nasir al-Din Shah's photo albums depicted his realm as it appeared physically and reinforced his own sense of control over his *ro'aya*, through his collection of human faces.[28]

Historically, therefore, an elite found itself standing in front of the

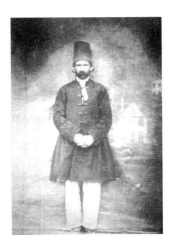

257. *Servant to the court of Nasir al-Din Shah, c.1865.*

258. *Album of* cartes-de-visite, *c. 1880.*

camera by order of its king. However, beyond the palace walls and through the years, the 'ritual' became an act of self-assertion and the portraits testified to the emergence of an originally eclipsed self-image – independent of the king.[29] The photo albums of old affluent families documented this rise in self-esteem. They commissioned local studio portrait photographers to celebrate their ideal selves and gave each other the resulting photographs as gifts. Group photographs of peers and friends, whether taken by professionals or amateurs, helped to strengthen the notion of group identity within an increasingly confident elite.

Returning from European travels, members of this class carried their *cartes-de-visite* photographs, which they placed alongside those of European celebrities in the elaborate albums that were then popular (photo 258). Dressed in top hat and tails, checkered Bermuda shorts or sporting a cane, they achieved a redefinition of self in anonymity, brought about by passing through or living in foreign lands. By placing themselves among European images, they made a visual record of their mental displacement, which was to characterize the secular intellectual movements of Iran during the events leading to the Constitutional Revolution and beyond.

The man in the street had to wait for the Revolution. During the upheaval a cross-section of Iranian society came together and interacted in a public space

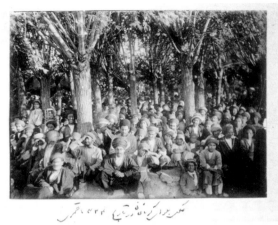
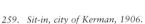
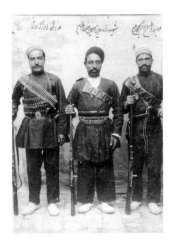

259. *Sit-in, city of Kerman, 1906.*

260. *Revolutionary partisans, 1908. The written label indicates that the man in the centre was killed later.*

and in unprecedented numbers. These interactions prefigured the building sense of commonality of purpose. Photographs not only recorded events but also contributed to the creation of that sense of commonality. The notion of group identity for the first time modified, even replaced that of the individual. A group portrait is a visual document of such symbiosis. The ideal self-image of the individuals portrayed has found expression in a concept outside the framed image. The photograph is viewed primarily from the standpoint of the reason for the gathering; the identity of the individuals is secondary. The 'cause' thus supersedes the 'self'. The photographs taken during the peaceful mass protests leading to the signing of the constitution illustrate this 'self-expansion' (photo 259). Eventually a new sense of political identity was created, which transcended narrower notions of identity such as guild, neighbourhood or status group. At the least, all city-dwellers became conscious of their mutual interests; at most, they became the emergent 'Iranian nation'.

Elevated and humble, general and soldier, leader and follower, orator and audience, clergy and faithful, nobility and merchant, educated and illiterate were all caught indiscriminately within the camera's frame. If photography democratized portraiture in the West, the constitutional movement, if for a short time, democratized photography in Qajar Iran. What is of utmost

importance is that a range of faces across the social spectrum was registered side-by-side on a single photograph. The group photographs separately and as a whole present a single image, an image of protest and defiance towards the political system headed by the king. In other words, the group image is in direct conflict with that of the autocratic system he represents. It represents a demand for reform and for justice.[30] It is only with the violent suppression carried out by Muhammad Ali Shah (in a coup d'état in 1907) that this image becomes personal and confrontational. Carrying a gun or a club against life-threatening forces, the hitherto faceless *mujahed* has developed an awareness of his individuality and he steps into the studio alone to be photographed (photo 260).

Once again one may ask, who saw these photographs? We do not know if every man received a copy of his photograph; one assumes that many did not. We know, however, that many of the photographs circulated within the militias and among city-dwellers around the country.[31] The importance of such portrait photographs is twofold. To the men themselves, being photographed was a novel experience that had previously been reserved for a lucky few. The picture was a commemoration of the person's 'self'. As he stands alone with a gun or with his brothers-in-arms in a makeshift studio, his posture speaks of an awakening. The photograph is a document that makes this abstraction real and tangible. The transformation is made visible to himself and to others.

Citizens of Tehran were well-acquainted with the faces of Sattar Khan and Baqer Khan, long before they rode triumphantly into Tehran after the defeat of the loyalist forces (1909). They were two ordinary citizens of Tabriz who had risen to become leaders of partisans fighting the king's forces during the siege of Tabriz, while the capital city of Tehran remained in the hands of the loyalist forces.[32] Portrait photographs of these men circulated extensively around the country (photo 261),[33] reinforcing their status as national heroes, known as *Sardar-e Melli* (national general) and *Salar-e Melli* (national leader).

The man in the street, seen standing up to the 'king', had gained significance by appearing in a photograph that was in the public domain. Portrait photographs of the resisting forces joined the unflattering images promoted by inflammatory texts and satirical caricatures in the print media.[34] Moved by revolutionary fervour, the photographers had proceeded to

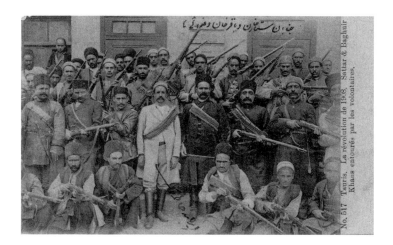

261. *Postcard of Sattar Khan and Baqer Khan, printed 1910.*

document as many faces as possible. Once the situation reverted to relative normality, the photographers returned to their studios to build an archive and more of these photographs were made available to the public.[35] Political institutions and elected bodies were replacing the shah's traditional domain. In addition, increasing numbers of local committees/councils (*anjoman*) and modern schools were springing up, marking the first stirrings of a civic society.[36] Portrait photographs thus placed a face on the *dowlat* (government), the *majlis* (parliament) and the *mellat* (nation) (photos 262–4). All these photographs entered a common visual space in a society hitherto dominated by the 'infallible' royal image and ultimately contributed to its erosion.

It was not long before people began to take a keen interest in revisiting recent events. Many of the photographs taken during the constitutional period found their way onto postcards during the reign of Ahmad Shah (reg. 1909–25).[37] The selected photographs included images of the sit-ins, the celebrations, the individual and group portraits of the *mujahedin* and even violent scenes of executions and public hangings.[38] These postcards represented an attempt by the young (proud) government and *majlis* to stress the country's 'constitutional' and therefore 'modern' identity and to create an image of the ideal Iran to be projected to the world beyond its borders, an

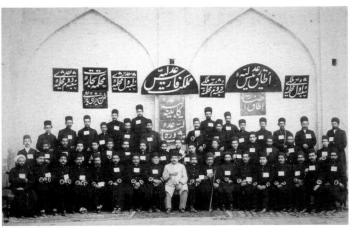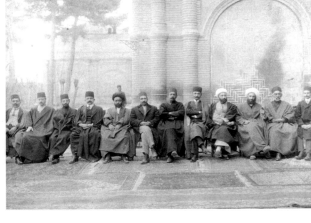

262. *Judicial corps, c. 1915.*

263. *Members of Parliament, 1906.*

image constituted by the very figures who were instrumental in bringing about the country's new identity. The postcards found many eager buyers and collectors, thus revealing the photographs to a still wider audience.[39]

The *majlis* publishing house (est. 1910), along with its photography department, was a centre of public dissemination of parliamentary news and images.[40] In due course it also inspired the establishment of similar public relations departments in other branches of the government. Tucked away in the basement of the library of the *majlis* some hitherto unknown photo albums have come to light that were taken to the First Universal Races Congress in London (1910) by a scholar and political activist who was to present a paper on Iran.[41] Next to photographs of different Iranian ethnic groups, cities and royal palaces, one finds portraits of all the protagonists of the constitutional movement: the kings, secular and clerical leaders, grassroot forces, martyrs and deputies. The importance of these albums lies in the fact that they convey a vision of an ideal Iran at a sensitive time. Side by side, king and citizen carry equal weight. One can see that although a rogue king has been punished, the concept of kingship is indisputably present, but only thanks to 'the will of the nation'.

National Geographic published an issue on 'Persia' in 1921, the year of Reza Khan's coup. The image that was portrayed of the country via both

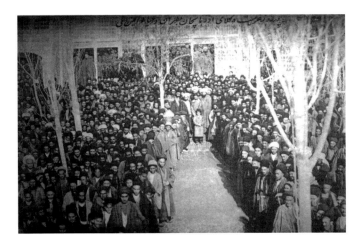

264. Citizens of Tabriz (province of Azerbaijan) sending their representative to Parliament in the capital city of Tehran, 1909.

photographs and text was precisely what Reza Shah set about eradicating in the subsequent years. If the same journalists had returned to the newly renamed 'Iran' in 1934, they would not have found their 'oriental' types. The new regime had penetrated deep into society and forced many changes, even to the physical appearance of Iranian citizens. By law, men were to shave off their beards and exchange their traditional garb of long cloaks and turbans or felt hats for Western suits and bowlers.[42] The other side of the coin was that it was made mandatory for women to lift the veil (photo 265).[43] As men and women mingled freely on the streets of the capital, people became ever more 'image conscious'. Interestingly, the many public photographic studios that were established during this period lined the popular promenade (*Lalezar*) where men and women exhibited their 'modern' selves to one another.

The radical facelift of city-dwellers was accompanied by far-reaching social overhaul. The centralized reform and modernization campaign gave birth to a large bureaucracy and expanded the apparatus of government to an unprecedented extent. Educated technocrats, the military and security forces (photo 266), merchants, urban shopkeepers and skilled artisans all prospered as well, and along with the notables of the previous regime they came to define the Iranian bourgeoisie. Government initiatives on all fronts triggered

economic activity and employment. For the first time in Iranian history favourable circumstances were created for the emergence of a middle class and the establishment of institutions in which ordinary citizens could attain advancement.

The first photographic commissions by Iranian citizens were for the identity papers and certificates issued by different arms of the state. In fact, the taking of photographs for identity papers constituted the bulk of the work of the public studios for many years. A photograph and a name constructed an identity and became the minimum requirement for receiving public recognition. After a time the demand changed. The ordinary citizen had risen not only in economic status but also in self-esteem, and was no longer satisfied with a mugshot but instead wanted a commemoration of himself as an individual or within the framework of family or friends. Peer pressure among members of the same class ensured that this type of photograph proliferated.

The 'emancipation' of women left its mark on family portraits. Whereas previously women had been conspicuously absent from family photographs, whether alone or next to their husbands and children they were now prominently present. Outside the family circle, the classical pose in all its variety is seen within the bulk of studio photographs of men and women of this period. Imaginative and creative poses are, however, abundant as we approach the first decade of the reign of Muhammad Reza Shah (1940s), particularly among group portraits of friends. All the sitters were young or middle-aged and the majority, like the new king, had not seen nor did they hold any recollection of the Qajar era. These 'theatrics' within the four walls of the studio may stem from youthful excitement and (at times comic) expressions of camaraderie. However, these are chronologically the first portrait photographs of their kind and as such indicative of the subjects' maturity and ease within their social status in the new economic order. The portrait photograph is no longer just a public statement – it has become personal; it has come of age (as the portrait photographs of Isfahan in this book demonstrate). The man in the street has thus found a reason to buy a photo album.

State-sponsored photography assumed a new and more active role during the reign of the first Pahlavi. Official rhetoric had placed the 'nation'

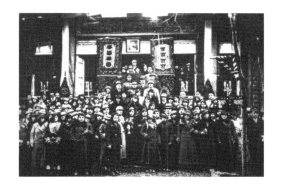

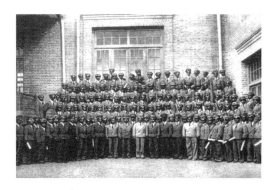

265. *The second anniversary of 'Women's Emancipation', celebrated under the portrait of Reza Shah Pahlavi, 1937.*

266. *First graduates of the Air Force Academy, c. 1935.*

267. *The first Iranian woman pilot, pictured on the cover of* Iran-e Emruz *journal, April 1939.*

among the three pillars that supported the country – *khoda, shah, mihan* (God, king, nation). In their keenness to advance and uphold a fresh vision of the country, the print media published photographs not only of the king and his modernizing campaign but also of the ideal, 'new' Iranian woman and man (photos 266–7). The photographically illustrated journal *Iran-e Emruz* ('Iran Today') was a case in point. Vibrant, active, positive and always 'grateful to the king', the Iranian citizen was depicted embracing the Shah's reforms. A loyal soldier, an inventor, an athlete and the first woman pilot were among the faces presented to the public. Schools across the country were ordered to photograph their students for official newsletters,[44] and the king would pose with college graduates and those 'he' was sending abroad on academic scholarships, or technocrats implementing 'his' projects. Together or apart, king and citizen found their images printed on the same page of a newspaper. Thus the regime gave public exposure to the bourgeoisie it had created, granting them further confidence. These were the men and women who were to form the power base of the new regime. The new king had risen from among their ranks and now tried to prove his kingship to them. Whereas the Qajar monarchs may have been oblivious to the *ro'aya* (plebeians), the new king found it necessary to address the *mellat* (nation). The royal image was thus no longer

disconnected from that of the citizen in the public visual space. Finally, next to the portrait of the king, the man in the street could also place one of his own – after all, one was a citizen-king while the other had become a kingly citizen.

Reza Shah's reign may be viewed as the incubation period of a rising bourgeoisie. After the Allied forces had physically removed him from the scene (1941) and departed (1946), the unfolding events brought the two images of the king and citizen face to face, a process that gradually became confrontational. From the start, the young Muhammad Reza Shah, who was in his early twenties, had been relegated to the ceremonial status of a well-wishing monarch.[45] It may be that he was trying to mitigate the rough image of his father. His portraits depict him posing for different audiences while performing charitable duties or handing out sport trophies. Two factors in conjunction also contributed to the promotion of this 'soft' image. First, he was constantly being compared with his father, who had left at the peak of his power. The public had not been given the chance to witness a natural ageing process. His image as an iron-willed dictator was alive in the public mind. Second, in Reza Shah's absence, civic institutions and the three branches of government took the opportunity to exercise their constitutional rights. It was also the first time since the constitutional period that Iranian citizens outside the government had been able to voice their concerns through political parties and newspapers. As in the constitutional period, yet with more force and fury, Iranian journalism now enjoyed a renaissance (1940–53).[46] Thus all the protagonists fought for their share of public attention, as their image was under scrutiny in newspapers that published their portraits along with probing articles. These newspapers became the battleground of images, both photographic and textually implied.

Tehran Mossavar was emblematic of such journals. Its outspoken editor published controversial articles alongside photographs and caricatures of politicians, pitting images of the king, the politicians and the people against one another (photo 268–9).[47] The journal's use of 'image' in a public domain in fact reflects the evolving purpose and emphasis of the portrait photograph in its first century in Iran, as a means of self-representation and projection of an image during a period characterized by an emerging state and a rising

268. *Boys' secondary-school parade, pictured on the cover of* Iran-e Emruz *journal, March 1940.*

269. *The Prime Minister is challenged in the headlines after a workers' demonstration turns violent in Isfahan,* Tehran Musavar *journal, May 1946.*

bourgeoisie, who were in turn crowding the domain of the king.

The camera was first placed in the hands of the king and eventually found its way to those of the citizen. In Iran it was a long journey but the final outcome was the same as anywhere else in the world: the camera, however it may have been used within public or private spheres, democratized portraiture and the champion was the bourgeoisie.

Isfahan, a city whose name alone evokes a multiplicity of images, produced its own rich heritage of photographic portraiture. This book opens a window onto the world of portrait photographs taken in the public photographic studios of Isfahan. The majority of the photographs in this collection were taken during the two decades 1930–50. There are also photographs dating back to the 1910s, providing a visual record of the socio-historical transitions of the period. The Isfahan images typify what may have been found all around the country. They are images of the first generation of Iranians who may be classified as middle class – each face is as important as the next in this corner of public visual space.

Notes

1. The main precepts of this paper were first presented at a conference on Photography of the Islamic World hosted by the Aga Khan Program at Harvard University (December 2000).

2. Gisèle Freund, *Photography and Society* (Boston, 1980), p. 20, quoting Jean Jaurès, *Histoires Socialistes: La Reigne de Louis Philippe*. Full text: 'On July 28, 1831 a bourgeois Parisian proudly exhibited his portrait next to one of Louis-Philippe with the following inscription: "There is no real difference between Philippe and me: he is a citizen-king and I am a kingly citizen."'

3. The Qajar dynasty ruled Iran from 1785 to 1925. The court of Muhammad Shah (d. 1848) was the recipient of the first daguerreotype camera.

4. Abbas Amanat, *Pivot of the Universe: Nasir al-Din Shah Qajar and the Iranian Monarchy 1831–1896* (Berkeley and Los Angeles, 1996), p. 11.

5. Even the official census of the time divided the city-dwellers into *nokar* (servant) and *ro'aya* (plebeian). See Cyrus Sadvandian and Mansureh Ettehadiyeh, eds, *Amar-i darolkhalafi-yi tehran* (Tehran, 1368S.).

6. Referring to the popular prime minister Muhammad Mossadeq, who nationalized Iranian oil and was later ousted by a CIA-backed coup in August 1953.

7. A. Soudavar, *Art of the Persian Courts* (New York, 1992), p. 14.

8. The peaceful years of Nasir al-Din Shah's long reign had allowed the main cities of Iran to grow slowly. Although there were no important industries, economic activity, especially trading, was increasing and a prosperous merchant class was emerging. An urban face-lift was accompanied by a restructuring of the city-dwellers' social status. There was also a small, heterogeneous, active and articulate group who stepped on to the urban stage during this period. Their numbers constantly grew, and they found further prominence during the early decades of the 20th century (1900–20). They were to become the nucleus of a modern middle class, which included mostly younger aristocrats and merchants, graduates of modern schools and colleges from varied backgrounds, sons of clergy and minor officials and even a few sons of peasants. Although a minority, they were to become the voice and political conscience of the country. These men and their families also became clients of the photographic studios. See Ahmad Seyf, *Eqtesad-e iran dar qarn-e nuzdahom* (Tehran, 1373 S.), p. 65, and Mansureh Ettehadieh, 'Patterns in Urban Development, the Growth of Tehran (1852–1903)', in Edmond Bosworth and Carole Hillenbrand, eds, *Qajar Iran* (Edinburgh, 1983), pp. 198–204.

9. The invention of Kodak's hand-held camera in 1888 was the main technological breakthrough that finalized the democratization process.

10. Graham Clarke, ed., *The Portrait in Photography* (London, 1992), p. 3.

11. Gisèle Freund, *op. cit.*, no. 1, p. 20.

12. The gradual appearance of an Iranian middle class was a process that began by the early 20th century and was well underway by 1910. For a detailed treatment of photographic portraiture in the Qajar era see Reza Sheikh, 'Beyond the Palace Walls: The Evolution of Qajar Portrait Photography 1880–1925', in *Proceedings of the Conference on Qajar Art*, London, September 1–4, 1999 (forthcoming).

13. For a thorough study of Qajar portraiture see Layla S. Diba and Maryam Ekhtiar, eds, *Royal Persian Paintings – The Qajar Epoch* (New York: Brooklyn Museum; London: I. B.Tauris, 1998).

14. All the albums are currently held at the archives of the Gulistan Palace in Tehran. However, many of the Qajar royal photographs have come into the public domain. It is conceivable the court photographers may have sold copies without the knowledge of the kings. With the change of regime in 1925, the vaults of the Gulistan Palace were neglected and thus many photographs were dispersed. Nevertheless, the archive holds over 40,000 photographs of the Qajar monarchs, spanning the period (c. 1850–1925).

15. Mirza Ibrahim Khan Akkasbashi was the court photographer of Muzaffar al-Din Shah and became

Iran's first cinematographer as well. In 1903 he accompanied the king to Europe, where he bought a printing press capable of printing photographs. See Yahya Zoka, *Tarikh-e 'akkasi va 'akkasan-i pishgam-i iran* (Tehran, 1376 S.).

16. For a portrait of Nasir al-Din Shah, of which multiple copies were made and handed to officials, see Julian Raby, *Qajar Portraits* (London, 1999), pp. 80–81.

17. Layla S. Diba, 'Images of Power and the Power of Images', in Diba and Ekhtiar, *op. cit.*, no. 12.

18. *Ruzname-yi vaqaye'i itifaqiye*, later called *Sharaf* (which became *Sharafat*) and *Shahanshahi* (during Muzaffar al-Din Shah's reign) was the only illustrated newspaper used for the dissemination of court news. It carried lithographed images of the king and a selected few of the royal entourage and government officials. It had limited circulation.

19. Cases of famine during the 19th century; occurred in 1810–11, 1816, 1830, 1856, 1870–2. Plague and cholera occurred in 1821, 1830–1, 1860–1, 1892. During the century Iran experienced periods of negative population growth. See Ahmad Seyf, *Eqtesad-i iran dar qarn-i nuzdahom* (Tehran: Cheshmeh,1373 S.).

20. The author has found many copies of this photograph in a variety of collections around the country.

21. After abdicating in 1909, Muhammad Ali Shah attempted to regain his throne with the help of his brother, returning from exile in Russia in 1911. A third brother made his own attempt at the throne separately. The *majlis* placed a price on their heads as a means to solicit public support in hunting down the three men. For a copy of the proclamation see *Iran Sal*, no. 2 (Tehran, 1378 S.), p. 88.

22. On February 22, 1921, after a coup d'état, the man who would become Reza Shah, the first Pahlavi monarch, took control of the army. In a series of public proclamations, which were posted on city walls, he explained his motives. He signed them at the end simply 'Reza'.

23. See *Safarname-yi khuzistan* (Tehran, 1303 S., reprint 1354 S.), a travelogue written by Reza Khan during his last military campaign to the province of Khuzistan prior to coronation. All through the book he expresses his disgust with the Qajar monarchs and the need for a 'strong and benevolent man to save Iran from its misery' (p. 24). Also see *Safarname-yi mazandaran* (Tehran, 1305 S., reprint 1354 S.), a travelogue written by Reza Shah during a trip to the province of Mazandaran inspecting projects in progress. All through the book he portrays himself as the 'father' and 'modernizing patron of his country'. It has been argued that these books were not written by him but rather written for him. It may be a valid conjecture. However, the personal themes expounded have clearly been derived from his thoughts.

24. While Nasir al-Din Shah's photographers had to manoeuvre around cumbersome camera boxes and glass-plate negatives, those of Reza Shah enjoyed the use of the latest hand-held cameras and roll film. Whereas one demanded a static pose and encouraged formality, the other captured movement and allowed for candid composure.

25. Other Iranian photographically illustrated magazines appeared earlier on the scene, but they were printed outside the country, such as *Chehrenama* (Cairo) and *Shams* (Istanbul). *'Asr-e jaded*, published in Tehran at the end of Ahmad Shah's reign, carried occasional photographs, most often a single photograph on the cover sheet.

26. Documents # 225004381 (1288 HG) and # 295002561 (1290 HG) at the Iranian National Archives refer to such a royal decree.

27. All the albums are held in the archives of the Gulistan Palace in Tehran.

28. On the subject of collecting photographs Susan Sontag has interestingly observed that 'To collect photographs is to collect the world'. Susan Sontag, *On Photography* (New York, 1979), p. 3. See Chapter 1.

29. This process continued in essence and gained momentum during the short reign of Muzaffar al-Din Shah. Moreover, increasing numbers among the elite community solicited services of photographers in European, Russian, Ottoman and Indian studios. This may be due to Muzaffar al-Din Shah's loosening of the foreign travel restrictions that were imposed by his father. For information on later Naseri travel restrictions see Amanat, *op. cit.*, p. 415. For a discussion of the greater cultural receptivity, social mobility and openness toward the West during this period see J. Behnam, *Iranian va andishe-yi tajaddod* (Tehran, 1375 S.), pp. 36–58.

30. The movement began with the demand for justice and the establishment of an independent institution to hear the grievances of the people. Neither 'kingship' nor the 'king' were the targets. As events unfolded, however, the king personally became the object of protest. On the evolutionary nature of the constitutional period see N. Sohrabi, 'Revolution and State Culture: The Circle of Justice and Constitutionalism in 1906 Iran', in G. Steinmetz, ed., *State/Culture: State Formation after the Cultural Turn* (Ithaca, Cornell University Press, 1999), pp. 253–88.

31. The different committees (*anjuman*) that found prominence and legal stature during the first constitutional period maintained extensive networks around the country, which facilitated communication during the counter-revolution. For example, the Tabriz committee was in touch with the committees in Tehran, Rasht, Anzali, Isfahan, Shiraz, Qum, Mashhad, Qazvin and Kirman, among other major cities. Such a network would have been a perfect conduit for transferring newsletters and photographs. The author has found photographs of militias of the *Shotorban* district of Tabriz with the signature of a photographer's studio in Mashhad dated 1325 AH. For discussion of networking among committees during the constitutional period see N. Sohrabi, 'Historicizing Revolutions: Constitutional Revolutions in Ottoman Empire, Iran, and Russia 1905–1908', *American Journal of Sociology*, 100, 6 (1995): 1383–1447, especially 1402–6.

32. The Constitutional Revolution of 1906 inaugurated the chapter of constitutional monarchy in Iran. Muzaffar al-Din Shah signed the constitution. His son, Muhammad Ali Shah, staged a coup shortly after he replaced his father in 1907. The *majlis* was bombarded; MPs, political activists and journalists were killed and imprisoned, and Tehran was placed under military rule. Partisan forces in Tabriz were among the first to revolt. Their rebellion was met with violent resistance from the loyalist forces and Tabriz was placed under siege. As their plight found national recognition other forces around the country joined them. Tehran fell to the partisan forces in 1909.

33. Photographs of the siege are discussed in Yahya Zoka, *op. cit.*, no.14, pp. 283–5.

34. For examples of caricatures published in print media of the constitutional period see H. Saher, *Seyr-e tahavvolat-e haftad sal karikator dar iran* (Tehran, 1377 S.), pp. 7–112. For a thorough analysis of newspapers of the constitutional period as vestiges of a young civic society see H. Khaniki, 'Sakhtare mashrute va nesbate an ba sakhte matbu'at', *Tarikh-e mo'aser-e iran*, 3 [10] (1999): 65–98.

35. The author has seen, in the possession of families, entire photo albums dedicated solely to photographs of the period. The studios sold the photographs, which were catalogued and numbered, either singly or as an entire collection.

36. For a list of modern schools established in the years 1900–20 see Nazem ol-Eslami Kermani, *Tarikh-e bidari-ye iraniyan*, part. 3, pp. 653–5.

37. Qassim Safi, *Kart pustalha-yi tarikhi-yi iran* (Tehran, 1368 S.). In later years, even down to this day, these postcards continue to be the main source of images for much of the historical text published about the Constitutional Revolution.

38. Further study is required to verify the selection process of the photographs. Many of the postcards continued to be printed during the early part of the Pahlavi era.

39. This heightened sensitivity and pride towards the recent events found a personalized outlet when, later, verses of poetry or passionate commentaries were written on the surface of the photographs. Many have survived to this day. Authors of the first illustrated histories of the constitutional period chose to reproduce such inscribed photographs.

40. For a detailed and photographically illustrated report on the history of the *Majlis* publishing house refer to *Iran-e bastan*, 26–7 (1932), p. 6.

41. These albums were commissioned by Mirza Yahya Dowlatabadi. Twelve albums were prepared, of which he himself took four to London and then returned to the *majlis*. They are currently classified as albums Q (1–12) at the Library of *Majlis* multimedia archive. For detailed treatment of the topic see Reza Sheikh, 'One Hundred Days of Dar al-Funun: Iranian Representation at the First Universal Races Congress 1910', in *Axnameh* 3 (12), 2004.

42. On December 27, 1928 the *majlis* ratified the proposed law to make men's clothing uniform and in Western style. The traditional cloak and turban were to be reserved for clerics.

43. Mandatory unveiling took place from January 8, 1935.

44. Official decrees on the subject can be found in documents # 297004626 (1306 S.) and 297005068 (1306 S.) at the Iranian National Archives.

45. For a chronological listing of the monarch's daily activities refer to *Gahname-yi panjah sal saltanat-e Pahlavi* (Tehran, 1350 S.).

46. See Mas'ud Barzin, *Tajziye tahlil-e matbu'at-e iran 1215–1357 shamsi* (Tehran, 1370 S.), pp. 19 and 31. This book presents a statistical analysis of the historical trends in Iranian journalism.

47. Ahmad Dehghan was a controversial figure. He was later assassinated.

Life Captured on Glass Plates

Josephine van Bennekom

In 2003 I visited the travelling exhibition 'Women Unveiled', which was shown in different places in the Netherlands. The exhibition contained photographs of Iranian women, and they were truly spectacular. I was impressed by the intensity that they displayed, the seriousness and boldness in their faces. Wearing Western clothes and surrounded by contemporary accessories, the women looked self-conscious. Their attitude contradicted common prejudices about mysterious and/or oppressed Oriental women. I soon discovered that these portraits were only a small part of the archives contributed by many different Iranian photographers. I became curious to know whether their other work would be as interesting as these pictures.

The Orient

Early photographs from Iran are not unknown in Europe. In fact, it is officially estimated that some 2,650 photographs dating from 1850–1920 are held in Dutch collections alone. There are photographs taken by famous professionals including Antoin Sevruguin and Ernst Hoeltzer and by amateurs who worked and travelled in Iran, for instance Albert H. Hotz (1855–1930). He was a businessman who, in 1874, at a very young age, travelled to Iran to develop commercial activities. Together with other Dutch and British partners, he opened a number of trading offices. One branch of the Hotz trading companies, Perzische Handelsvereeniging, was based in Isfahan. Hotz not only took photographs himself but also bought pictures from Iranian photographers. Nor was he the only one. Many Europeans who were working in Iran for academic,

political or commercial reasons made and acquired photographs that now enrich Western collections.[1]

Most of these Europeans remained foreign to the Iranian culture, however, and their photographs, beautiful though they are, reflect a specific way of seeing. Generally speaking, the photographs reinforce the image of the 'mysterious' East as opposed to the 'rational' West. Stereotyping is thus a serious danger.

In his book *Orientalism*, Edward Said describes clearly the complex interactions of power, knowledge and representation between 'us', the Europeans, and 'them', the non-Europeans. Referring to European perceptions, he says: 'The Orient was almost a European invention, and had been since antiquity a place of romance, exotic beings, haunting memories and landscapes, remarkable experiences [...] The Orient is not only adjacent to Europe; it is also the place of Europe's greatest and richest and oldest colonies, the source of its civilizations and languages, its cultural contestant, and one of its deepest and most recurring images of the Other. In addition, the Orient has helped to define Europe (or the West) as its contrasting image, idea, personality, experience. Yet none of this Orient is merely imaginative. The Orient is an integral part of European *material* civilization and culture.'[2]

Said emphasizes the fact that the West commonly characterizes the East as exotic, corrupt, mysterious and, compared with Europe, backward. As he says, however, these ideas tell us more about the lives, the culture, the fears and the desires of the West than about those of the East. He makes a distinction between the Europeans and the Americans, for whom the Orient and the Far East have different connotations. Nevertheless, there are still plenty of examples of American books and movies filled with clichés about Iran and branding it as part of the 'axis of evil'. Take the memoir *Not Without My Daughter*. The author, Betty Mahmoody, sketches a picture of the country and its people, especially women, that is biased and demeaning.[3] They are filthy and stinking, they 'muddle along the streets' and they eat with their hands like animals. By contrast, Western people are hygienic, tolerant, civilized and friendly.

Is there any possibility we can break through the mutual hostility?

Edward Said pays a lot of attention to Western representations of the East, but he ignores the ways in which people of the East look at themselves. I think the photographs in this book offer a unique chance for the two sides to get to know each other better, because the only way to challenge stereotypes is to show that there is, as John Berger puts it, 'another way of telling'.[4]

The photographs

The exhibition 'Women Unveiled' was my first introduction to the photo collection put together by Parisa Damandan. As part of the preparation for this chapter, she sent me a CD-ROM with the photo selection for this book. Other than these images, I had no further information (dates, titles, descriptions, names of photographers, etc). I had to work with 'what I saw in the photographs'.

At first I saw only many apparently random, unconnected images of men, women and children. After a while I began to distinguish recurring patterns and similar themes. I tried to identify some order in the pictures by looking for different relationships between the people, for example by looking at the story in each face. Their expressions intrigued me. After repeatedly examining these images, I recognized many similarities and, while some of the portrayed characters became more and more familiar to me, others kept their distance. With only a few exceptions, the faces that look into the lenses are solemn. One thing was very clear: a visit to a photographer in Iran was a serious business. Levity and joking were not on the agenda.

Most of these photographs were taken in a studio. They probably belong to different photo archives. We can divide them into seven groups: professions (clergymen, soldiers, artists, hunters and scientists) and masquerades; women and girls; wedding photographs; children; men with children; family portraits; the rest (masses, cruelties). The portraits were probably taken for private purposes, for example to show their subjects in a domestic environment or as a souvenir of a special occasion. Most of the portrayed people didn't care whether we, the observers, liked them or not. They were indifferent to our observations and attention. This sometimes resulted in odd images, such as that of the girl sitting on the floor with her legs spread wide apart (photo 90).

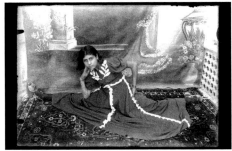

Photo 90.

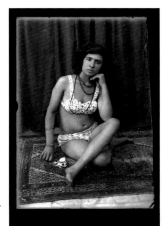

Photo 100.

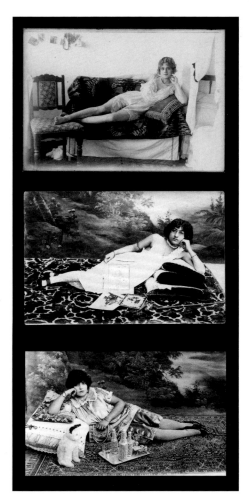

From top to bottom: Photos 67, 101 and 102.

She does her best to look graceful, with one hand supporting her cheek and the other hand on her waist. It is clear that this is a 'trick' she is performing for the photographer, with little enthusiasm or pride in herself. There is a similar photograph of a young woman in a bikini, also sitting on the floor, but with her legs crossed (photo 100). Her left hand supports her cheek and her head is tilted to the left but she looks neutral. Were these women 'performers', and was this how they really were?

The same neutral look is visible on the faces of the women who pose in a rather lascivious way on a couch or a carpet. Their clothes (or lack of), their pose, their attributes and the surroundings suggest eroticism, but the lack of provocativeness in their expressions has the opposite effect (photos 67, 101–2). They look at us as if it is the most normal thing in the world to pose as they do. They show a great deal of candour. They look confident. They appear independent. They may even have commissioned these photographs themselves.

For me, the photographs are puzzling. Maybe for the first time in their lives, these women had the chance to be who they really were. The pictures remind me of the work of the American photographer E. J. Bellocq. Around 1912 he photographed prostitutes in the red-light district of New Orleans.[5] They, too, posed in their own rooms or against a backcloth. In contrast to the Iranian models, however, the American women participated in the game of producing a suggestive and sensual picture. Some show their breasts in a provocative way, others pose with their arms behind their head. All do their best to please the photographer and hence the viewer. They take delight in our spectatorship.

The women from Isfahan have no such overt intention but there is no mistaking the sexual message in the photograph of the woman lying on a sofa in her underwear. On her right is an inviting bed. Her fingers are placed elegantly to her cheek. (The two other pictures show the women supporting their heads with their fists.) She is an exception to the rule in several ways: she is posing in her own environment, she is barefoot and ready to go to bed and her accessories suggest intimacy. If glasses refer to intellectuality, does the bed refer to sex?

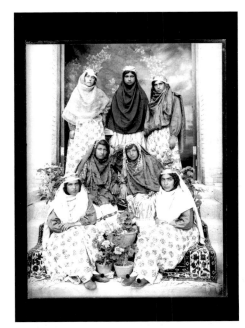

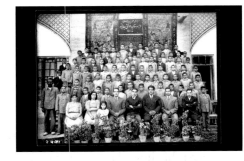

Photo 248.

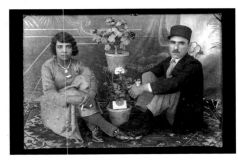

Photo 117.

Photo 159.

Flowerpots

The photograph of the seven women on a doorstep is altogether different. The women sit or stand in perfect symmetry around three flowerpots, like a trapezium around a vertical axis in a classic geometrical front view. The photo does not discriminate between them: everyone is equally important. The women are fully dressed. Are they friends celebrating a birthday together? The flower pattern on the tapestry seems to continue on through the plants, creating a three-dimensional effect (photo 159).

In many of the photographs, carpets and tapestries play an important role, but flowerpots are also prominent, as can be seen in the group portrait of men and boys arranged – like the seven women, in the form of a trapezium – behind a row of plants. This is a much larger group, however, involving a whole school (photo 248).

The flowerpots give structure to many of the photographs, even where one would not expect it. A good example is the picture of the man and woman sitting impassively beside each other on the floor, both with their arms around their knees. They are, as it were, mirrored through the two plants in the centre.

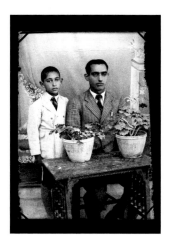

Photo 139.

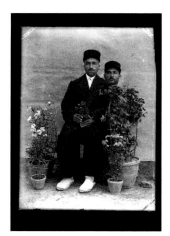

Photo 199.

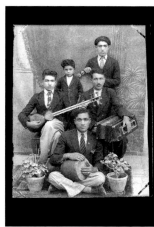

Photo 172.

They give the photo its symmetry. The card in the lower flowerpot may indicate the specific occasion for this portrait, but it is difficult to read the inscription (photo 117). The man and the boy sitting behind a small table with two plants also pose in an unusual way. Who are they? Father and son? Like the previous pair, they look not at each other but stoically towards the photographer (photo 139). In yet another picture we see a man almost invisible behind another man and a plant (photo 199). Is this a photomontage? Another picture shows two plants forming the framework for the pose of five musicians. I believe the flowerpots are structural as well as decorative elements, as are the patterns in the carpets and the tapestries (photo 172).

Do the plants have a hidden meaning? In the woven tapestries of the 15th and 16th centuries, garden motifs play an important role and I would argue that representations of gardens are intimately connected with Islam. The Koran frequently refers to certain trees and plants. Perhaps the flowerpots are symbolic of the pleasure garden and hunting ground *(pairidaeza)*. The word 'paradise' entered the Bible via the Greek *paradeisos* and the Latin *paradisus*. The *pairidaeza* evolved into more symmetrical, structured gardens, where nature was much more controlled and designed than before and thus calmer and less wild. Such a design of Persian gardens was used in France, Germany and Holland and inspired European poets such as P. N. van Eyck (1887–1954). Consider his poem 'The Gardener and Death':

A Persian nobleman:

This morning my gardener was running, white with fear, into my house, crying, 'Lord, Lord, one moment!

There, in the rose bushes, I was cutting rose after rose, then I looked behind me and saw Death.

It scared me and I rushed to the other side, but could just see the threat of his hand.

Master, your horse, and let me go quickly. Before the night I will be in Ispahaan!'

This afternoon – he was parted already – I met Death in the park.

'Why,' I ask, because he waits and is silent, 'did you threaten my gardener this morning?'

With a smile he replied, 'It was not a threat for which your gardener fled. I was surprised to find calmly working here the man I was supposed to collect in Ispahaan this evening.'

Iranian and European photography

There are some similarities between Iranian and European photography. Around 1900, photo albums came into fashion in Europe. They displayed photographs of the main occasions in family life, such as engagements, weddings, births and other celebrations. The photographs were mementos of special moments. Wedding photographs featured full-length images of the bride, so as to show off her beautiful dress; painted backcloths of church interiors were applied to create a sacred atmosphere. Photographs of parents with children, especially mothers with babies, were common. Friends and family members regularly exchanged *cartes-de-visite* or pictures of deceased relatives in order to include them in their albums. Young children were sometimes portrayed in death who had not had their portrait taken in life.

Equally numerous are school photographs and pictures of boys in military service. Students loved to be photographed in their masquerade costumes. From the beginnings of photography, jubilees, graduations and hunting parties were popular subjects. Small events from everyday life were seldom recorded.

Iranian photographers chose exactly the same universal subjects, only with a time lag of thirty or forty years. Surprisingly, they rarely produced close-ups or half-length portraits; the photographs that have come to light are all full-lengths. Another difference is that where many European photographs show mothers posing with their children, Iranian photos show fathers with their sons. What is extraordinary, however, is the fact that most of the women are unveiled. Why? Presumably the photographs were taken in the 1930s during the reign of the Pahlavi dynasty, when the *chador* was forbidden.

All in all, the photographs yield a great deal of information. They are homely and familiar. They contradict the stereotypes about the mysterious, the suppressed or the fanatical Oriental woman. It is possible that a visit to the studio gave the women the opportunity to escape from the strict conditioning

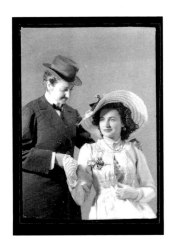

Photo 104.

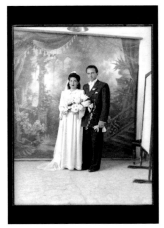

Photo 121.

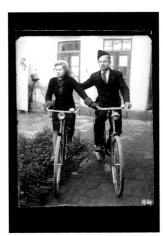

Photo 222.

of society, religion and gender, that the intimacy of the studio allowed them to be themselves, freely and completely, if only for a short moment. The photograph of two women, one dressed in male drag, peeking down the unbuttoned dress of the other, shows that an image can have multiple layers (photo 104).

An historical legacy

Photographs communicate by documenting and illustrating history. This collection of photographs provides us with valuable information about the past that is available from no other source. Each snapshot is a frozen moment, a tiny slice of life captured on glass plates, a story full of meaning that it is up to us to tease out. In Western societies people learn to smile and 'say cheese' to the camera at a very young age. In Iran this behaviour is probably unknown, thus neither encouraged nor looked on as impolite, and the way the photographs are conceived and composed is infused with other cultural factors also.

The photographs reproduced in this book provide important information about the history of Iranian photography and Iranian photographers. The fact that the original glass plates have been saved should not be underestimated. However damaged they are, the photographs give us clues about the cameras and attributes used (photo 222) and the studio environment (photo 121). This is the advantage of negatives; the prints that were made for the customer probably lack this kind of information.

Foreigners could not and still cannot enter the daily life of ordinary people. Iranian photographers do. They portray people as themselves and not as interesting anthropological specimens. Iran offers more than carpet weavers, street vendors, beggars, prisoners and tribesmen. Women are much more than shy, veiled creatures or dissolute prostitutes. People are not pictured here because of what they wear but because of what they are.

The photos were not sold as *cartes-de-visite* to tourists. They are intimate portraits that people used for themselves. They were placed in a frame or pasted in a family album. In this respect, they were indeed 'another way of telling'. Such fragile images as family portraits, John Berger points out, refer to an existence and a state of being that historical time has no right to destroy.

'The private photograph is treated and valued today as if it were the materialization of that glimpse through the window which looked across history towards that which was outside time.'[6]

This photo collection belongs to the cultural heritage of Iran, just like the mosques, the tapestries and the mosaics. Too much photography has already vanished. Let us make it our business to take good care of the small number of photographs that have survived.

Notes

1. Corien J. M. Vuurman, 'Qajar era photographs in Dutch collections', *Qajar Era Photography, Journal of the International Qajar Studies Association*, Vol. 1, 2001

2. Edward W. Said, *Orientalism* (Random House, New York, 1994)

3. Betty Mahmoody, *Not Without My Daughter* (St Martin's Press, New York, 1987)

4. John Berger and Jean Mohr, *Another Way of Telling* (Writers and Readers Publishing Cooperative, London, 1982)

5. E. J. Bellocq, *Storyville Portraits. Photographs from the New Orleans Red-Light District, Circa* 1912 (Museum of Modern Art, New York, 1970)

6. John Berger and Jean Mohr, *op. cit.*